EXTRAORDINARY POOLS

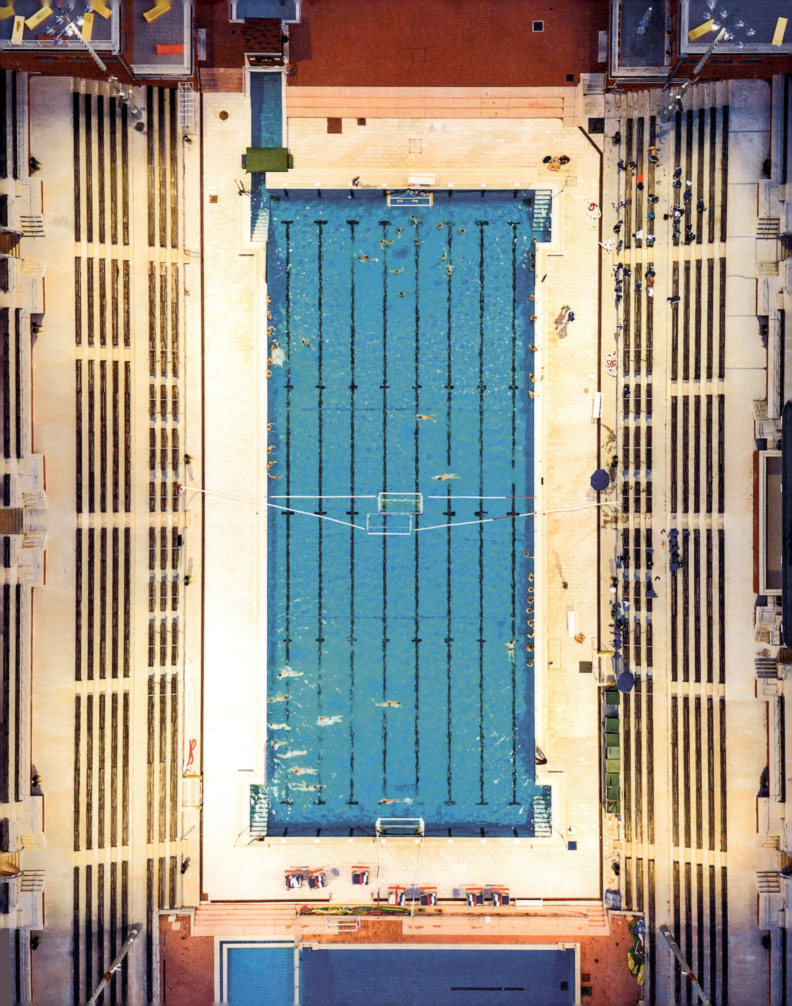

EXTRAORDINARY
POOLS

NAINA GUPTA

PA PRESS
PRINCETON ARCHITECTURAL PRESS · NEW YORK

Contents

	Phantom Pools, Naina Gupta	6
1.	Progressive Visions	12
2.	A Matter of National Importance	36
	Mussolini's Boys: *Muscles, Messages and Mosaics*	42
3.	A Pool with a View	60
	Deep Diving: *Half Air, Half Water, A Fantasy*	68
4.	A Very Private Affair	90
5.	'Natural' Pools	106

6.	Free Form, Free From	124
	Concrete, Tiles and Coping: *How Skateboarders Fell in Love with the Swimming Pool*	134
7.	Pool Culture	152
8.	In Suspension	172
	Domestic Monument	184
	Where to find the pools	198
	Index	200
	Further reading	204
	Acknowledgements	206
	Picture credits	207

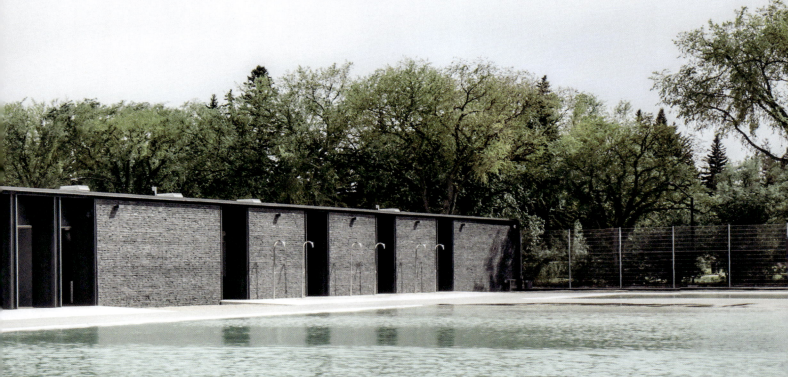

Phantom Pools

Naina Gupta

The architectural historian Thomas van Leeuwen observes that swimming is possibly the closest a human being will come to experiencing the sensation of flying. Swimming is a learned movement – it is different from what we consider our natural stance to be. Therefore, the question then arises: how does swimming inform the design of the space and in turn, how does the space enable and enrich this way of moving? What is the role of architecture in swimming pools? The projects that have been profiled in this book have in different ways contributed to these questions. Swimming allows one to move in ways that are simply not possible on land. Moving in water – skimming or floating on the surface; suspended in it with a 'frog's-eye' viewpoint of the world; penetrating it as one dives in; or piercing through it underwater – at the least fosters new ways of exploring space physically, visually and textually. The potential that it opens is what I believe makes for extraordinary pools in architecture. Even after being contained, water is anything but predictable. The nature of water as a material, as an effect and as an inhabitable space, fires the architectural imagination where reflection, transparency, fluidity and immersion continually birth new ways of interacting with the space. In this introduction, I am going to talk about the relationship between the swimmer and the architecture of the pool, using examples of some of the pools – real and imagined – that exert their presence phantom-limb-like on the architectural history of swimming pools.

On the surface, a pool is a deceptively simple object – a shaped hole in the ground. One of the more legendary swimming pools in architecture was exactly this – a circular hole in the ground that was an afterthought. In 1937, Moscow announced Boris Iofan's winning design for the towering Palace of the Soviets. Construction stopped in 1941 and did not resume after the war. Instead, in 1958, the 130m (426ft) diameter hole was filled with water, creating a sport and recreation destination simply called the Moskva Pool. The pool was divided into wedges that

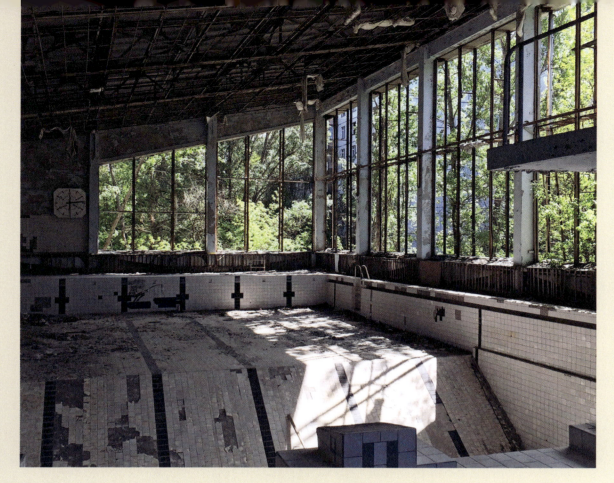

were segregated by sex. An Olympic set-up graced its centre, which included a soaring A-shaped diving structure that framed views across the diameter, most likely axially with the bridge across the river. There are just enough people outside the Soviet Union who have swum in this pool to help to keep its mythical status intact. One of the beautiful stories I heard was about a swim enveloped in rising steam and falling snow in the bitter Moscow winter. Today, the pool has been replaced by the Christ the Saviour Cathedral.

Beneath their shadowy depths, swimming pools conceal a powerful space of imagination where spatial, socio-political, physiological and psychological constructs are being continually constituted and challenged. Where does a pool begin? Is it at the surface of the water or the edge of the basin? Or perhaps it begins at the point where one gets the faint but distinctive whiff of chlorine? The key elements that constitute a pool include the basin, the changing rooms, diving structures, ladders and, to a lesser extent, depending on the type of pool, tiled surfaces, the black line and a clock. This already rich palette is compounded by minute, even invisible, textural qualities that incessantly calibrate the way that our body moves and perceives space. The near-naked swimmer's skin is in direct contact with and sensitive to materials, temperature, vibrations, colour, sound and smell – all of which

are intertwined, leading to a feeling that every pool is unique, and every swim is slightly different. Swimmers have favourite pools and pools that they do not return to. Some swimmers swim only in 'their' pool, content with the novelty that each day brings. For others, pool hunting and all the physiological and psychological response that it incites is part of their swim make-up. Most swimmers lie in between those two extremes. Then there is the category of the non-swimmer pool hunters – the Insta swimmers – who play an equally important role in swimming pool architecture: they motivate innovation and, inadvertently, support architecture.

There is an almost childlike sense of wonder and exploration in swimming – the colours of sunrise and sunset on water, swimming in the moonlight, looking a duck in the eye or hovering above a city – which provokes an equally playful response in the architect/artist, where small inclusions, changes, tweaks and innovations build upon known experiences to create new ones, which in turn are complemented by material advancement and technical expertise. The richness of the palette – materially, experientially and as a social project – is an essential part of the fantasy of designing a swimming pool.

An empty pool is a sad object. Of course, one cannot swim without water, but it is more than that. What is a pool without water? It is surely not a hole. A hole implies that it can be filled, though there have been many attempts to fill an empty pool with other functions; however, its emptiness shadows everything else that is there, except in the rare example, when it births something else such as skateboarding or, perhaps, ice skating. Water gives a pool a function, it gives it colour, and it brings the composition together. Moreover, it gives it a scale – the tiles in a pool are scaled in consideration of a swimmer's speed, gaze and body. Water connects and separates a pool from nature. Azure, the infamous abandoned pool deep in the heart of the nuclear disaster zone in Pripyat in Chernobyl (pictured opposite) was potentially an extraordinary pool. Its yawning jaw-like concrete building opened the swimming hall to natural light and vegetation. Twelve years after the disaster, the pool was finally abandoned when the liquidators left the site – a void in the fabric of the world symbolized by the void of the pool that is slowly being overtaken by nature.

In plan, swimming pools are organized as concentric rings with numerous one-way paths designed to keep ideas of cleanliness and social propriety intact. The architecture marks a sequence of movement, space and behaviour – dry to wet, clothed to swim-suited, closed to open – that is reversed as one leaves the space. The

centrality of the pool encourages seeing and being seen, which over the decades has included portholes pierced below the waterline or completely glass-fronted pools that instantly transform the swimmer into a mythologized Mer-person. In 1925, Adolf Loos met Josephine Baker in Paris and, unsolicited, drew up a plan of his fantasy house for her. The house is pierced by a double-height, top-lit pool that is surrounded by low passages fitted with glazed panels through which a spectator (he) might catch a glimpse of Baker as she glides past in the water. There is the play of exhibitionism-voyeurism in the design that Loos assumed that Baker would willingly partake in.

There is something intimate and vulnerable about immersing oneself in a shared body of water that does not translate quite the same way in most other spaces. Therefore, pools are spaces with some of the more problematic segregationist policies related to gender and race, which in turn is what makes them vital as they unveil unresolved conflict, forcing society to reconsider its outdated and unhelpful norms. Otto Koenigsberger, a Jewish-German émigré to India, designed a municipal pool in Bangalore in 1940. It was one of his first projects in the country. It is a simple, functional project that is a scaled down version of the lidos that were built in England in the 1930s. There is very little mention of this building in his portfolio, and few images of the project survive in his archives, though he did write to his mother about it; nonetheless, the legacy of this pool in the city cannot be overstated. Housed in the heart of the city close to Cubbon Park, the pool was in use until the 1990s, after which it was demolished. Interestingly, Bangalore is peppered with municipal pools, which is not typical for an Indian city. Now, while the relationship between Koenigsberger's pool and the swimming culture in the city cannot be ascertained, nevertheless, concluding that there is a connection between the two is surely within reason. Koenigsberger's pool was most likely designed as the counterpart to the pools in the many clubs in the city. While the club pools were meant for the people of the empire and, in the words of Salman Rushdie, the 'better sort of Indian', Koenigsberger's municipal pool was meant for the people of the colony.

Social ideas about comfort, disease, safety and ecology are often at odds with each other and contribute to the early demise of the building – pools have notoriously short life spans. Chlorine and condensation eat at the structure; sunscreen plays havoc with the mechanical and biological filtration systems of pools. To boot, diving structures are increasingly being decommissioned in public pools, limiting diving to a spectator sport. The architecture of diving was a space ripe for experimentation that was intimately connected to the development of the skill. Compositionally, its

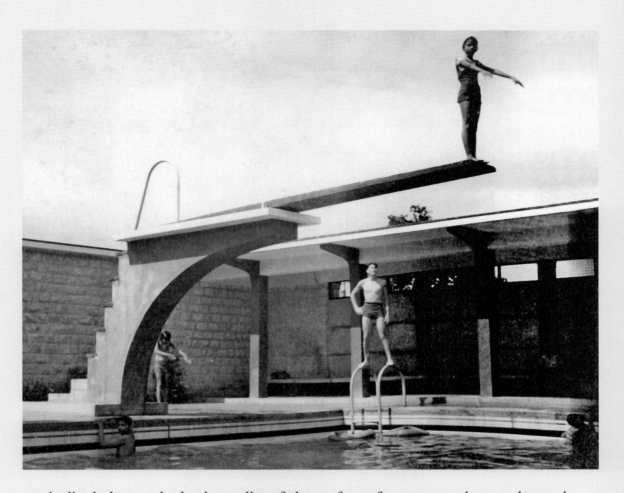

verticality balances the horizontality of the surface of water, creating a volumetric reading of the pool. Its only role is to support a series of platforms at different heights from which people could spring off into the water below. The variations are infinite – a structural and aesthetic problem waiting to be solved. Springboards still feature in pools deep enough for them, but pools are increasingly becoming shallow, in many ways. In a few decades, we are possibly going to be seeing a generation of swimmers who have never catapulted themselves cannonball-like into a pool or belly flopped painfully on its surface – thereby, learning an invaluable lesson.

Rem Koolhaas and Madelon Vriesendorp were living in New York in the 1970s when they wrote 'The Story of the Pool' (1976). The young couple had a bulletin board populated with postcards of swimming pools. It is likely that many of the pools on that board, built in the 1930s as part of the New Deal, were closing or were in a deplorable condition. In the story, the floating pool in its 'ruthless simplicity' represents the remaining vestige of radical vision in architecture, which by the end of the story suffers a fatal end.

1

PROGRESSIVE VISIONS

Badeanstalten Spanien

Spanien 1,
8000 Aarhus,
Denmark

The 'Spanien' was designed by city architect Frederik Draiby in 1933 in the then novel Nordic Functionalist style (funkis). Spanien was then one of the four swimming pools in the country, and was equipped with state-of-the-art technology that included purified salt water in the pool, an artificial rain shower above the pool that was fragranced with the smell of pines, and a solarium, to mention a few. It has been renovated twice in the last decade to modernize its facilities; nevertheless, it retains its 1930s charm.

Externally it is a four-storey unadorned brick building that is divided into two wings on either side of a water tower, which is embellished with a neon sign that is integrated into the façade – a signal of modernity when electricity was new. While the bathing wing is punctuated with square windows, the swimming hall on the other hand has vertical fenestrations that fill its cavernous volume with daylight. A gallery divides the hall vertically into two halves. The lower half is painted green, which continues as tiles cladding the swimming basin. The upper half is painted yellow, which changes into a deep blue on the ceiling, complementing the pool below. The bright contrasting colours liven the otherwise stark interiors.

In the 1930s, the gallery led to a diving board that sat in front of the windows silhouetting the divers; however, today it has been replaced by a viewing deck that juts out over the pool, creating the feeling of standing at the bow of a ship. A circular copper clock with disks that mark the hours adorns the wall opposite the viewing deck. This circular motif is repeated in the porthole windows pierced in the copper-clad room on the top floor of the water tower that looks upon the rapidly changing gritty industrial city and its harbour.

Spanien is a listed building and a treat for both architecture and swim lovers.

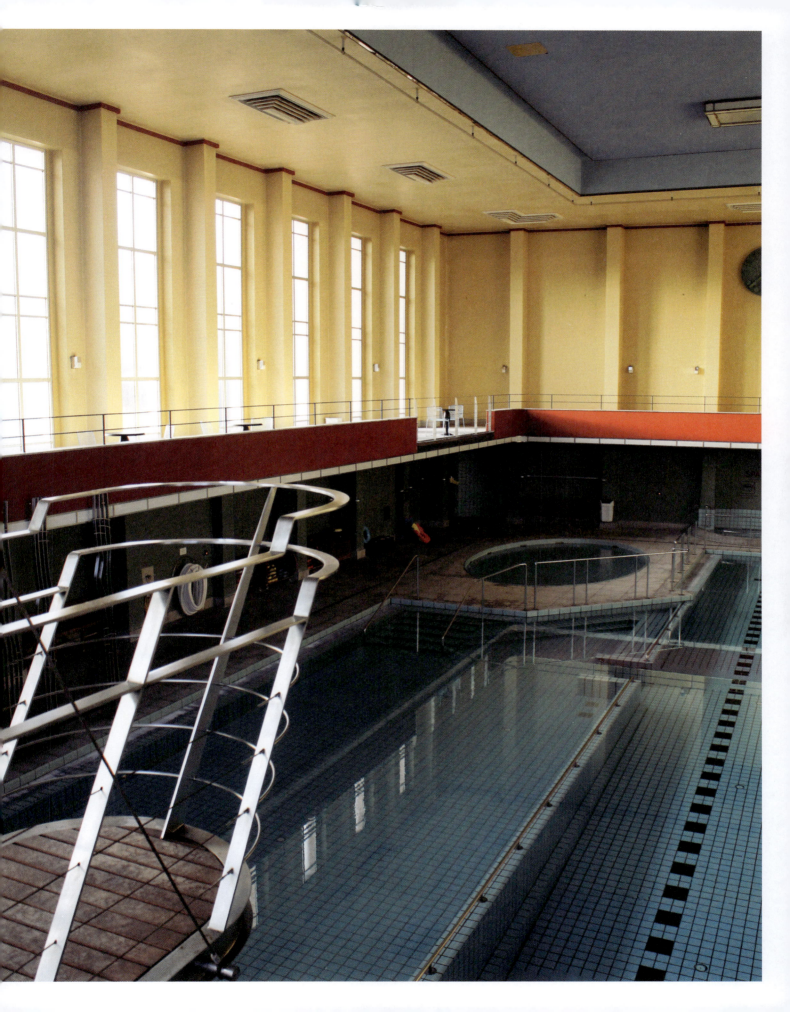

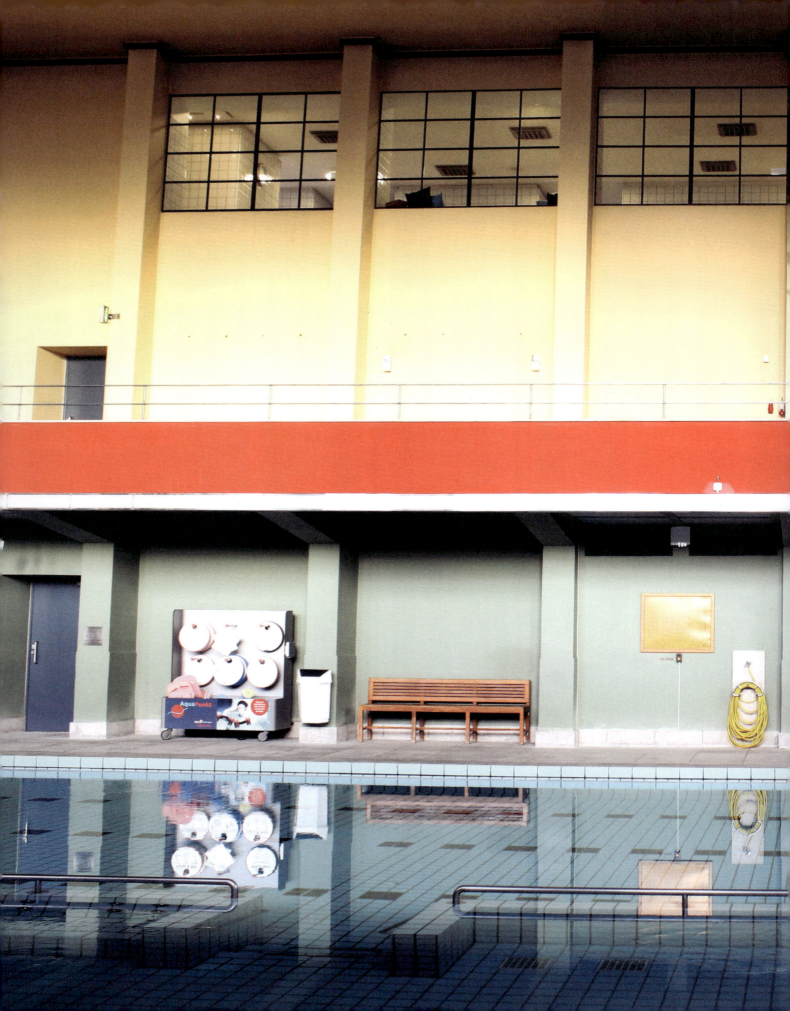

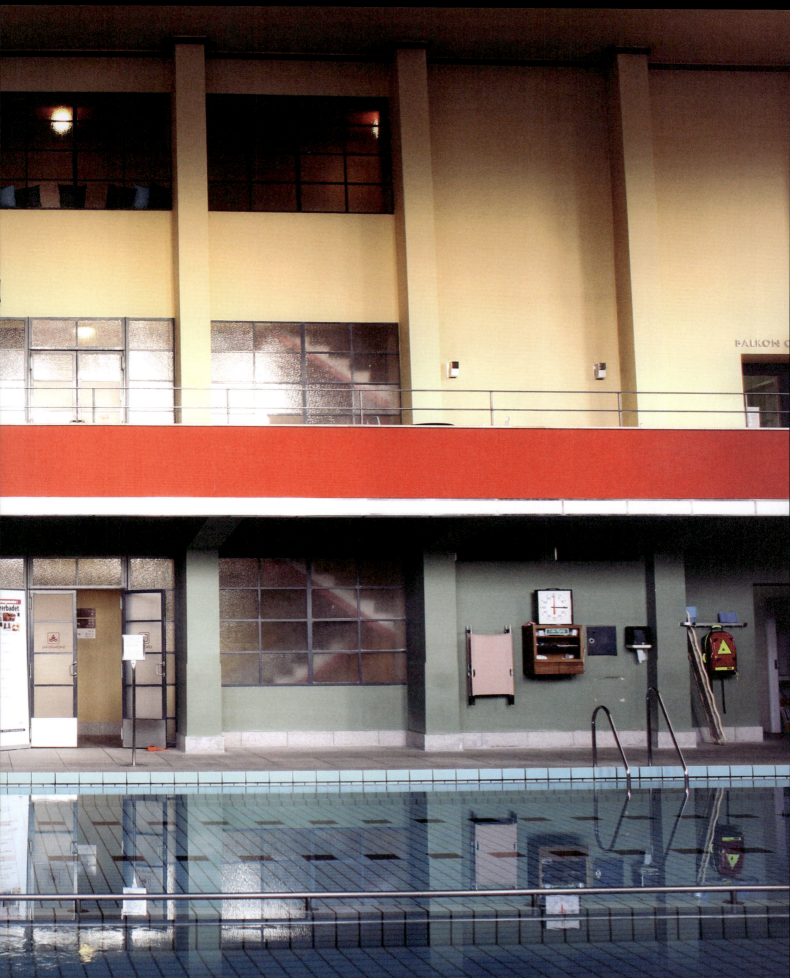

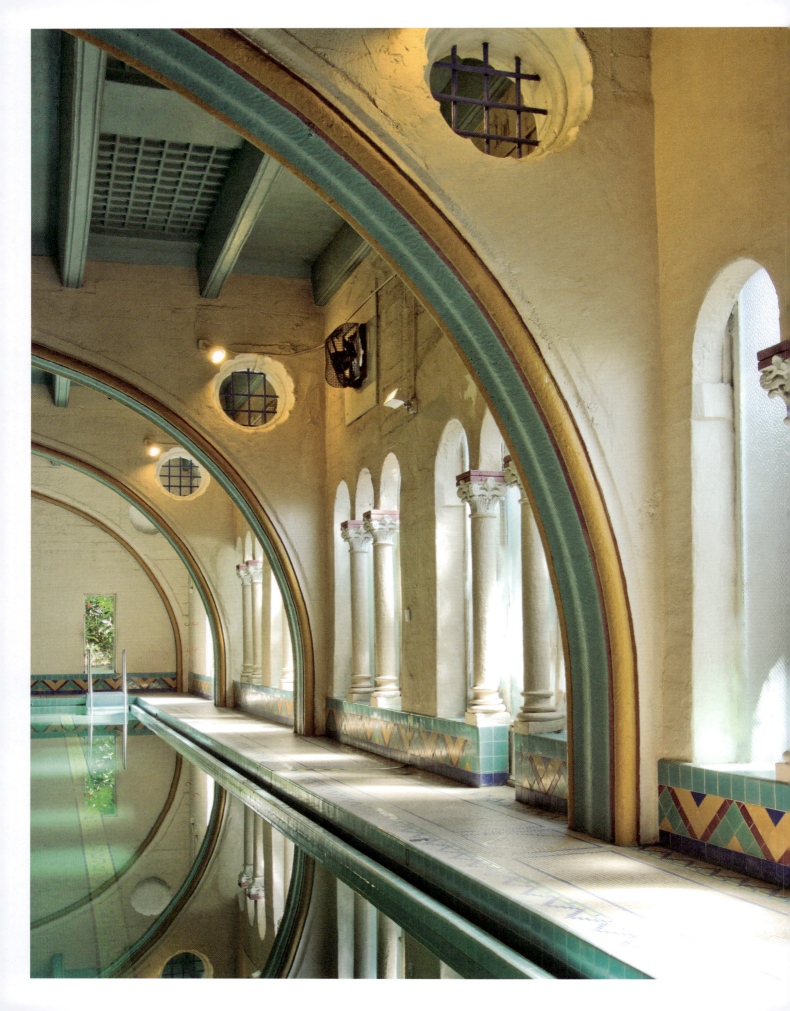

The Berkeley City Club Pool

Berkeley City Club,
2315 Durant Avenue,
Berkeley,
CA 94704,
USA

In 1929 Julia Morgan was commissioned to design the Women's City Club in Berkeley, which opened its doors to men for the first time in the 1960s when it rebranded itself as the Berkeley City Club. The pool is a Morgan 'original' that is open to members and hotel guests. Phoebe Appleton Hearst's early support of Morgan's architecture fostered two diverging interests that occupied Morgan for the most part of her active career – William Randolph Hearst's fantasy projects, and the YWCAs, women's clubs and community projects along the west coast. The club was one of the few places where a woman could access a swimming membership that spanned the entire year in the early 20th century.

Morgan was intimately involved in the design of every aspect of the pool, including the seahorses on the capitals of the columns, the hanging light fixtures for late evening swims (these have now been moved to the tearoom above) and the skylights that animated the water surface when open. The pool, or the 'plunge' as she called it, comprised the entire east wing of the building and is wedged between the east court and the garden, allowing for ample morning light to wash the space through the triple arched windows, which are fitted with leaded glass. Morgan's maturity as a designer is realized in the use of the water surface as part of the formal articulation of the space. A vaulted ceiling dominates the central axis of the room, terminating in a recessed spectator gallery. The concrete beams between the arches are painted a turquoise blue to match the tiles in the pool and are mirrored on the floor of the pool as yellow lines, enhancing the depth of the reflection of the vaulted ceiling on the water surface. The yellow and blue are repeated in the chevron pattern on the skirting that runs around the room and on the edges of the arches, allowing every line and surface to be clearly articulated even as it comes together as a united whole.

The symmetry of the space along multiple planes earned the pool an entry on the social media platform Accidentally Wes Anderson.

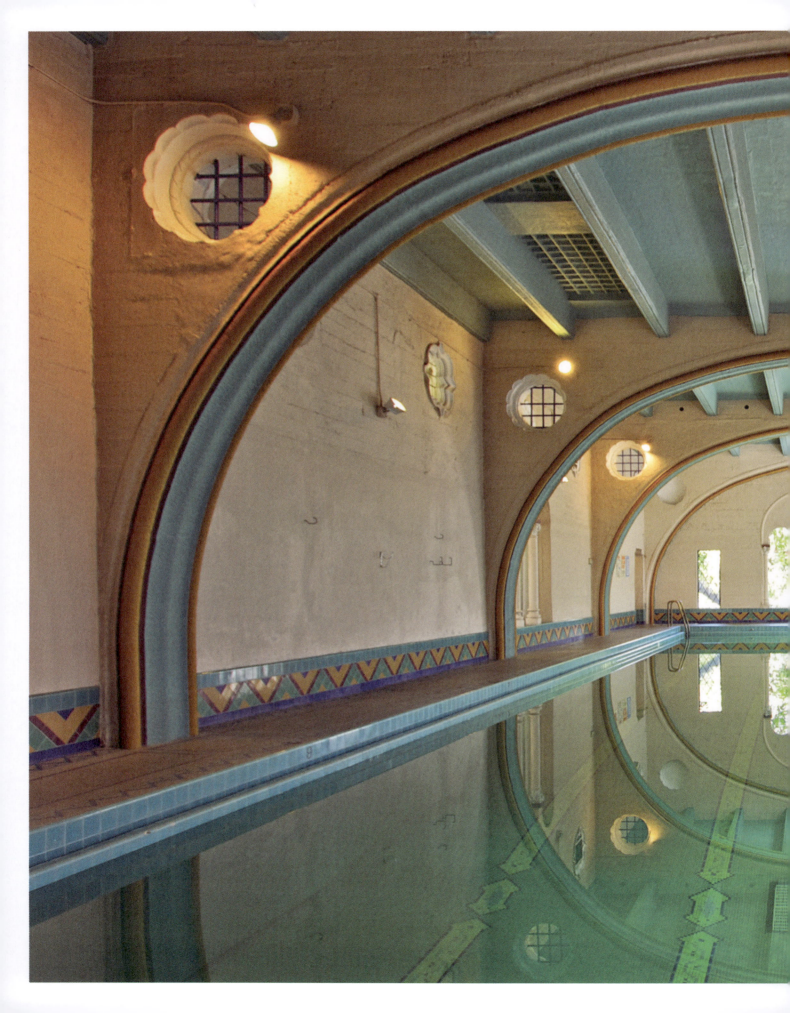

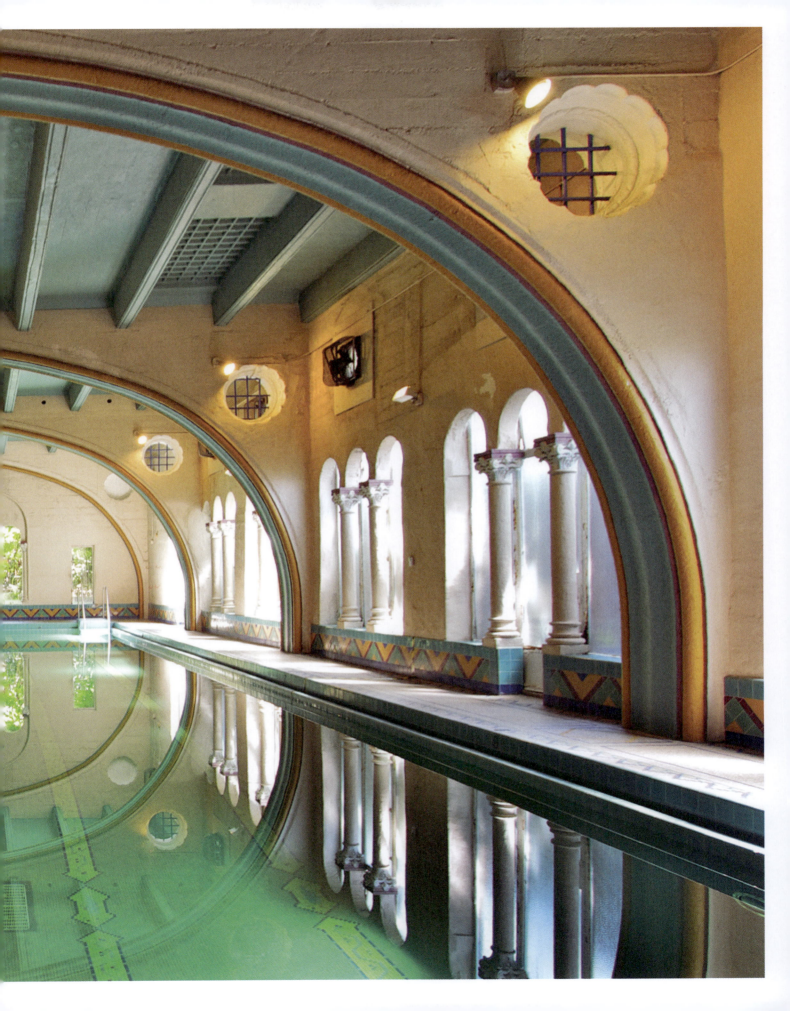

Piscine Pontoise

Piscine Pontoise,
19 rue de Pontoise,
75005 Paris,
France

The Piscine Pontoise was designed by Lucien Pollet in 1934 and is part of a series of swimming pools that he designed for La Société des Piscines de France, which includes the Molitor that was completed a few years before the Pontoise. Pollet's pools evoke images of ocean liners or, more historically, 18th-century floating baths that populated the Seine. The pool is housed in an intricate Art Deco brick building in the Latin quarter on the rue de Pontoise, just off the Boulevard Saint-Germain. It is one of the many jewels in this quarter that is rich with other treasures such as the Panthéon, the Bibliothèque Sainte-Geneviève, the Sorbonne University and Musée de Cluny.

On entering the building, one leaves the bustling streets of the fifth arrondissement behind to immerse oneself in the swimming culture of the 1930s. In lieu of communal changing rooms, the pool is circumscribed with overhanging galleries lined with individual changing cubicles with cerulean blue doors. The blue and white nautical colour palette distinguishes Pontoise from the other Parisian pools of the era. The wrought-iron railing along the gallery echoes a subtle Art Deco pattern and is painted a darker blue that matches the band of blue-gold mosaic that runs horizontally along the gallery edge. The pool is open until midnight on weekdays and the experience of swimming in the day is diametrically different from swimming at night. In the day the 33m (108ft) long pool is washed with diffused natural light from the translucent glass roof. At night, on the other hand, the light appears to emanate from the water, which renders the hall in an ultramarine glow.

It is a blue pool, which arguably made it the ideal setting for Juliette Binoche's nightly swims in the film *Three Colours: Blue*, directed by Krzysztof Kieślowski.

The pool was restored for the Paris Olympics in 2024, and is due to be reopened to the public.

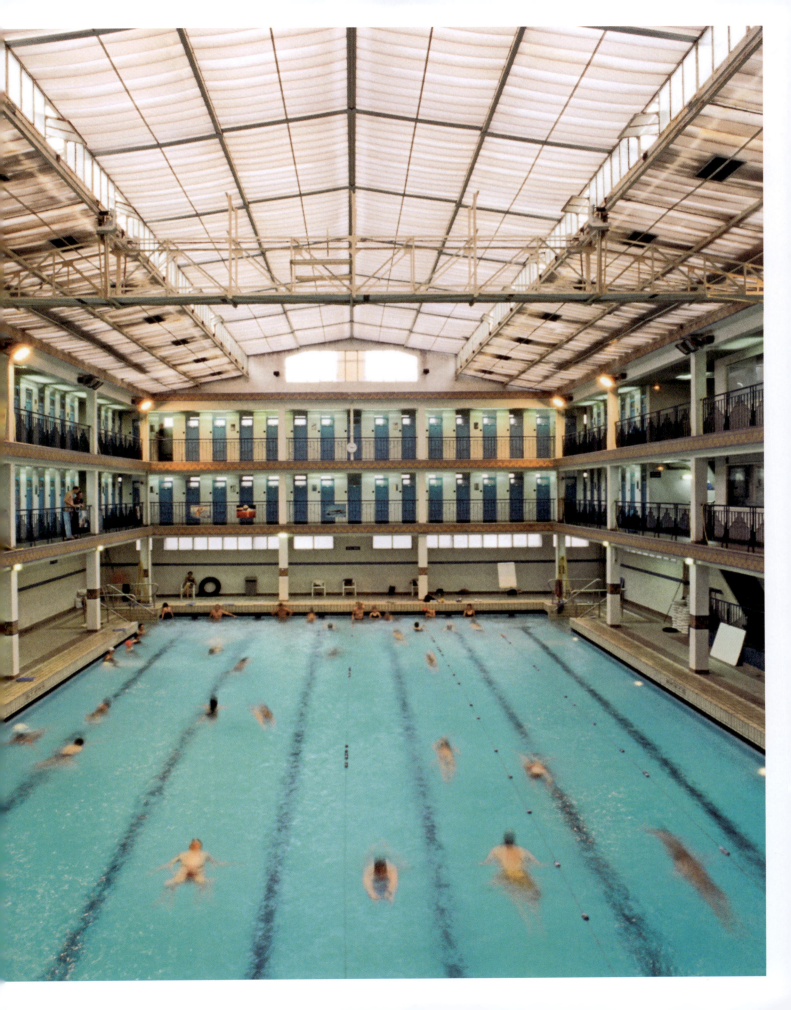

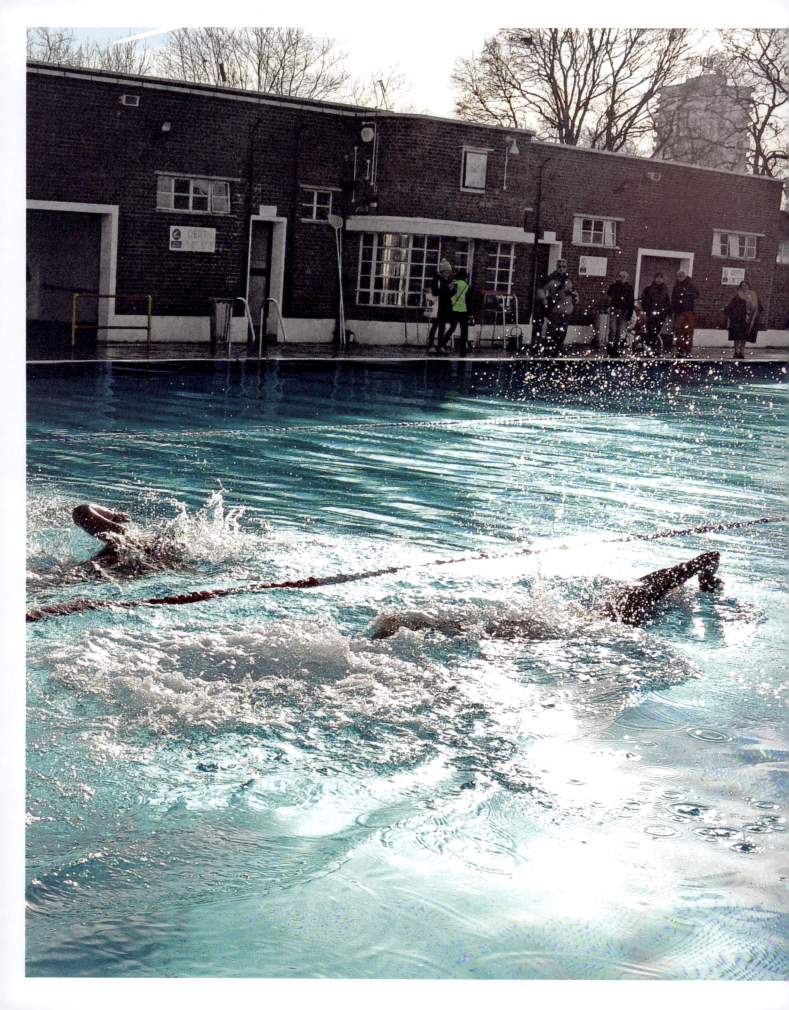

Parliament Hill Fields Lido

Parliament Hill Lido, Gordon House Road, London, NW5 1LT, England

Parliament Hill Fields Lido, completed in 1938, was designed by Harry Rowbotham and T.L. Smithson, who were responsible for several LCC lidos that were built between 1906 and 1939, including Brockwell Lido and London Fields Lido. Their signature tiered fountain that was used for aerating the pool water can be seen in all these lidos, even if today they are purely ornamental and sometimes not even used. A simple brick perimeter separates the lido from the heath and contains all the functions within its depth, leaving a large open space in the centre for the pool and sundecks.

The pool is approximately 60m x 27m (200ft x 90ft). In 2005, it was refurbished to include a stunning stainless-steel cladding on the pool basin with an articulated edge detail that sits on top of the concrete, and in the summer is a welcome transition from the warm concrete pool deck into the cooler waters. During the refurbishment the depth of the lido was reduced from 2.75m (9ft) and now is only 2m (6½ft) deep at the deepest end, with a shallow end of 1m (3ft) or so for at least half of its length. This allows it to function more like an urban seascape – catering to a spectrum of people with different needs, who range from water walkers to children to lap swimmers. The star of this lido is its highly photogenic stainless-steel basin, which reflects the temperamental British weather, colouring the water in a gun-metal grey on a cloudy day or an electric metallic blue on a sunny one – hues that are unique to this pool. Swimming in these colours makes one feel like one is flying, sandwiched between layers of the blue sky. The steel contributes to the auditory experience of swimming, as one can feel its vibrations as the tumble-turners hit off the edge, especially in the shallower end, which in itself is a remarkable feat.

Parliament Hill Fields Lido was called an 'aquatic generosity' when it was built, and it is a gift that keeps giving, especially in the recent times of economic hardship compounded by the extreme heat.

Paddling Pool, Unité d'Habitation

280 Boulevard Michelet, 13008 Marseille, France

Le Corbusier died of what is believed to be a heart attack while swimming in the South of France during his stay in his summer cabin in the Roquebrune-Cap-Martin. Le Corbusier's love of swimming parallels him meeting Dr Pierre Winter, a French physician problematically associated with the fascist Vichy regime. Dr Winter was a regular columnist in *L'Esprit Nouveau* – the journal founded by Le Corbusier to forward a modern lifestyle. Revised historiography suggests that Le Corbusier was not innocent of propagating neo-Lamarckian eugenicist thought. However, some of his arguments about the importance of exercise being integrated in everyday living could be weighed with a lighter touch when seen through the lens of the housing project Unité d'Habitation in Marseille.

The rooftop of the Unité was centred around children and therefore was part of the territory of the nursery. The parapet wall around the terrace is around 1.6m (5¼ft) high, for safety and, equally pertinently to block the unsightly and instead frame a view that stretches towards the mountains and the sea in the distance, the language of which was abstracted and recreated in miniature on the terrace. Along with formal enclosed rooms, the terrace is equipped with open air rooms, gardens, inclined and curved surfaces for playing, flat areas for gymnastics and of course the sparkling blue-green paddling pool that sits proud on the roof surface, in contrast to the otherwise drab concrete. The pool is partially shaded from the midday sun by the hovering mass of the nursery above. It is not far-fetched to imagine Le Corbusier sitting in his studio in the Immeuble Molitor in Paris while designing the Unité, looking down towards the neighbouring Piscine Molitor and deciding that a pool was a necessary inclusion in this project.

The terrace was once the centre of festivities in the building, such as an annual fair that included donkey rides. Emptied of children, the jewel-like pool is captured in photographs by Maria Svarbova that poignantly display two adults standing in the pool who are nearly touching the soffit of the mass above, clearly displaying that the space is missing its intended users in the way that it highlights the scale of the space.

It is possible to visit and stay at the Unité in the Hôtel Le Corbusier.

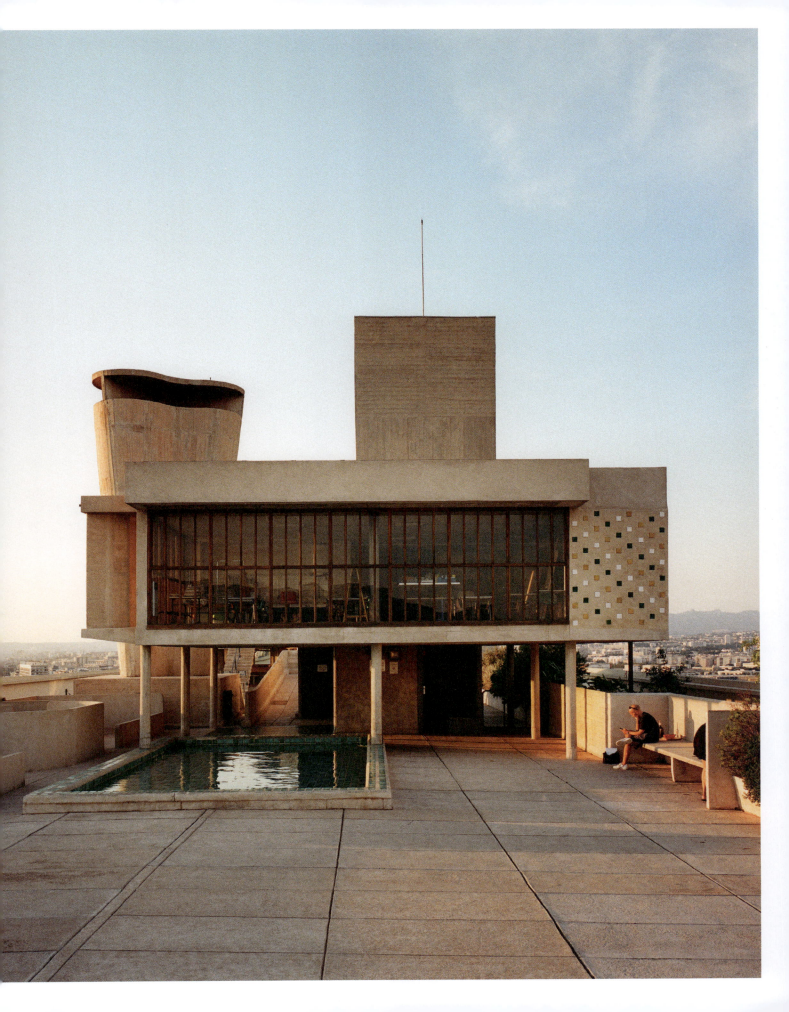

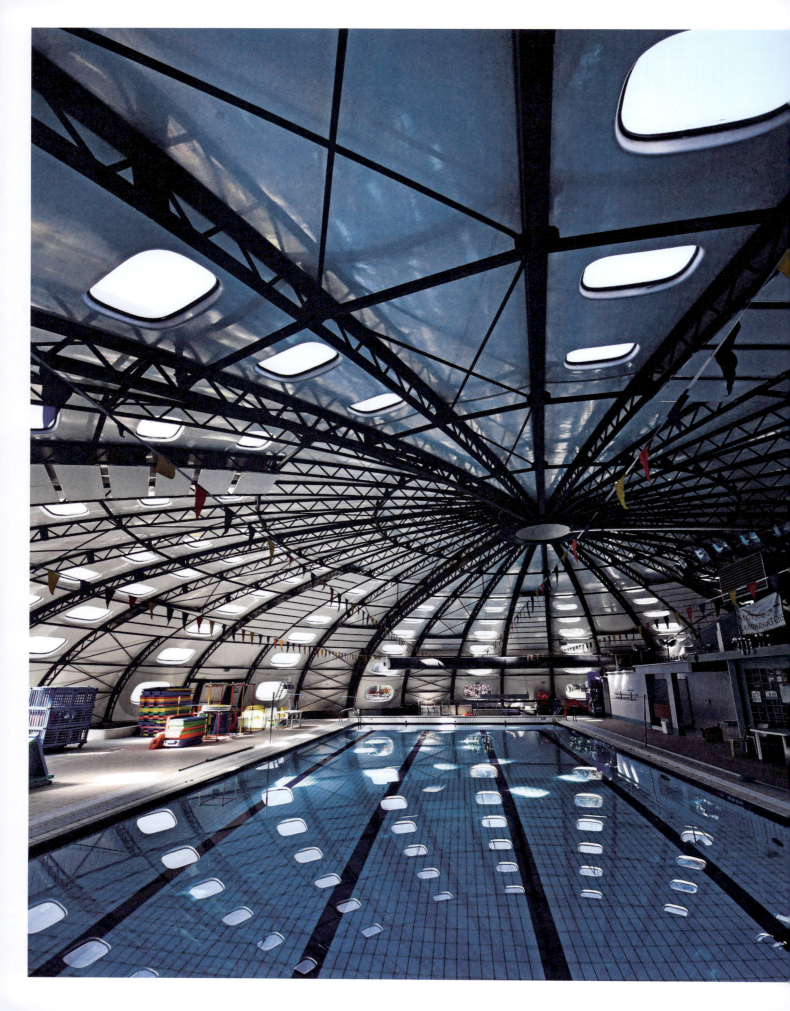

Tournesol swimming pools

France (multiple locations)

In 1969 the Ministry of Youth, Sports and Leisure initiated a programme of 1,000 swimming pools to be built around the country specifically to address the dismal performance of the French Olympic Swimming Team in the 1968 Olympics in Mexico. The history of physical culture in France runs parallel to a history of French failure – be it in war, such as the Franco-Prussian War in 1870, or in an athletic feat as mentioned above. Bernard Schoeller was commissioned to design one of the variations, which came to be called La Piscine Tournesol, or 'the sunflower'. The programme can be considered a success as around 600–700 pools were built, of which 187 were in the sunflower design.

The Tournesol is designed as a single space domed by a roof that spans 34m (111½ft) and is 6m (19½ft) high at its peak. The metal arched trusses are sheathed with polyvinyl panels which are perforated with rectangular portholes that cascade from the top of the dome towards its base. In Schoeller's initial proposal, the roof panels could be retracted such that at any given time 120 degrees of the circular form could be opened to the elements following the path of the sun, thus earning the pool its moniker – the sunflower – that remained even though the idea proved to be too costly. Instead, a fixed set of panels were made retractable on the southern face of the building to make it suitable for both summer and winter swimming. The plastic roof panels were available in a range of colours mirroring the palette of the Citroën DS, which was hugely popular in France. La Piscine Tournesol harks back to the age of High Tech architecture epitomized in Le Centre Pompidou.

Today the fate of the pools is divided – many have been given heritage status, but an equal number lie empty or are being disassembled even though France, like many other countries, has a large population of people who are unable to swim. The pool is beloved and @laffairetournesol and 'Architectures de Carte Postale' are some of the private online collections of this post-war masterpiece.

Les Bain des Docks

Quai de la Réunion,
76600 Le Havre,
France

Le Havre is no stranger to star architecture – the port city was heavily bombed in World War II, which resulted in a post-war reconstruction plan by architect Auguste Perret. One can appreciate a wide spectrum of architecture in the city where the rectilinear modernity of Perret sits alongside the seductive curvilinearity of Oscar Niemeyer, the Brazilian architect. In 2008, the city welcomed the aquatic centre designed by Jean Nouvel on its slowly transforming docks, affected by the changing tides of the shipping industry.

Externally, the aquatic centre responds to the scale and the container-like language of its context. It is a deceptively simple, grey panelled building, pierced with randomly arranged windows, with its name in skinny white letters on the otherwise stark façade. The interior, in contrast, is conceived as a shiny white geometrical abstraction of erosion in three dimensions, which is fitting for a building celebrating health and well-being through water. There are three main areas – the outdoor heated Olympic sports swimming pool, the indoor/outdoor flowing lounging pool and the spa areas. Tetris-like voids pierce the building, suggesting a natural topography of bodies of water that are physically or visually interconnected. When these voids don't completely penetrate a wall, they leave behind incidental spaces in which one can sit back and relax, which are equipped with tiny windows that selectively frame the city. The absolute whiteness of the building acts as a canvas for the play of light, shadow and reflections that animate and dematerialize the surfaces. Play appears to be the underlying theme of the architecture and is epitomized in the children's pool, which is surrounded by colourful foam blocks that mimic a geometricized version of a craggy rock shelf.

The aquatic centre is a hark back to the golden age of swimming pools that rejoices in play as a critical component of life in a city.

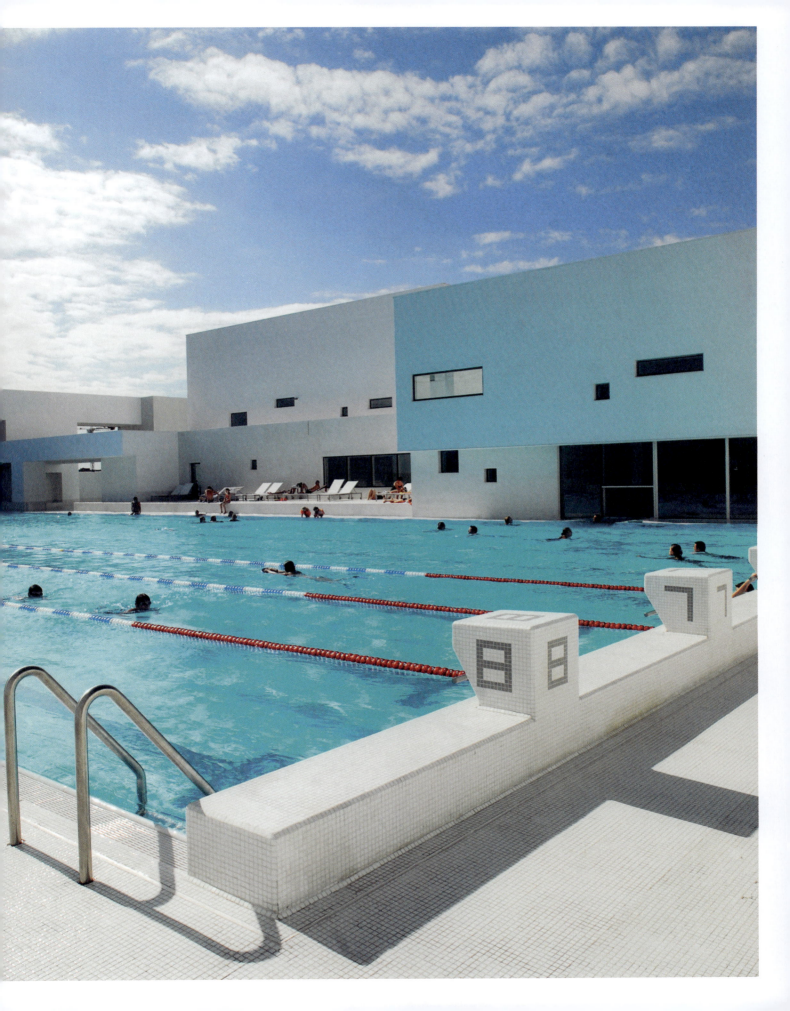

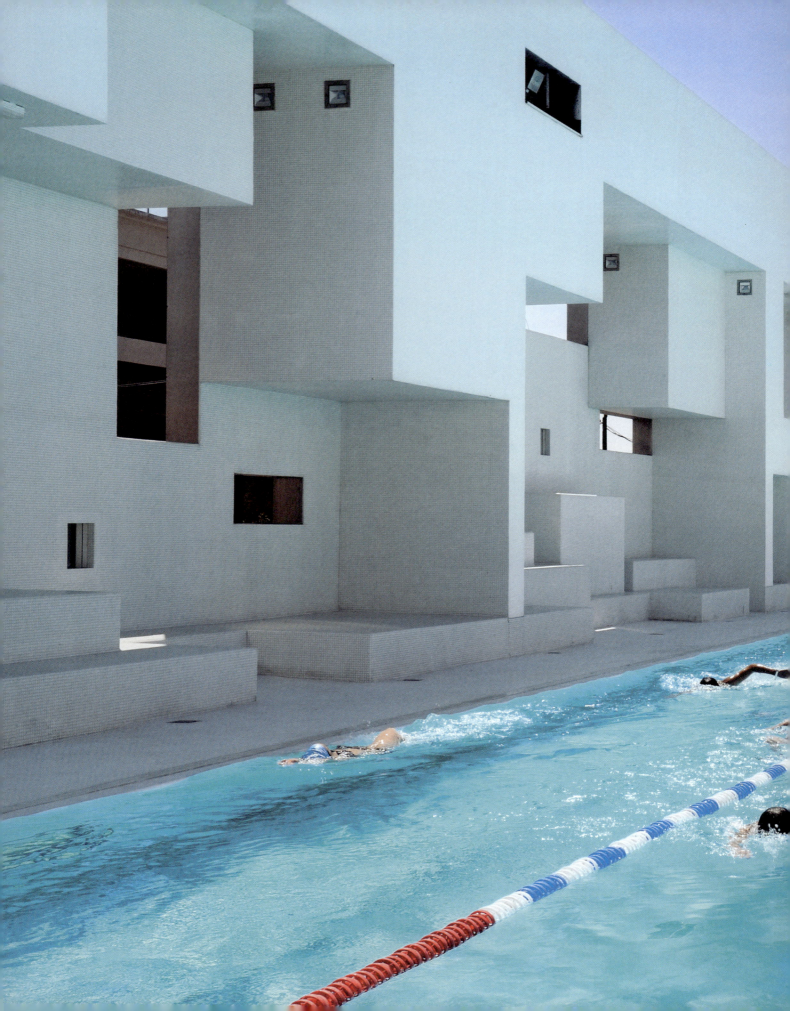

2

A MATTER OF NATIONAL IMPORTANCE

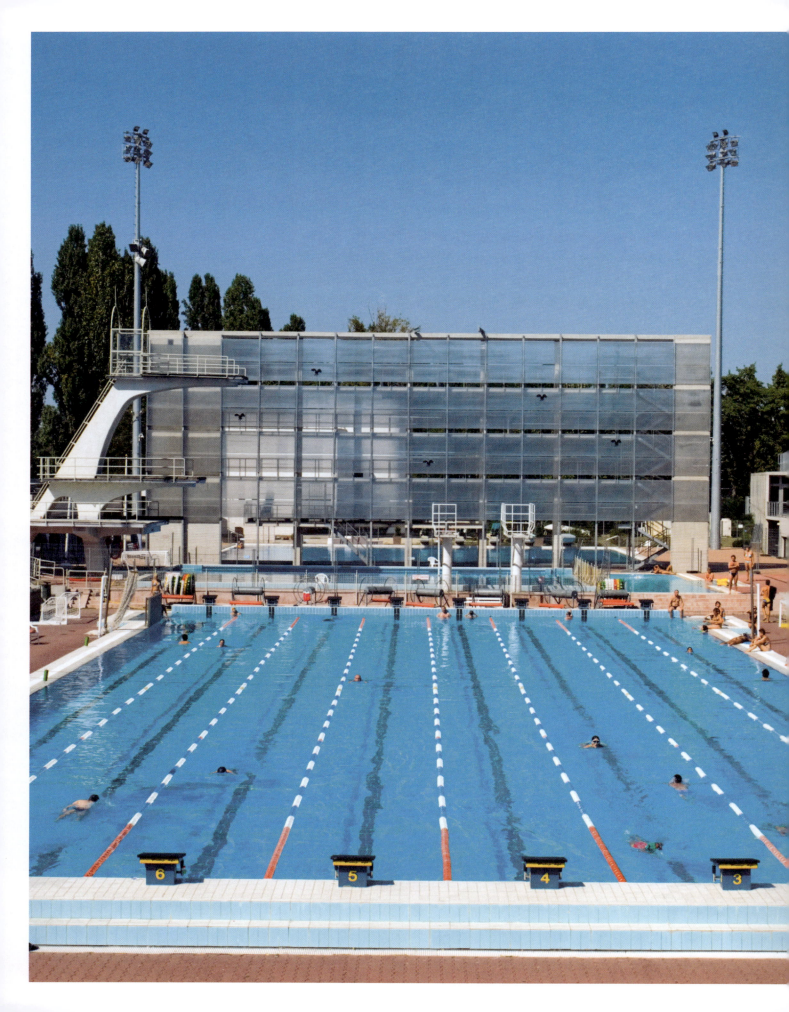

Alfréd Hajós National Swimming Stadium

Budapest, Margitsziget 23800, 1138 Hungary

Alfréd Hajós (born Arnold Guttman) was a proficient swimmer, a soccer player and an architect who won Olympic medals for swimming and architecture. He was one of the first modern Olympians, with two gold medals for the 100m and 200m freestyle in the Bay of Zea at the first modern Olympics in 1896. At the Paris Olympics in 1924, he was awarded a silver medal in the Arts Competition for his architectural design of a sports facility. The Olympic committee used to celebrate the relationship between the arts and sport, prompting figures of international renown such as Walter Gropius to submit designs for consideration. Decades later, after the practice had ended, the committee nevertheless recognized Kenzō Tange's design for the Tokyo Olympics stadium for its achievement.

In 1930, Hajós designed the National Swimming Stadium on Margaret Island in Budapest, which is 8,000 square metres (86,000 square feet) in area and has eight pools in total. Hajós's legacy buoyed the country, which is a leading proponent of aqua-athletics, centred in this stadium that is also the home-training ground for the national water polo team. The hall was structurally resolved by Eszter Pécsi where reinforced concrete vaulted beams span 31m (102ft) across and rise 14m (46ft) high to create a unified cavernous volume for the competition pool that includes spectator galleries on three sides. Pécsi was one of the first female architects in Hungary, and along with her own practice, she consulted as a structural engineer for many other modern practices of the era in the country. After World War II she emigrated to the United States, practising with Marcel Breuer and as a fellow at SOM. Her structural work informed many buildings along the Hudson River.

Though Budapest is no stranger to beautiful bathing spots, the National Stadium is an important precedent in the history of swimming pool architecture.

Palazzo delle Terme, Foro Italico

Complesso Foro Italico (ex Foro Mussolini), Piazza Lauro de Bosis (via Leopoldo Franchetti), Rome, Italy

The Foro Italico was called the Foro Mussolini when it was planned by Enrico Del Debbio and Luigi Moretti from 1928–38 under the fascist rule of Benito Mussolini. It anticipated an Olympics in Rome in 1940, which never took place. It lies to the north of Rome across the Tiber River and balances the other mega project, Esposizione Universale Roma (also known as EUR or E42) in the south that was built for the Universal Exposition of 1942, which also did not take place. Nevertheless, the two projects display some of the finer examples of Italian modern architecture in the country, built by some of the finest architects of the time. This makes it impossible to completely disregard the period and its contributions to the discipline.

The Palazzo delle Terme was designed by Costantino Costantini, who also designed the obelisk to Mussolini that greets visitors as they enter the complex. The project is monumental in scale. It houses a 50m (164ft) long Olympic pool with famous monochrome mosaics by Giulio Rosso on the floor around the pool that make their presence felt on the swimmers' bare feet. The hall is voluminous – everything is relatively well proportioned except for the diving structure that simply dwarfs the space, perhaps in response to Angelo Canevari's larger-than-life figures that lie around it, with its highest platform a little too close to the ceiling for comfort. Floor-to-ceiling mullioned windows in between columns line one of the longer sides of the pool. On the other side, a stepped raking used by spectators connects the hall to the rest of the building, including to the Piscina del Duce, or what is now renamed as the Piscina Pensile – a swimming pool for children. This 25m (82ft) long marble-clad pool surrounded by a colonnade was designed by Moretti himself when he overtook the expansion of the Foro.

Mussolini prided himself as an athlete and more so as a swimmer. This is probably the reason that the swimming pools received special attention to match the more public avenues of the project.

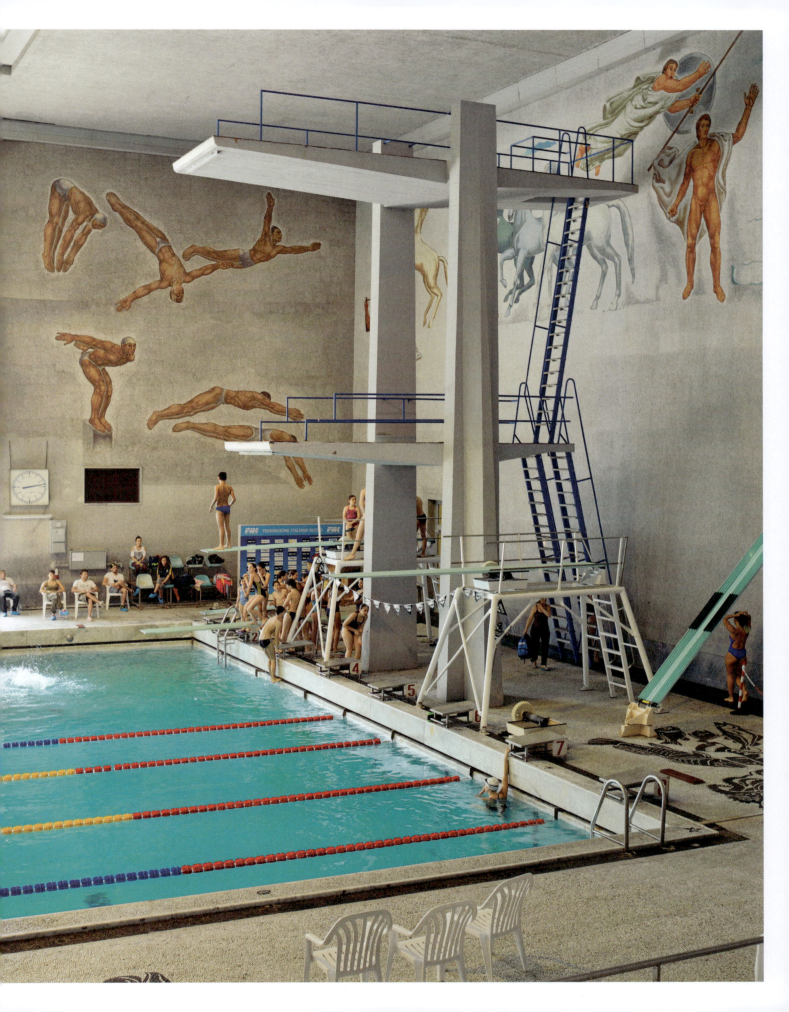

Mussolini's Boys: Muscles, Messages and Mosaics

Tatjana Crossley

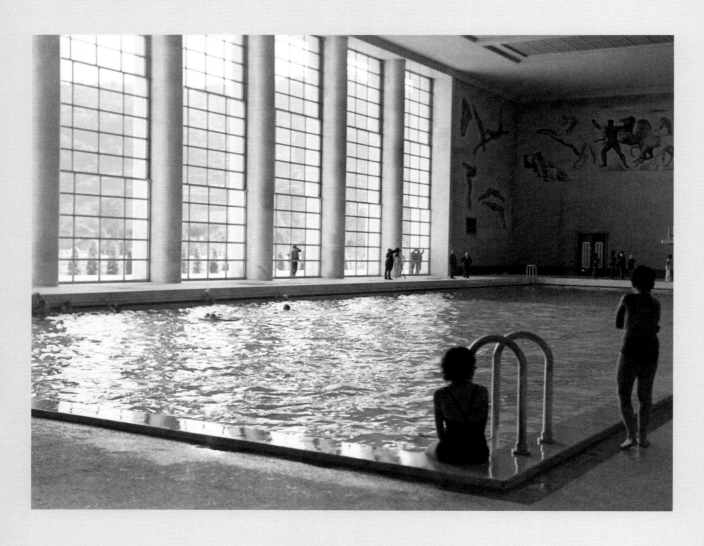

It was the interwar period. Nations were rebuilding after the devastating losses of World War I. The Olympics, while an event aiming to promote peaceful competition, was used instead as military spectacle veiled in the form of athletic prowess. While Italy went through phases of sports policy that focused on health and physical activity, Italian – as well as worldwide – politics used sport as a vehicle for nationalism. It was a means of disseminating an image of the nation that served as propaganda and was a significant aspect of creating a national identity. Furthermore, at the turn of the 20th century, the eugenics movement was gaining ground as a so-called remedy for weak and sickly populations. While Italy did not adopt measures of sterilization and procreation limits common in other nations that implemented eugenics policies, it instead focused on welfare programmes as a remedy. Mussolini began a campaign to accommodate the physical and athletic training of young Italian men and women, focusing on the production of a strong Italian 'race'. This complemented imperial attitudes towards Italian expansion, which corresponded with the acquisition of several colonies in Africa, the annexation of Abyssinia (modern-day Ethiopia), and the invasions of Albania (which lost Rome its bid to host the 1940 Olympics), France, Greece and Yugoslavia over the course of the 1930s and early 1940s. War and sport were concurrent, as the athletic training received by young men incorporated military training that aimed to produce a generation of soldiers physically and mentally ready to go to war.

This rigour of producing champions paid off. After Italy's successes in the 1932 Olympics in Los Angeles, the American press dubbed its all-male team 'Mussolini's Boys'. They had come second after the United States, winning 12 gold medals. This athletic triumph followed the fascist political campaign to redefine the identity of the 'New Italian' as physically fit, disciplined and virile. This also included women, with the addition of grace and under the umbrella of motherhood, to make it more palatable to the Catholic Church. Italy needed strong mothers to raise strong men, after all. Towards this end, several building projects were begun to provide new sports and fitness centres in which to train these 'New Italian' men and women. This image of virility represented by the athletes is an aesthetic that was translated into the architecture of these spaces.

The indoor pool at the Palazzo delle Terme, part of the Foro Italico (formerly called Foro Mussolini), is an example of the glorification of sport and physical education that became widespread in the interim of the world wars. The entire complex was designed initially by Enrico Del Debbio. The construction began

in 1927. Costantino Costantini subsequently took over the projects for the North Hostel and Palazzo delle Terme, and Luigi Moretti designed the Palestra del Duce in the Palazzo delle Terme.

It is reasonable to understand how a relatively new nation, one that had unified in 1861, would use sport to create a national spirit and a common identity to exude this sense of strength and power. Italians at this time became avid sports followers, supported by the inception of the national radio broadcasting corporation, EIAR (Ente Italiano per le Audizioni Radiofoniche) which allowed the nation to follow the victories of its athletes. Italians trained rigorously in these newly constructed sports facilities, their coaches and physical education instructors tasked with 'biologically engineering' this new identity through sport.

Before even entering the Palazzo delle Terme, visitors were, and still are, greeted by monumental structures and statues echoing Michelangelo's *David*. The architecture aimed to produce *romanità* or Romanness, by taking inspiration from ancient Roman visual culture and merging it with modern sensibilities, materials and modes of construction. It echoes buildings from the ancient forums and repurposes the iconography and mythologies to produce a space that could inspire ideas of discipline and empire. The architecture uses symmetry and colonnades, seeming to make an allusion to the Palladian windows of the Renaissance, another point in history where Italian culture thrived. The building is a volumetric mirror and is symmetrically located in relation to the Accademia Fascista di Educazione Fisica. These buildings use 'Pompeian red' and sparingly contrast this with white Carrara marble highlights to further link them with Roman tradition. The mosaic language that decorates the main Piazzale dell'Impero at the centre point of the complex, designed by Luigi Moretti, and the colossal figures that frame the exterior, carry into the interior space as we move within the Palazzo delle Terme.

The light-filled space of the indoor pool brings attention to the orthogonal and minimal architectural details and the intricately decorated wall and floor surfaces. The material choices are not insignificant, using a combination of marble, stone tiles, concrete, glass and steel, making reference to the material and building cultures of both antiquity and the modern. The Olympic-sized pool is lined with Carrara marble with stripes of Bardiglio Carrara marble delineating the lanes. Surrounding it, swimmers are faced with testosterone-heavy imagery on all sides. The larger-than-

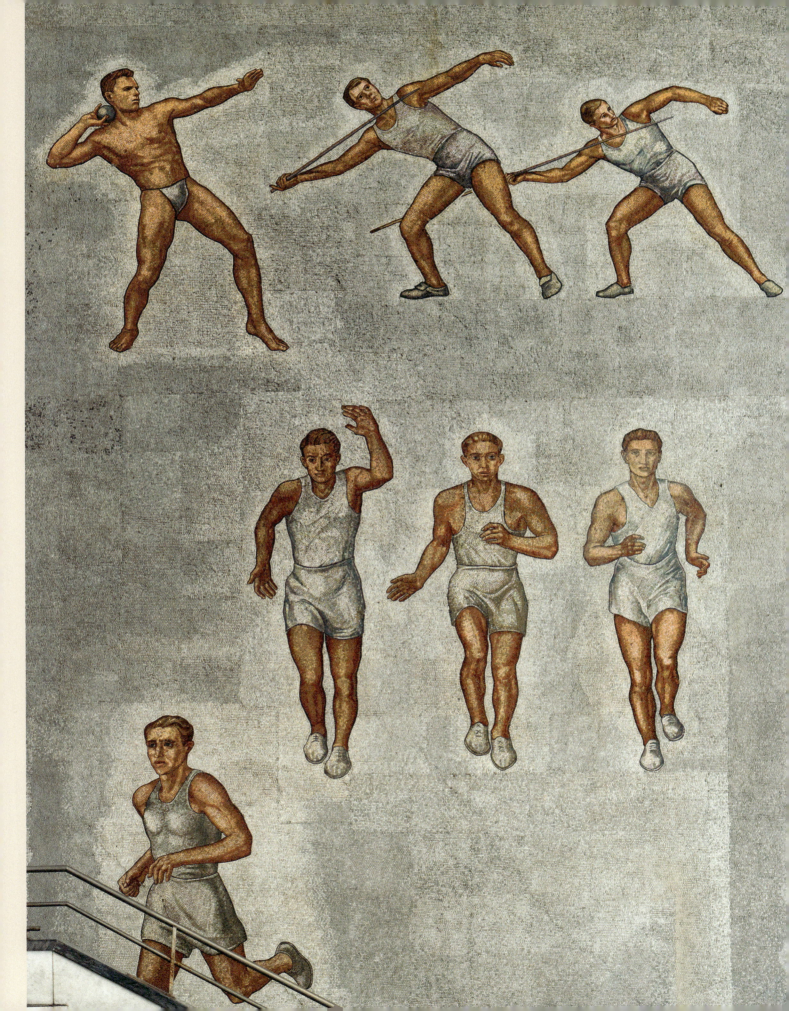

life mosaics depict athletic male bodies, some wearing basic sports gear, others naked, many wearing only competition briefs, their musculature strongly defined as they perform different sporting challenges and pose confidently, almost erotically. Angelo Canevari (who designed the wall mosaics) and Giulio Rosso (who designed the floor mosaics) masterfully employed mosaics to give a strong sense of both modernity and antiquity. Canevari used gradient-coloured tiles to create shading that emphasizes the definition and muscle tones, the folds of cloth, and an idea of movement and energy. Rosso used stylistic black-and-white relief and imagery evocative of classical Rome commonly found in sites such as Pompeii, or ancient spaces such as baths and palaestrae (a central feature in gymnasia). This notion of movement in the mosaics is quite special as it can be paralleled with the nascent cinema and new technologies in film that broke down movement into a sequence of images. The mosaics, arranged as a montage or sequence of images, take cues from the visual culture of the time.

We can make equivalencies between these images and press photos of Mussolini performing various sports that included swimming, skiing and horseback riding, posed or 'in action', positioning himself as the 'New Italian' par excellence, a modern athletic man. We can think of these representations as a 'mental engineering', creating an ideal image to aspire to. The association with the visual culture of ancient Rome is strategic in that it evokes a memory of mythological heroes and an Italian empire. Juxtaposed next to these diving and competing figures, athletes could position themselves in this world of heroic idols and mentally prepare themselves for maximum performance in service to the nation. As with the mosaics found in the main Piazzale by Moretti, there is an assumed interaction between the bodies of the viewers, the athletes and those of the represented that allows for an identity doubling. The viewers identify with the imagery and can therefore feel included in something larger and grander. As they move through the space, they can bear witness to and be a part of greatness. In fact, the mosaics rely on the moving spectator to produce their impact in generating a narrative of power. Independently the mosaics would not have this effect, but as a sequence, they are highly energized. They are viewed as a panoramic story that can immerse its audience and motivate them to also participate in sports, therefore performing an instructional purpose by cultivating collective respect for discipline and strength that translates to individual action.

The space of the swimming pool is replete with contradictions. It is minimal yet monumental, simple yet ornate, light yet heavy. It is a large rectangular room that can be read as an ancient Roman temple or courtyard with a colonnaded perimeter.

These columns frame walls of windows that let in light on either side and emphasize the gridded pattern of the windowpanes. A ceiling with faux windows, which reiterate the rhythm and patterns of the façade windows, simulates a grand skylight and brings in artificial light. Again, we can understand this design decision as taking inspiration from the atrium of an ancient Roman villa that would have been open to the sky over its central pool (impluvium). Light trickles in from all sides. These planes mimic the linearity of the pool aisles. While those emphasize the horizontality and Olympic length of the swimming pool, the windows and columns produce a verticality that makes the space appear grander. These strong orthogonal lines define the space's boundaries: the swimming pool, the decking, the diving board and the risers, while remaining in contrast to the detailed and sinuous wall and floor ornamentation reminiscent of ancient Roman frescos and mosaics. The simplicity of the architectural lines only serves to amplify the richness of these mosaics and draws attention to their function within the space. There is a clear play of flatness and depth that undulates between the use of rhythm and repetition in the architecture and the use of sensuality and movement in the figures. Canevari capitalized upon the minimalism of the architectural space to allow for narratives to spring forth from the walls, literally and figuratively. In antiquity, these representations would have told the stories of the gods and their heroes. They would have served as a memory tool to remember mythological feats. In the context of the Foro Italico, they tell the mythologies of Mussolini's aspirational boys partaking in Olympic feats as they are judged by three cloaked women that can be paralleled to the three mythic Fates. Though, instead of spinning thread, these three cast down votes and award trophies signifying who will advance to stand among heroes and the 'New Italians', and who will fall from grace. These images also serve as a memory tool that projects both backward and forward: on one hand, to remember Rome as an empire, on the other hand, to imagine a new Italian unified and imperial power.

If we recognize this as a story, we can see how it comes together to demonstrate athletic triumph on land and in water and the strong desire of Fascist Italy to produce men who could excel in a number of sports. The wall mosaics glorify the human male form in all types of activity. Generally, they depict an effortlessness of movement and a sense of virility and confidence. The western walls focus on the acts of competition and mythical judgement. The lithe divers are not so subtly juxtaposed with naked figures and several charging stallions that morph into almost serpentine sea horses. The images are distinctly sensual, using this masculine energy almost oppressively. These are the bodies the Fates are making their verdicts on. These are

the athletes who stand to represent Italy. Opposite the divers, the runners and jumpers equally demonstrate graceful and synchronized movement, thrusting forward powerfully, every muscle in their back, arms and legs engaged.

Reinforcing these more heroic images of competition, the eastern walls seem to focus on acts of athletic training. Canevari uses his mosaic techniques to again highlight the musculature engaged in the respective sports or posed positions and to produce a couple of pseudo architectures – steps going up to another diving platform where an athlete leaps, seats for a few resting athletes and, perhaps most distinctly, a play with the existing architecture of the risers continuing up the space of the mosaic for another athlete to sit. This one, naked and confident in his posture, stands out among the others on the wall as he looks directly at his audience, producing a sort of visual communication through the intensity of his gaze. As if he is suggesting, 'You can compete among champions too.'

Overall, the imagery is meant to exude power, strength, and inspiration for this New Italian way of life. While contextually the mosaics were intended to support fascist agendas of the time period, their beauty and relevance today are undeniable. As an active swimming centre since its conception and even after the fall of fascism, they have continued to serve this heroic role for countless athletes who have since swum within this space. They are a welcome reminder of the power of imagery to produce a sense of identity and national pride.

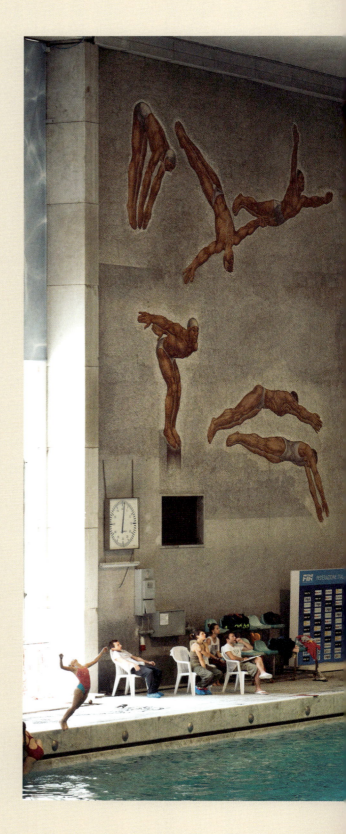

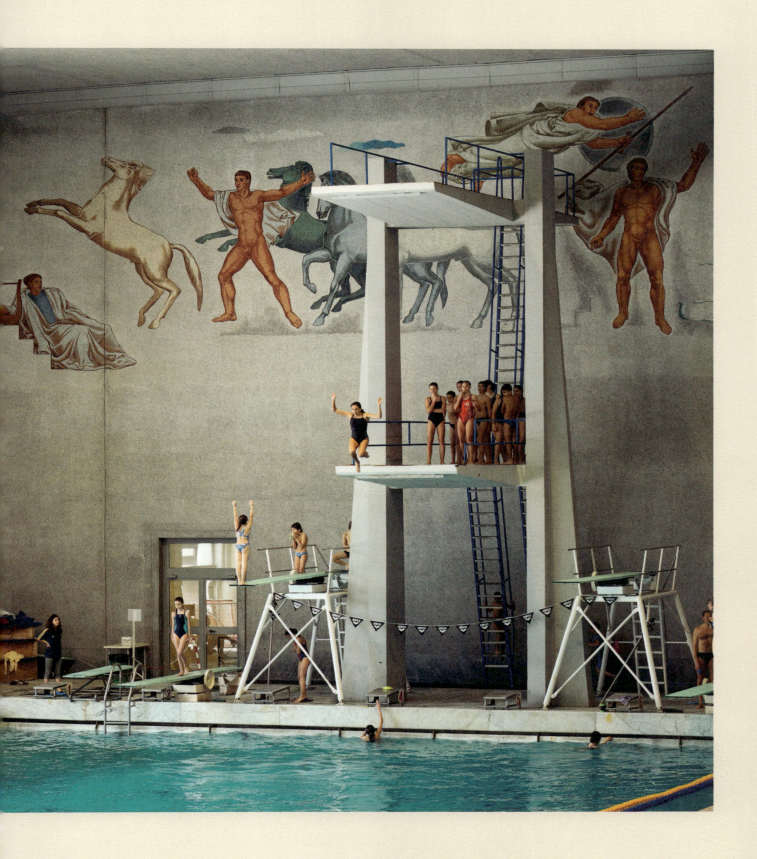

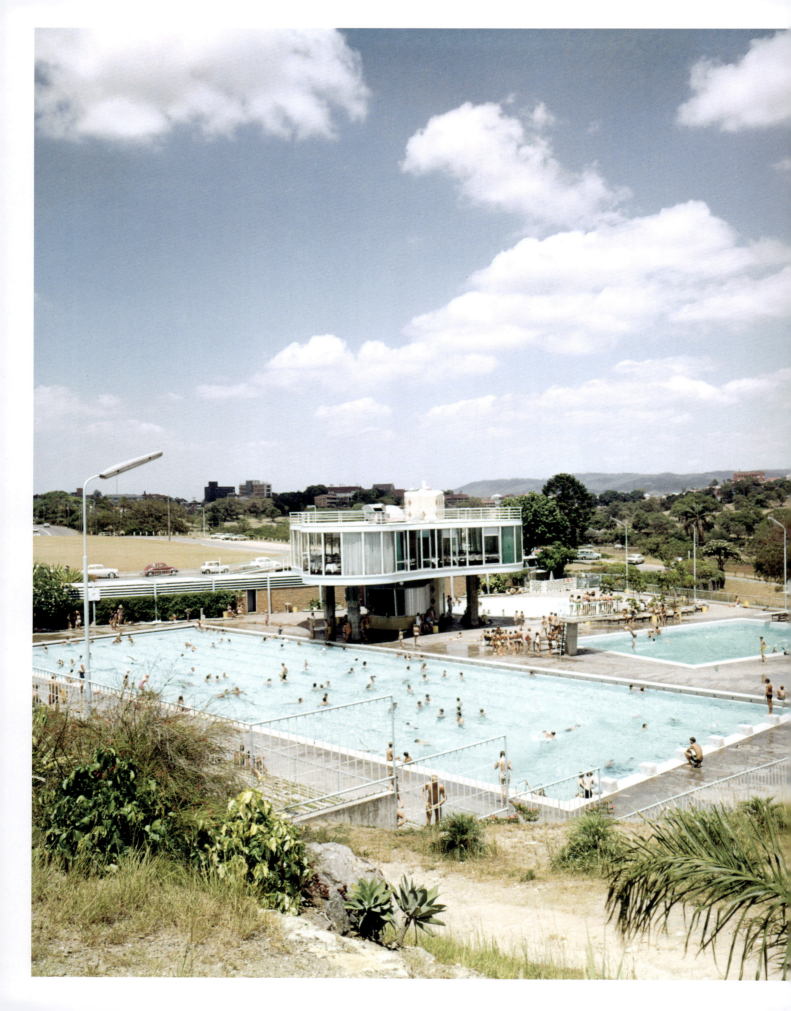

Centenary Pool

Gregory Terrace, Spring Hill, Brisbane, Queensland, Australia

James Birrell was an educator, writer and practising architect. While he was the city architect of Brisbane from 1955–61, he designed several public buildings, which included the Centenary Pool, completed in 1959. In 1956, Melbourne hosted the Olympics, where Australia won thirteen gold medals, eight of which were for swimming. This buoyed the nation into a swimming pool construction frenzy – Brisbane built ten in quick succession – plausibly fostering the national identity connected to the sun and water. For three decades, the Centenary Pool was the main aquatic facility in the city for training, diving and recreational swimming.

Birrell planned the pool as a composition of forms in plan and elevation, which included a 50m (164ft) long rectangular pool, a smaller, deeper diving pool and a circular paddling pool with mosaics that subtly reference the sidewalk of Copacabana by Burle Marx in Brazil. Niemeyer's and Le Corbusier's influence on the design, however, is evident in the ameboid kiosk/restaurant, which is now a gym, that hovers above the paddling pool. The entire composition was built on a platform to accommodate the difference in level between the adjoining park and the road. Therefore, one of the raised corners is equipped with a lower viewing gallery with portholes looking into the pool, which was useful for training athletes. While this is commonplace in today's pools, it was an early innovation in aqua athletics. Lastly, to tie the composition together is the slender four-tiered diving platform composed of a truncated square pyramid mast that leans along the diagonal, supporting the diving platforms on one side and a spiral staircase on the other.

In 2016, Aileen Sage Architects Amelia Holliday and Isabelle Toland, along with Michelle Tabet, installed a swimming pool as part of the newly constructed Denton Corker Marshall pavilion at the Venice Biennale to reflect on the national identity of the country, and its relationship to swimming and the murky segregationist policies that deprived the indigenous population of swimming pool access.

Royal Commonwealth Pool

21 Dalkeith Road,
Edinburgh,
EH16 5BB,
Scotland

This 1970 RIBA (Royal Institute of British Architects) Regional Award recipient, designed by Robert Matthew and Stirrat Johnson-Marshall (now RMJM) and headed by partner John Richards, is an example of post-war welfare state generosity that is less evident in politics today. It was built for the XI British Commonwealth Games, but unlike some of the other swimming pools built for similar occasions, such as the Empire Swimming Pool in Wembley and the National Recreation Centre in Crystal Palace, both in London, it has survived the test of time and is listed as Grade A heritage status by Historic Scotland. A beloved social space, it is affectionately called the 'Commie' by locals. In 2009, it was renovated and modernized by S&P Architects, reopening in time for training for the 2012 Olympics and as a competition site in the 2014 Commonwealth Games in Glasgow.

The building is dedicated to water sports and is equipped with a 50m (164ft) main pool, a 25m (82ft) teaching pool, a specialist rowing tank and a diving pool. During the renovation, the diving pool was changed from its irregular pentagonal shape into a 25m long rectangular pool with a mechanical floor. Irrespective, it remains the pièce de résistance of the building. Instead of lifting the entire Iroko wood-clad slatted ceiling of the swimming hall to accommodate the diving structure, the architects only raised the ceiling above the diving pool – externally legible as an additional storey that helps to balance the otherwise horizontal Brutalist composition. The diving platform is a composition of cylindrical shafts of different radii depending on structural need. Spiral staircases painted in black with precast wedge-shaped formed treads snake around the slender banded cylinders, alternating with diving boards as they service two boards at different heights, contributing to the rhythm and movement in the space.

Soo Burnell, a Scottish photographer whose work has regularly been submitted to Accidentally Wes Anderson, has added to the splendour of the diving structure in the way that she has captured it. Burnell's swimming pool photography documents several swimming pools in Scotland, which boasts of eight heritage-listed baths.

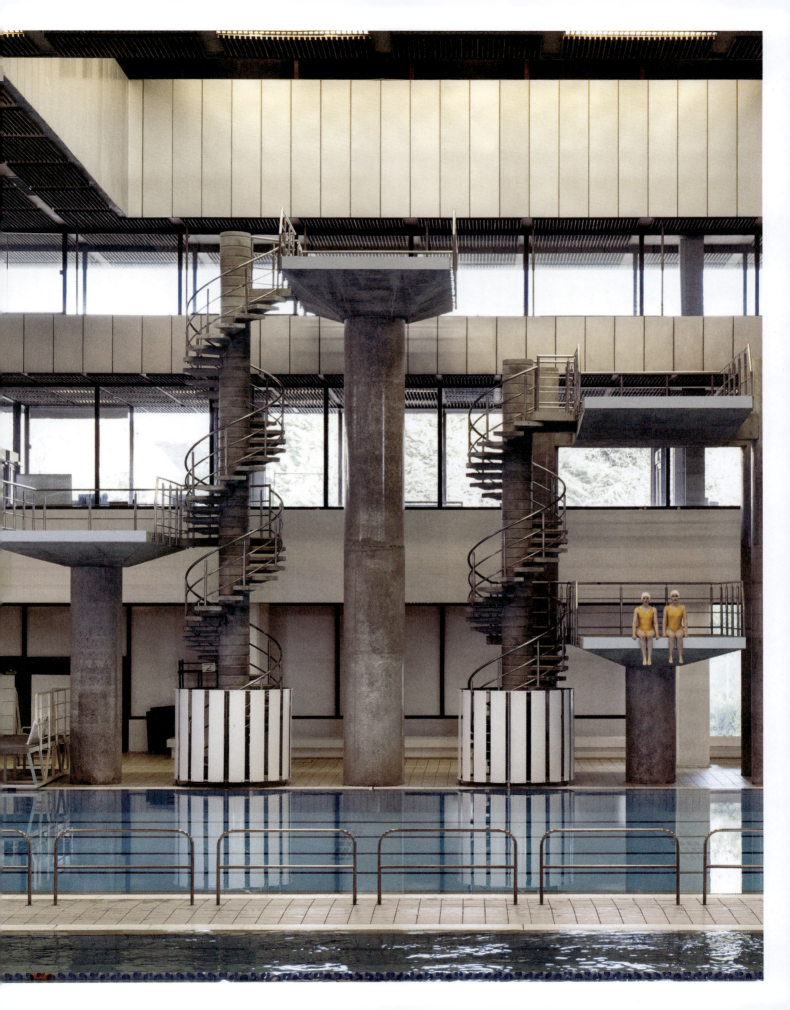

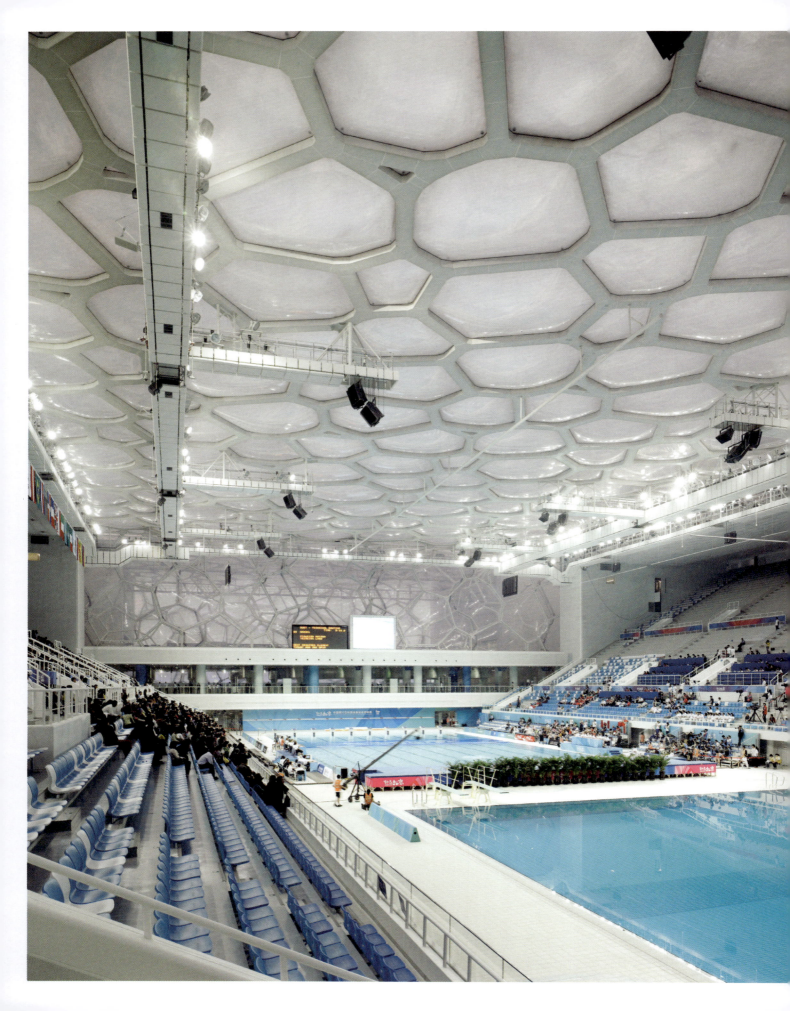

The National Aquatic Centre
(The Water Cube)

Olympic Park, 11 East Tianchen Road, Chaoyang District, Beijing, China

On 17 August 2008, Michael Phelps won eight gold medals in the Beijing Olympics, beating the previous record of seven gold medals won by any one athlete in a single Olympic championship. The Water Cube, designed by a consortium consisting of China State Construction Engineering Corporation, China State Construction International Design Co. Ltd, PWT Architects and Arups, clearly holds a special place in the heart of the swimming legend, who returned to the venue with his wife and first son years later. During the architectural competition, the consortium was faced with the additional pressure that the cube was going to be facing the stunning Bird's Nest, or the National Stadium, designed by Herzog & de Meuron and Ai Weiwei, and surely must respond to it. The winning design by the consortium was in a dialogue with the stadium.

The cube is the yin to the stadium's yang. It is square in plan to resonate with the Chinese symbol of earth, while the stadium's circular form evokes the heavens. Where the stadium displays strength in its use of steel, the cube, to the contrary, suggests softness with Ethylene Tetrafluoroethylene (ETFE) panels that gently billow out, rendering the building like soap bubble foam in the shape of a cube – a structure proposed by Denis Weaire and Robert Phelan. The skin plays a crucial role in the building – it is structural, thereby allowing for large column-free spaces in the interior. In addition, it acts as a benevolent greenhouse, trapping solar energy that is used for heating and lighting the building. Lastly, the use of the Weaire-Phelan structure generates a geometry that adds variation to the interior.

In 2022, the Water Cube was converted into an ice rink for curling for the Winter Olympics and the Paralympic Games. There is a natural affinity between swimming, skating and surfing – all three are movements that skim over the surface of water in its different forms, and all three share a history in the swimming pool.

London Aquatics Centre

Queen Elizabeth Olympic Park, London, E20 2ZQ, England

Zaha Hadid was the first female architect to win the Pritzker Prize, in 2004. Hadid graduated from the Architectural Association in the late 1970s, and Athena-like she emerged fully formed, briefly collaborating with Rem Koolhaas (OMA) before beginning her own practice. Her drawing-paintings changed architecture – the way that it was described, represented and conceived. Though initially her critics claimed that Hadid would be a paper architect, her practice, Zaha Hadid Architects, was soon designing geometrically complex projects around the world. Some of Hadid's international commissions, such as the stadium in Qatar for the FIFA 2022 World Cup, are less palatable because of the treatment of migrant labour involved in the construction.

The Aquatics Centre was built for the 2012 Olympics in London. This was the third Olympics hosted in the city, but the Aquatics Centre was the first swimming pool venue built for the Olympics. In 1908, the Olympics was hosted in the White City stadium, which had an integrated open-air pool beside the track. The Empire Pool in Wembley that was built for the Commonwealth Games was repurposed for the 1948 Olympics. As expected, swimming pools designed for the Olympics have stringent standards and this pool is no exception. The pool is homogenous, with a flat floor to ensure that there is no sensorial or visual disparity along its length, so that the athletes are competing on a level playing field. To compensate, it has one of the richest ceilings, comparable perhaps to Tange's Yoyogi pool (see page 181). The lights on the ceiling are distributed unevenly to ensure that the pool is uniformly illuminated. Immersed in the eerie blue glow from the screened windows, one feels like one is in the ocean, swimming in the shadow of a beautiful, rippling sea creature. The practice even managed to design a diving structure that conformed to their fluid aesthetics while ensuring that the rigorous standards of FINA (the international federation of aquatics) were maintained – an unrelenting spirit that underlines Hadid's work.

As part of the legacy of the Olympics, the London Aquatics Centre is managed by Better leisure centres and is accessible to the public for a small fee.

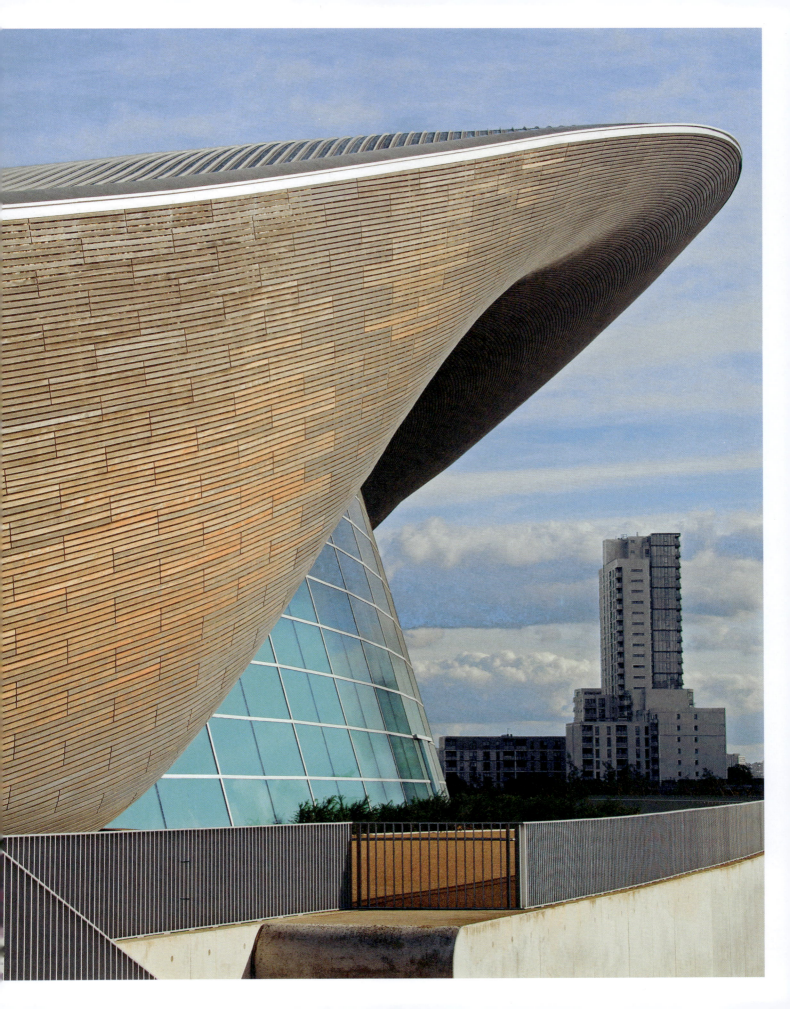

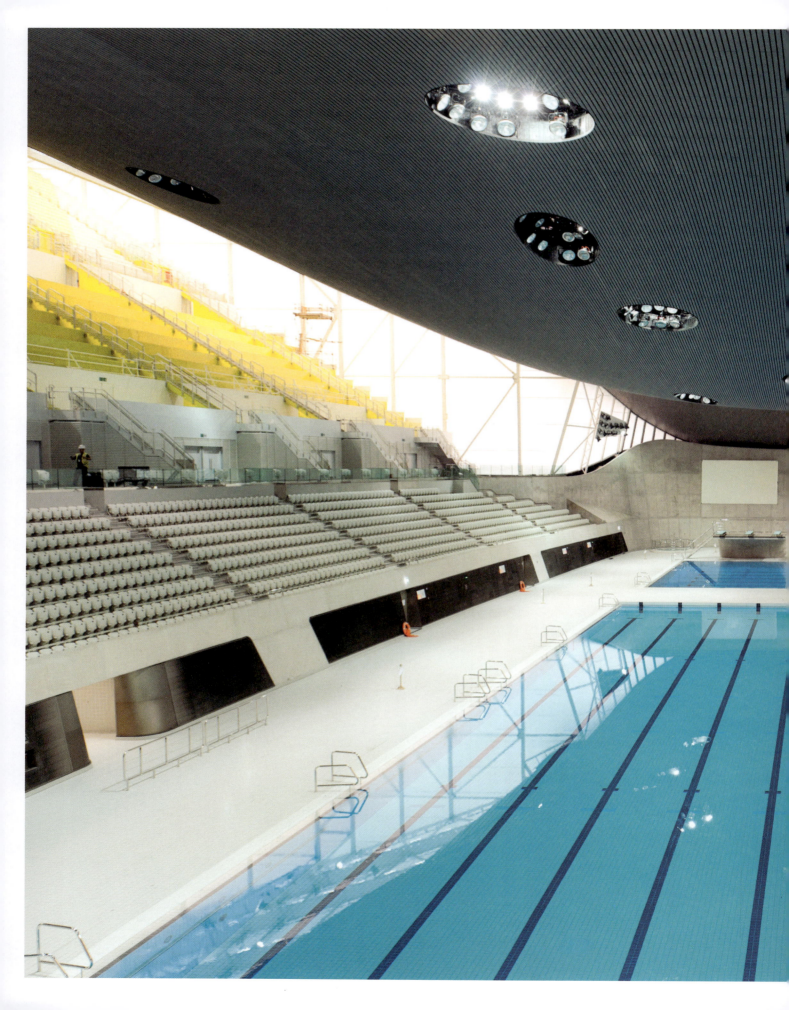

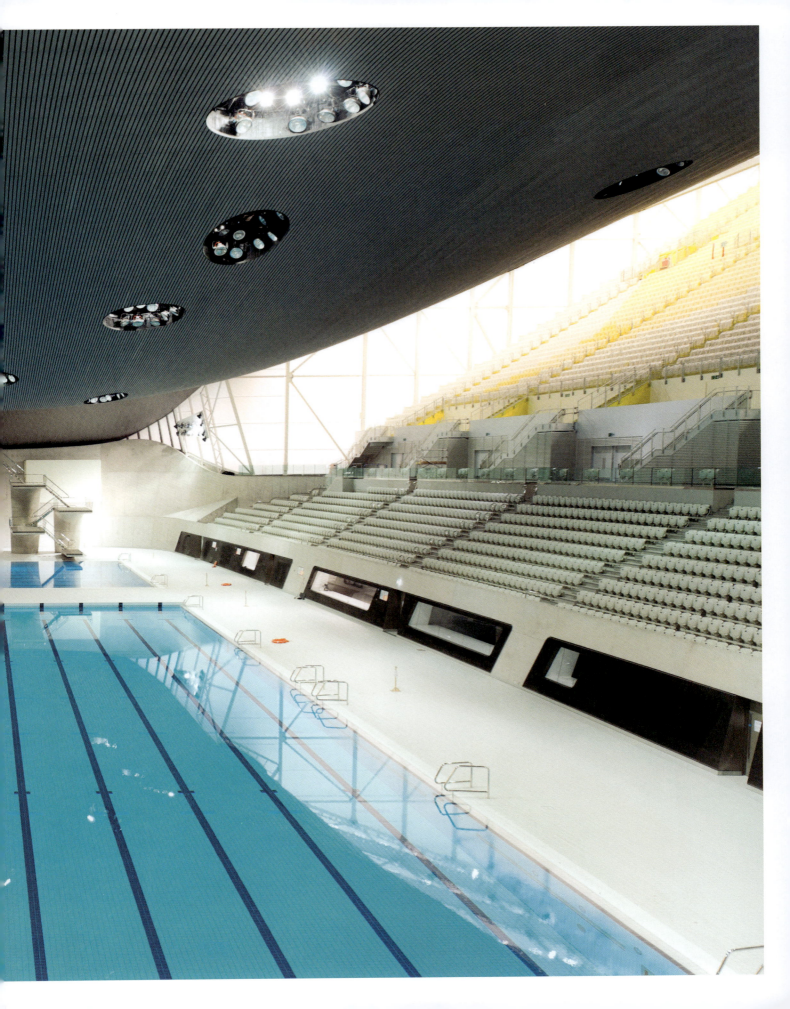

3

A POOL WITH A VIEW

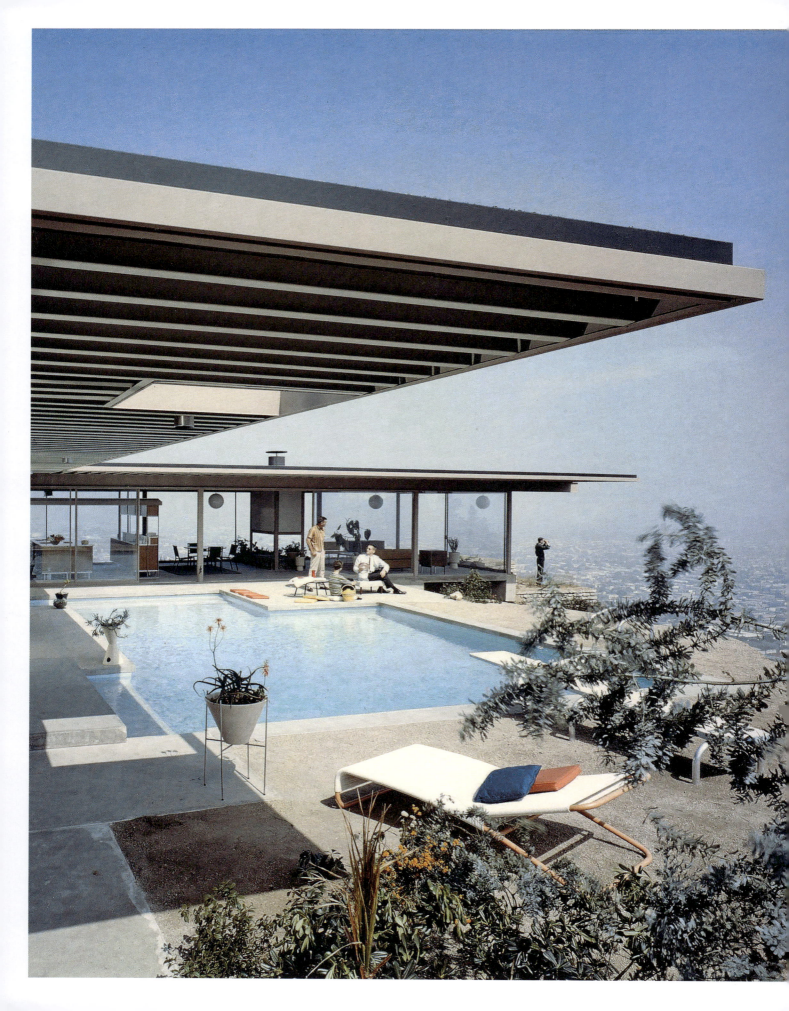

Case Study House #22
(Stahl House)

1635 Woods Dr, Los Angeles, CA 90069, USA

John Entenza, the owner and editor of *Arts & Architecture*, started the Case Study Houses (CSH) programme in 1946 in anticipation of the post-war construction boom. He was concerned that the need for affordable homes at pace, if not addressed, would result in rushed jobs leading to sub-standard housing stock. Therefore, the programme created a portfolio of affordable, prefabricated homes, designed by some of the coveted architects of the time. Pierre Koenig was the architect of two of those thirty-six homes. #22 was one of the more iconic ones, and was made even more memorable by Julius Shulman's lens displaying the continuity between the lines of the house and the twinkling grid of West Hollywood below.

The swimming pool is an integral component of the project – the house would not have happened without it. The Stahls sought a loan to build the house, but it was not forthcoming because of the precariousness of the site – the house sits on the edge of a ridge. As part of the eventual loan stipulation, the bank insisted that the house have a swimming pool to maintain its value. Compositionally, the pool completes the L-shape of the plan; organizationally it helps to connect dispersed parts of the project through bridges that are laid across it; and visually it overlooks the city below. Though it was equipped with a springboard, the low roof of the house also acted as a makeshift platform where friends and family were captured mid-air against the backdrop of West Hollywood.

Carlotta and Buck Stahl's two living children continue to care for their family home. They, like their mother before them, offer tours of the property in winter. The income from the tours and from being an in-demand location house allows them to maintain the property, which is listed in the Los Angeles Conservancy. The Stahls were a middle-class family who got lucky because the foresight underlining the CSH programme afforded them their priceless dream home.

Villa dall'Ava

Avenue Clodoald,
92210 Saint-Cloud,
France

Rem Koolhaas was commissioned to design this family home in the 1980s. The couple wanted a glass box with a rooftop pool. These demands – a weighted object suspended on something as fragile as glass – became the generating force of the project. The swimming pool spans two independent living spaces – one for the couple and the other for their daughter – while lying on axis with the Eiffel Tower. This bridge of water is held up by a concrete wall that the house appears to be cantilevered off; however, there is a series of columns concealed in a wooden partition that parallels this wall. This allowed for the insertion of a glass living room below the mass of the pool that opens seamlessly into the garden, thereby satisfying the couple and lending the project a sense of surreal weightlessness.

The pool can be accessed independently from either of the living spaces. One can imagine it as an alternative focal space of family life, filling in for the more classical dining room or hearth. There is a porthole in the couple's room that penetrates the swimming pool, bringing in dappled light, nightly reflections and, surely, a sense of being at sea. It also would allow the couple to decide when they will swim with their child and when they will swim alone. Their daughter does not have a similar window, which suggests that the parents are given a greater overview and control of the home. Therefore, the porthole reinstates a more typical familial relationship into a house that otherwise appears planned to accommodate a series of detached and independent lives.

The material palette of the villa challenges conventional symbols of luxury – the house looks like a life-sized cardboard model, and this is exacerbated in the context of the neighbouring suburban mansions. Nevertheless, it provides the inhabitants with the rare experience of swimming in the glow of the Eiffel Tower, introducing an alternative benchmark for luxury into the neighbourhood.

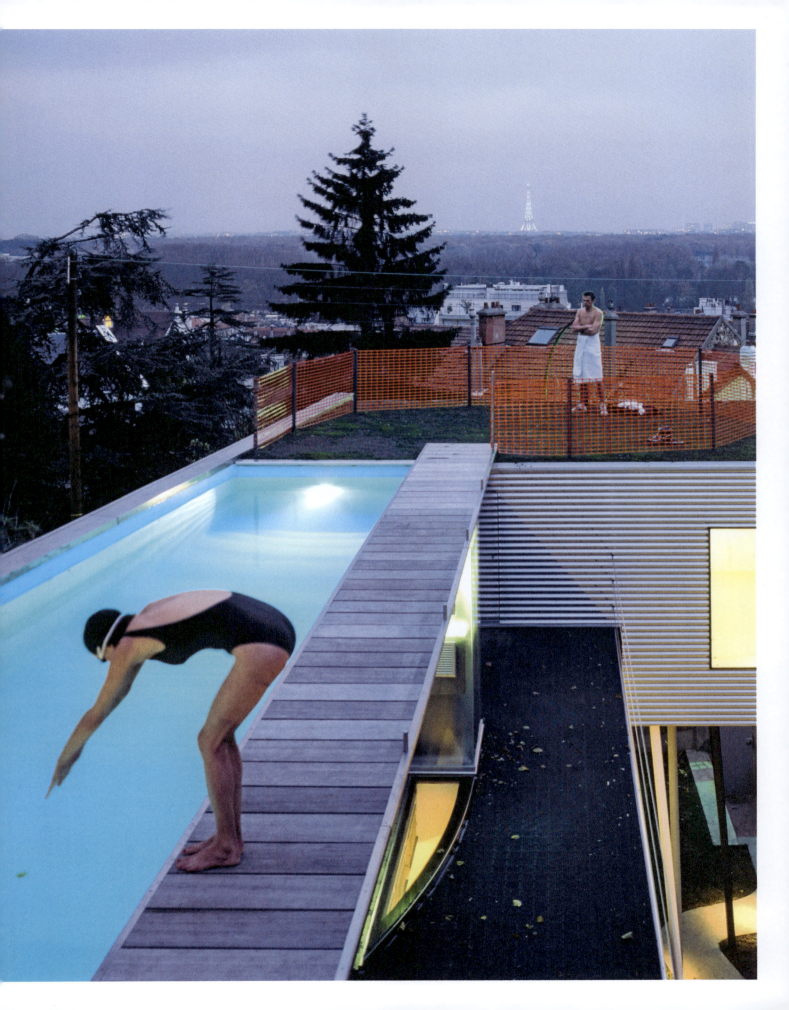

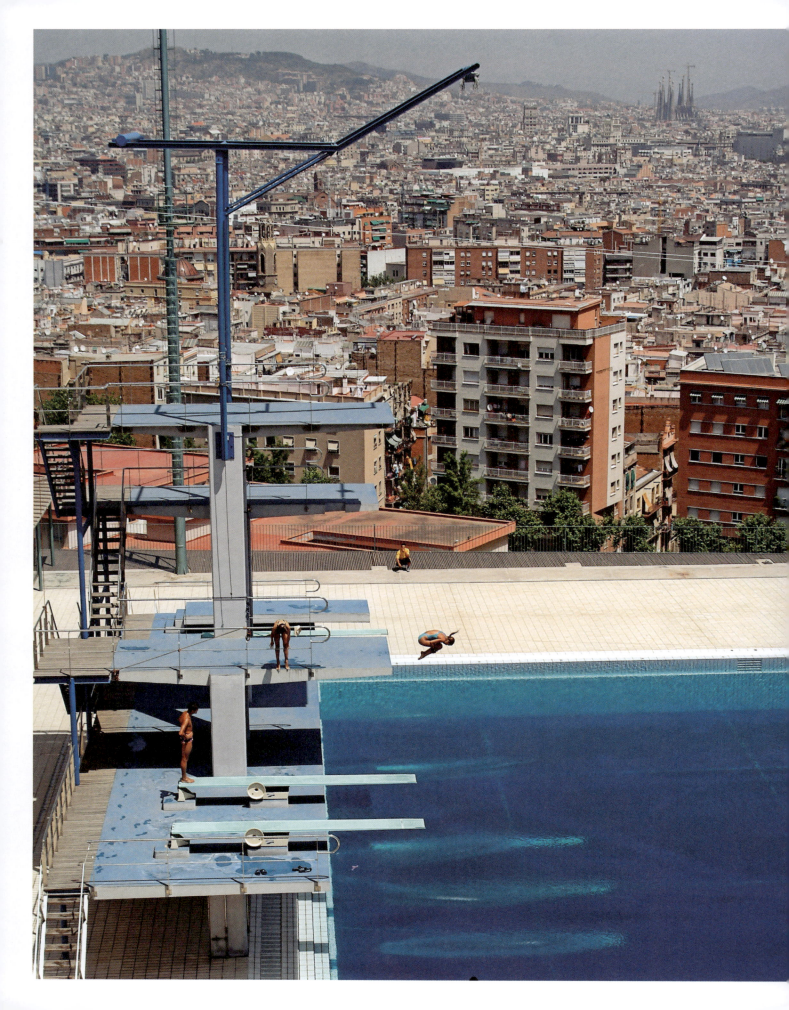

Piscina Municipal de Montjuïc

Avinguda Miramar, 31, 08038 Barcelona, Spain

In 1999, the RIBA awarded Barcelona the RIBA Gold Medal for Architecture – a prize that is usually reserved for consistent and extraordinary contribution to the discipline. This was unprecedented, and to date Barcelona is the only city in the world to have received this award. In 1992, Barcelona hosted the Olympic Games and, leading up to the event, the city was transformed by the inclusion of connective infrastructure and the reimagination of the old industrial and dock fabric into much-needed residential, social and leisure programmes that would continue to contribute to life in the city beyond the Olympics.

The municipal swimming pool on Montjuïc was refurbished by Antoni de Moragas. The refurbishment included the insertion of a diving pool and, equally importantly, the removal of the raking on one side of the older venue, thereby opening the pool to a panorama of the city. The diving platform is placed perpendicular to the view such that the diver descends against the backdrop of the city. This is captured beautifully in the video for Kylie Minogue's 'Slow', which zooms in to display the descent of the diver for 30 seconds in relative silence, as he is framed by different layers of the city. Today, this public pool boasts one of the finest skylines for a swimming pool, which, to boot, is truly accessible to most. The raking that remains is orientated facing the Sagrada Familia, plausibly being one of the best places to watch the rising or setting sun.

In 1929, the Universal Exposition was hosted on Montjuïc. Ludwig Mies van der Rohe and Lilly Reich designed the Barcelona Pavilion to represent Germany; it is a classic of modern architecture and holds two reflecting pools as part of its artistic composition. In the 1980s, a group of Catalan architects that included Ignasi de Solà-Morales reconstructed the pavilion on its original site, which is open to visitors in the warmer months.

Deep Diving:
Half Air, Half Water, A Fantasy

Anna Font

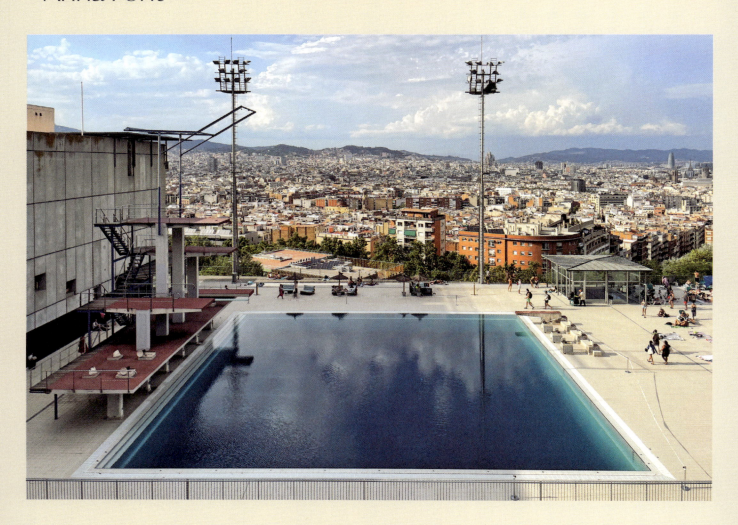

One of the most iconic pictures of the 1992 Barcelona Olympic Games captured in the collective historical retina portrays a diver in mid-air with the city as their backdrop. The pool is not in the frame, making its tacit implication an affirmation of its singularity. Since then, and for more than 30 years now, the pool has remained accessible as part of the municipal sports facilities in Montjuïc. As the twin of the swimming pool next to it, the diving pool keeps its mysterious aura. Even when purposely photographed, there is a certain ambiguity in the meaning of this deep basin. Is it the impossibility of seeing the bottom? The thinness of the rim around its edge? Or perhaps it is the perfect square footprint, suggesting no preferential direction but instead emphasizing a verticality that makes this pool ungraspable? In the image, the pool is at rest, dormant. Performative artefacts such as this one share a particular condition: activity is tangible even when not unfolding in real time. The pictures in this section speak of this dialogue between the diver and the pool, both simultaneously suspended in an off-time, while their meaning is constructed through the city, architecture, the art of synchronization and the resonance of popular culture.

The relationship with the city is probably the most apparent of all. More than a mere profile, the immediacy of the urban fabric in relation to the abrupt edge of the platform containing the pools results in an extended carpet-like skyline, framed by the mountains in the far horizon. An unexpected territoriality takes over. It is uncertain if we are looking at the city or the city back at us. It might be both. The preparation to host the Games of 1992 resulted in manifold urban interventions that propelled a major modernization of the infrastructure of Barcelona, especially in the reconstruction of its natural border with the seafront in all its length. In parallel, the construction of the major sports venue on the mountain of Montjuïc, where the International Exhibition of 1929 had taken place – leaving a trace of buildings representative of the European avant-garde of the time – reinstated the centrality of this geographic nuance, a mountain with the capacity to absorb the amusement of internationalism as part of the cultural appetite of the city one more time. Sitting at the north-eastern side of the mountain, the pool complex is a delicate operation of redrawing its topographical line. Its geological character resides in this seamlessness.

The pool is a cut-out from this horizontal platform, a hole bored into the massive ground. With a footprint of 25m x 25m (82ft x 82ft), and 10m (33ft) in depth, its basin is clad with white tiles, a continuous fine grain that is only interrupted by a dark rim that reticulates the bottom plane every 5m (16½ft). The edge of the pool is built as a 1m (3ft) wide step, slightly sunken from the horizontal plane, mediating the transition from the deep vertical body of water to the exterior. The water surface meets the outer edge of the pool to ultimately define a plane of symmetry between the 10m-deep body of water and the 10m-tall volume of air that extends upon it. A diving tower with three platforms – of staggered height – generates the first asymmetry of the otherwise Cartesian regularity of this Olympic artefact. Simultaneously technical and redundant, it sets out a series of dualities on either side of the waterline: half volume of warm water and half of open air; half regulated Cartesian medium and half topological realm of continuous movement; half infrastructure and half body. The stage is set – with the audience sitting at one side and the city at the other – for the spectacle to start.

There are two routines in the discipline of competitive diving: individual and synchronized (two athletes). Both forms require precision and sensibility, strength and flexibility, balance and power. From a layperson's perspective, divers come across as artists as much as athletes. While turning at high velocity in mid-air, bodies are also drawing graceful trajectories. The game of formal unfolding starts with the projection, either from the 3m (10ft) high springboard or the fall from the 10m (33ft) high plinth, to then turn and tumble in an attempt to defy gravity, only to finally succumb to it, crashing inevitably into the water. With their wrists bandaged as a measure of reinforcement for the moment of impact, the aligned bodies of the divers enter the turquoise realm at speeds between 48–56kph (30–35mph). With a delicate splash, and always perpendicular to the plane of water, following the rules of physics is the only way to make the exercise possible for the human body. As part of the pact between body and pool, the water is maintained at a warm temperature, to absorb the mass of the body with less resistance and embrace it as it disappears into its depths. There can be little left to chance. The environment is an essential part of the equation; much consideration was taken in deciding the location, orientation and other

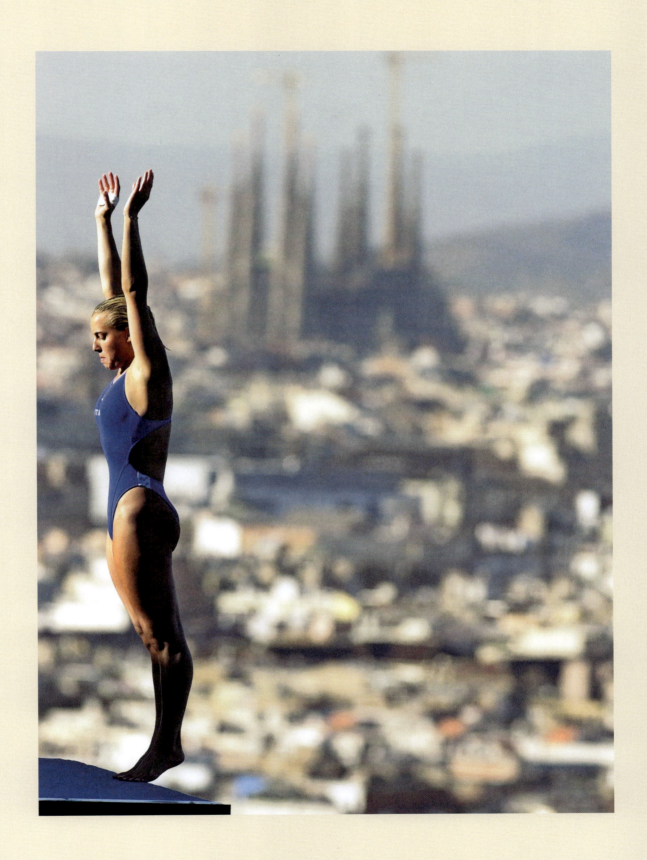

contextual operations of the pool, which were carefully calibrated to control exposure to the wind and sun, helped of course by the benevolent Mediterranean climate.

The meaning of water in the local context is both ludic and climatic, especially in the summer when pools and beaches operate as the public space par excellence for social gathering. A cooling device disguised as multivalent playground, the pool complex bursts into activity in the warm months of the year. While screams of excitement resonate in this open atmosphere, the diving pool remains a somehow distant space of desire, only accessible to skilful swimmers; its depth manifests an unattainability, a mystery – like all depths, provoking a mix of sublime vertigo and the fear common to the unknown. By its side, the spectacle of everyday life unfolds unapologetically: umbrellas, clusters of plastic chairs covered with towels, water mats, goggles, buckets, books, food, ice cream. Swimsuits of all colours and cuts. The awareness of the body reduces as the day evolves, as jumping in and out of the water becomes a habit to regulate the burnt skin. Activity and togetherness dissolve the self-referential gaze in unexpected ways, liberating the body when it is indeed most exposed. At the top of the stairs, maintaining the overlooking position upon this artificial landscape, tourists come to sit at the threshold, where sunsets are cherished, and all becomes background – the city, the pool, the people.

Appropriated by popular culture in different ways, the diving pool has been the stage to music videos and festivals. Exploiting the singularity of its Olympic roots via the montage and re-enactment of the liminal jump, these artistic formats flirt with the ageless space. The bird's-eye view is one of the preferred approximations to the place, and it is this abstraction that has built the imagery of the pool so consistently. The surplus of flat projections available in such a volumetric space turns it into a plane of immanence of meanings, upon which experiences trace lines. It is true that ultimately this pool is always empty. Even during a jumping competition, the occupation of the pool can be counted in seconds. The splash, the buffered silence inside, the crowd outside, the emergence of the body and its resurfacing at the border. Come to think of it, the stationary calm is uncanny. The popular charm that it emanates is also ritualistic: we celebrate the deep basin over and over, as a magnetic centre, secular

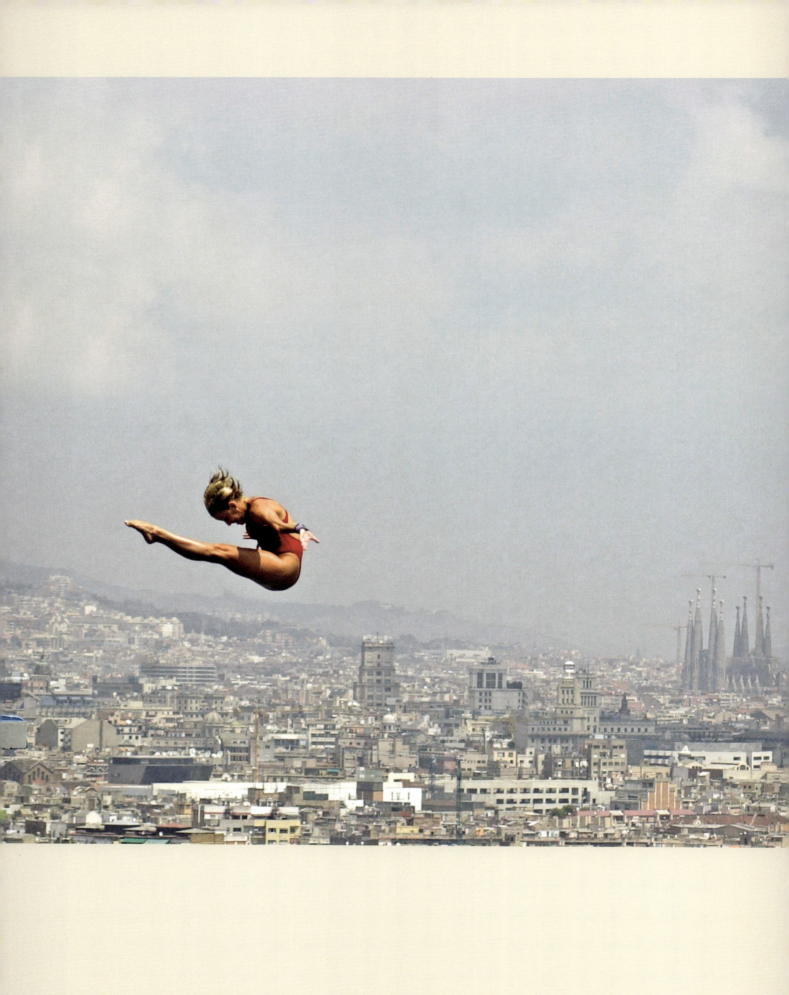

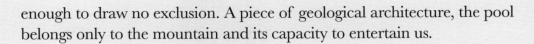

enough to draw no exclusion. A piece of geological architecture, the pool belongs only to the mountain and its capacity to entertain us.

To conclude, perhaps the most intangible of all connections has to do with the unconscious appeal of Catalan culture for surrealism. From Salvador Dalí to La Fura dels Baus, Albert Serra's films, or Quim Monzó's speeches and books, there is an amusement in playing with the true and the false. A confusion of what is and what could be, a wittiness in the games of meaning, especially when this surrealism intersects ordinary life. The disappearance of the divers into the belly of the mountain, or the attentive city as audience, could be part of one of these creations. This is also the context in which this delirious proposal of interpretation is inscribed. How much can the pool – as a typology, a place, an event – transport us to new ways of seeing, of being, without swimming? From the border of this surreal balcony, it is possible to start to draw a line across the culture, the territory and the city that frames its existence. And even if all these interpretations were considered pure contingency and conjecture, the austere and unconventional beauty of the pool could still be asserted.

Thermae Bath Spa

The Hetling Pump Room, Hot Bath Street, Bath, BA1 1SJ, England

Sir Nicholas Grimshaw won the international architectural competition to design the Thermae Bath Spa in 1997, in collaboration with Peter Carey and Donald Insall Associates. The latter provided the expertise for the restoration of the old Roman baths, which was included in the project brief in addition to the design of a new building. The project was funded by the Millennium Commission that resulted in some spectacular successes such as the Tate Modern and the Thermae and, equally, many less successful ones.

Grimshaw's new building is a sensitive addition to a complex and historically rich site. The building is a solid cube sandwiched between two baths – one on the lower ground and the other on the roof – and the entire ensemble is surrounded by glass. The cube is clad with Bath stone or oolitic limestone quarried from Limpley Stoke. The glass mediates the old and the new. In certain light conditions, the glass almost disappears, allowing the cube to come to the forefront, while at other times it mirrors its surroundings, thereby blending the building within its context. The two baths are fed by the natural waters that rise from the springs, which have been cooled and filtered to make them suitable for bathing. However, they still retain the 42 minerals that made Bath popular as a curative destination. The rooftop pool allows for some of the best views of the city skyline that can be accessed for an affordable price. Residents of Bath get a discount, as they are the rightful owners of the waters, as decreed by Elizabeth I.

In 2023, Cleveland Pools, one of the oldest open-air Georgian pools in England, was reopened after an ambitious and difficult refurbishment. The water is biologically filtered, and engineers are working through ideas of heating it through an exchange of energy from the river.

With the spa and the pool, Bath has proven itself as a centre of innovative ideas that ecologically connect the past with the future.

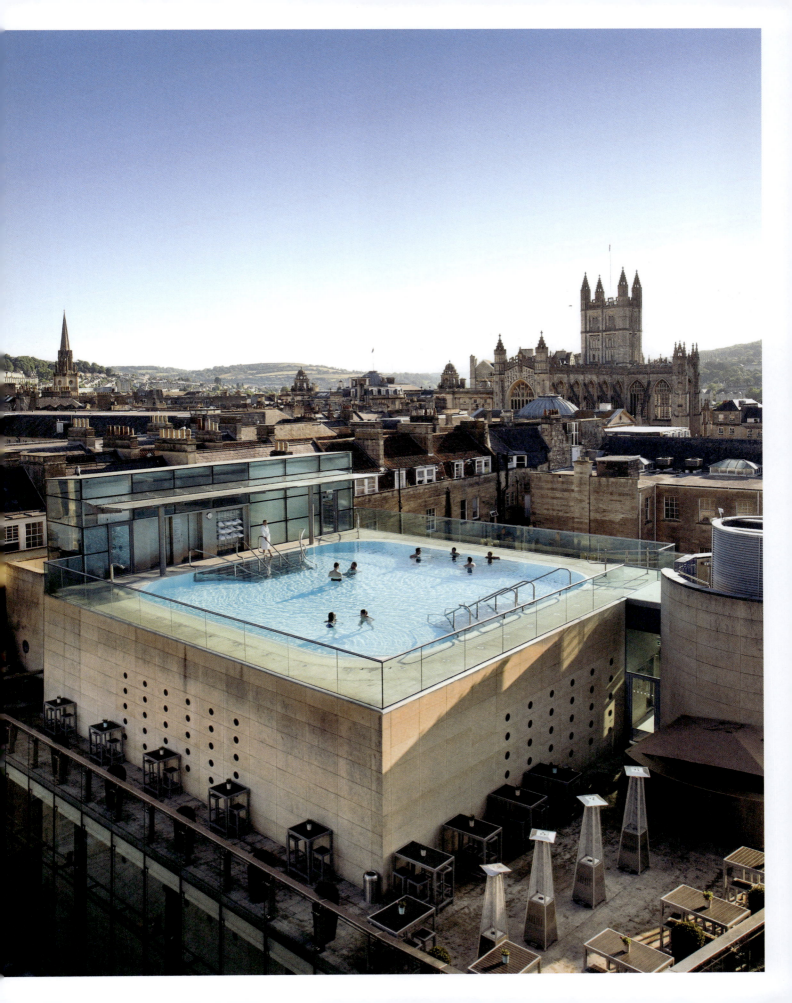

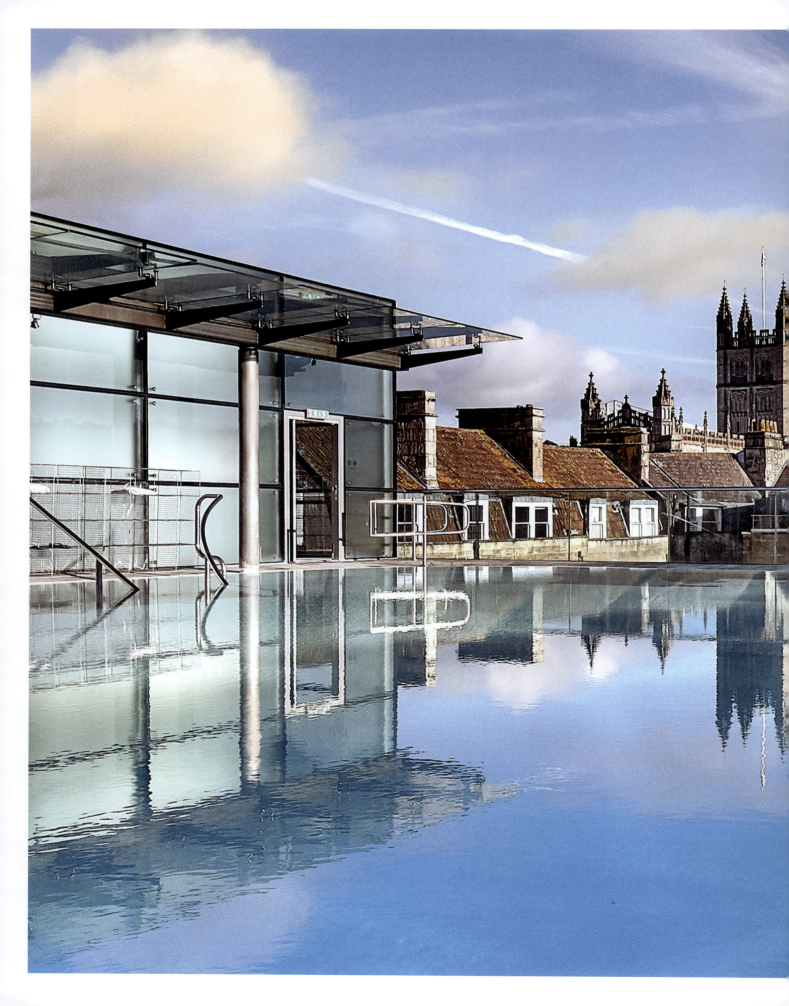

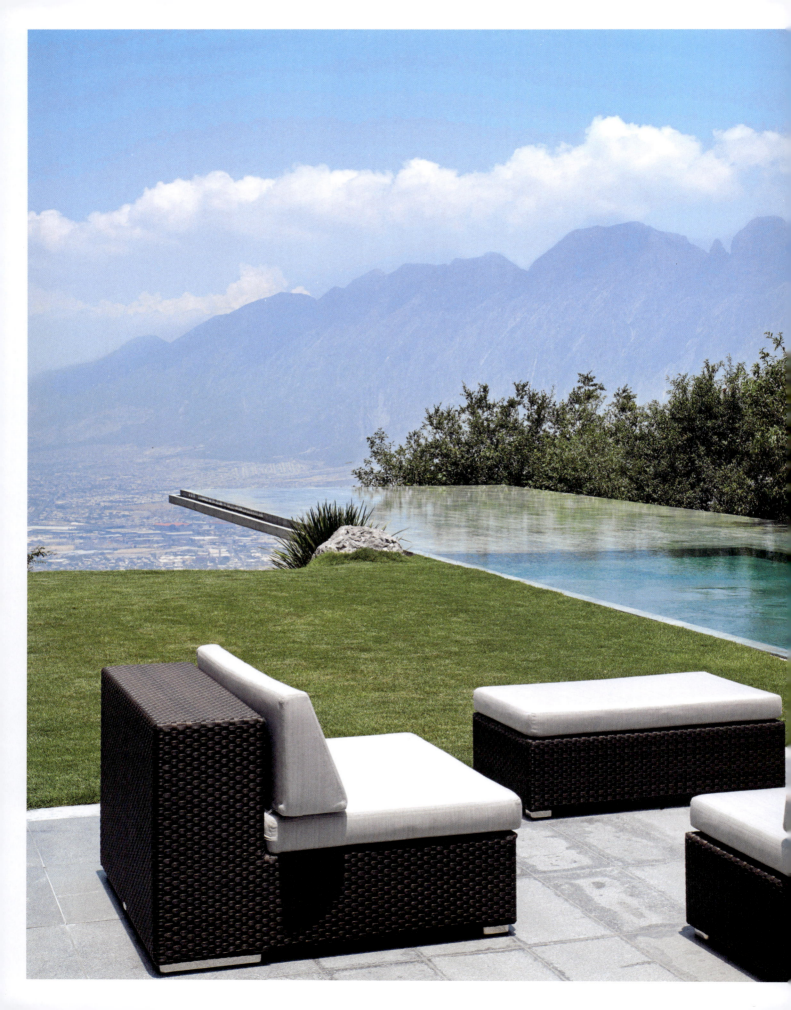

Casa Monterrey

Mexico
(private residence)

Tadao Ando is a self-taught Japanese architect who trained as a boxer. His work unleashes the protean qualities of light to animate his otherwise minimal material palette. Towards that end, water is used as a natural consort to light, and it is not uncommon for him to introduce a reflecting pool or some other water feature as part of his vocabulary. While many of Ando's earlier projects are introverted, recently he has designed two houses – in Sri Lanka and in Mexico – that have inward-looking spaces that are complemented with more outwardly orientated ones that pay homage to the sublime beauty of the Indian Ocean and the Sierra de las Mitras Mountains respectively.

Casa Monterrey in Mexico was completed in 2011. There are two water bodies in this 1,500 square metre (16,150 square foot) plot. The first is a shallow, pebble-bottomed reflecting pool in a triangular courtyard beside a library on the lower ground floor, where the water is barely perceptible as it lightly glistens and trembles, amplifying the reflection of light ever so slightly in this otherwise serene grey space. The other is what appears to be a mass of steel grey-blue water that resonates with the colour of the mountains that it is dramatically soaring towards. This mass is essentially a basin with three wider-than-normal edges that is faced with greyish-blue square tiles. The whole ensemble is submerged under a thin layer of water that reflects the beauty of the surroundings, interweaving them with the rituals of everyday living.

The house is not accessible to the public; nevertheless, it is possible to experience other exemplary projects designed by Ando, such as the Church of Light and the Church on the Water (a sought-after wedding venue), both of which are in Japan.

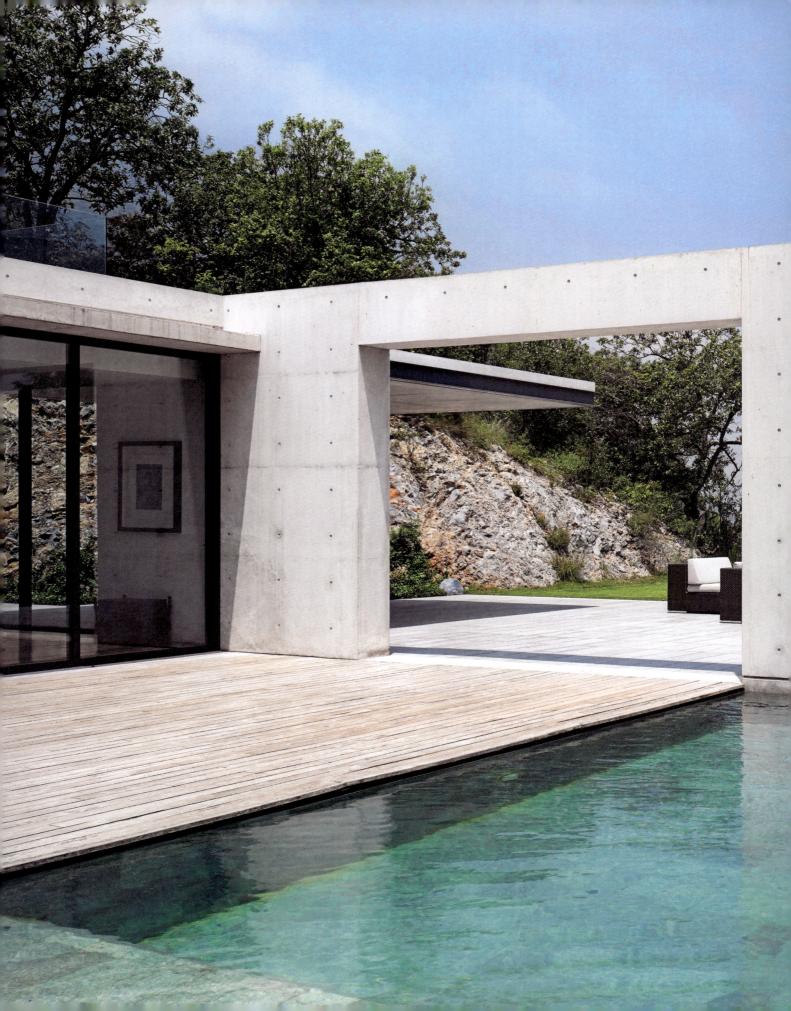

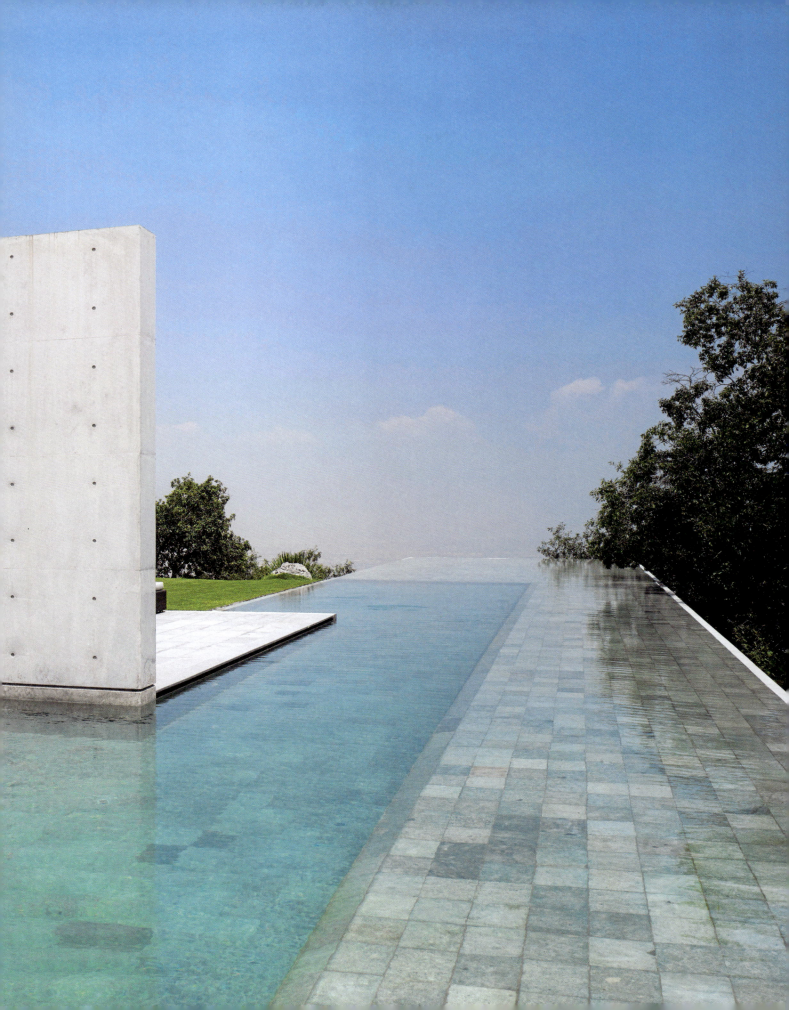

Marina Bay Sands Hotel

10 Bayfront Avenue,
Singapore 018956

Marina Bay Sands Hotel was designed by architect Moshe Safdie and hospitality consultant Jean-Michel Gathy, with technical expertise provided by world-renowned engineering practices including Arup and Natare Pools to address the complexity of the project. Safdie's vision generated three individual towers topped with a continuous curved ship-shaped platform that houses a 1 hectare (2½ acre) sky park and an observation deck that cantilevers 65m (213ft) beyond the tower, providing a 360-degree view of the island. Marina Bay is a land reclamation project to increase the seafront of the island city; therefore, it is fitting that it offers a part of its rooftop back to the sea in the shape of its infinity pool.

The 146m (479ft) long pool soars 57 floors above downtown Singapore, offering an experience of the cityscape horizon like no other in the world. The drama of the infinity edge at this height has certainly induced an unprecedented thrill or chill in many a swimmer as they inch closer towards the perimeter, fearful of falling off the invisible edge in a medium as unstable as water. This surely contributes to the memorability, for better or worse, of the pool. The pool is constructed in three parts. The middle part sits on the central tower and the other two, on either side, bridge the space between the towers. It was designed to withstand winds, movement of the towers and subsidence of the soil below, and boasts of innovative dynamic joints.

The pool is open only to hotel guests, who use their room key card to access the area. Part of its enticement appears to be the challenge of sneaking into it from the sky park – several blogs share tips on their alleged victorious escapades. It is a highly Instagrammable pool that is fittingly a part of Gathy's portfolio, which also includes the COMO Point Yamu resort in Phuket, Thailand, which offers panoramic views of Phang Nga Bay.

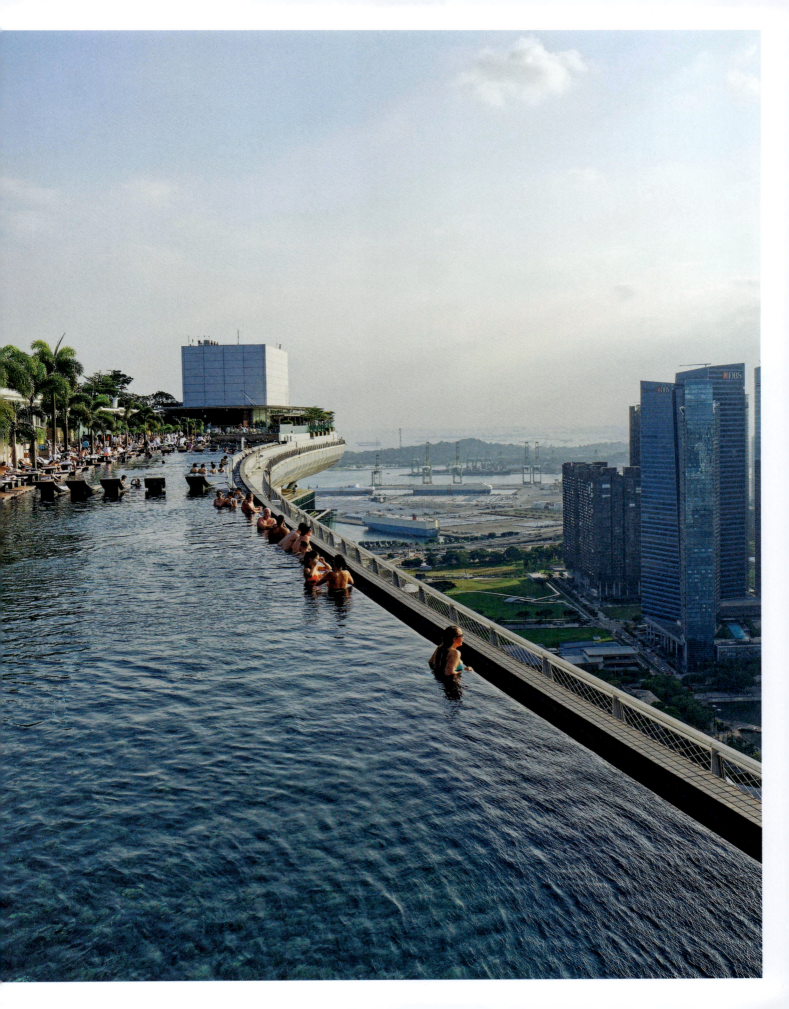

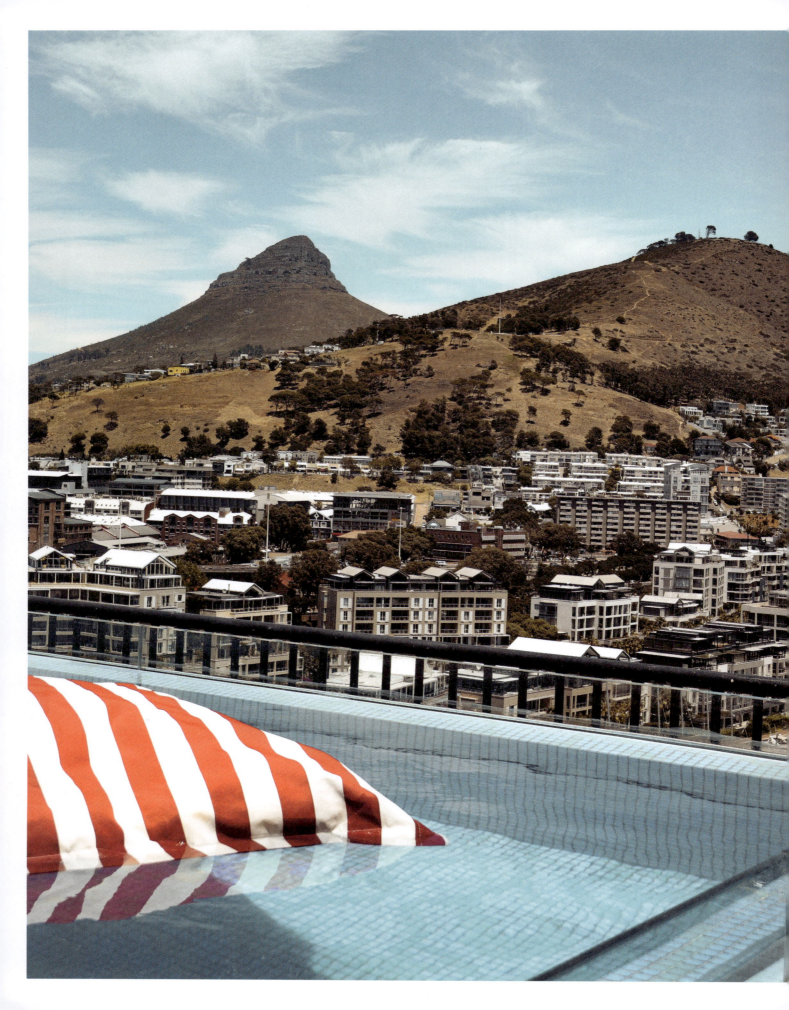

Silo Hotel

The Silo Hotel,
Silo Square,
Victoria and Alfred
Waterfront,
Cape Town 8001,
South Africa

The Silo Hotel sits above the Zeitz Museum of Contemporary Art Africa (MOCAA) in the Victoria and Alfred Waterfront development in Cape Town in a refurbished grain silo building from 1924 that was at the time, at 57m (187ft) high, the tallest building in sub-Saharan Africa. The site is steeped in a history of colonial power – the grain silo was built by prisoners who were incarcerated in Breakwater prison, which is today part of the same waterfront development that houses the business school and a hotel. Equally relevantly, the silo was used to store and package maize before it was shipped off to Europe. The repurposing of the building as a space for African art – local and as a centre for the diaspora – is especially poignant.

Thomas Heatherwick was commissioned as the architect of the building, and the interiors of the hotel were designed by the Royal Portfolio Group, who run the property. Heatherwick's design strategy involved a careful and complex removal of existing built material to create spaces for the new programmes. This resulted in a concrete frame on the façade of the hotel, which is filled in with delicate cut-glass-inspired windows that glow at night and offer expansive views of the city in the day. The roof terrace is fitted with a swimming pool that spans most of its length. The pool sits on top of the terrace and is partially detailed to resemble an aquarium, displaying the swimmer in profile layered against the city as a backdrop with landmarks such as Table Mountain, Lion's Head and Robben Island at a distance.

Unfortunately, the swimming pool is only for the use of hotel guests, or those with reservations at the restaurant or bar. The disconnection of the rooftop of an important landmark from the reach of many of the residents of the city seems to jar with the spirit of the project that is suggested by the museum.

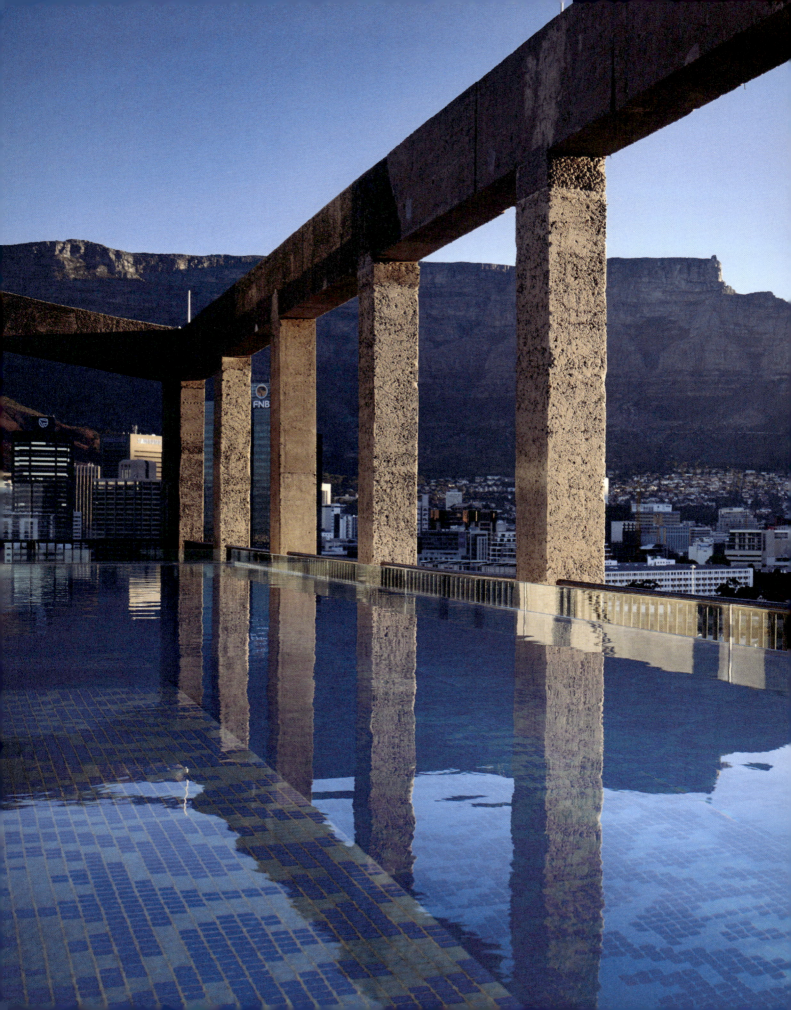

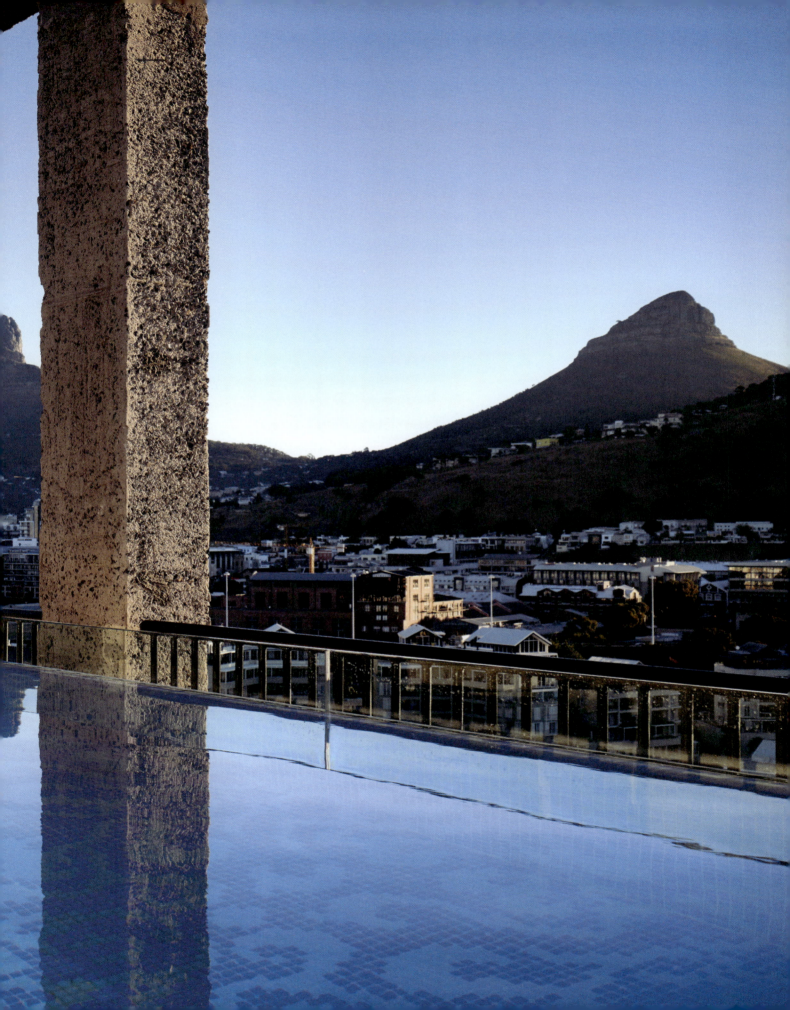

4

A VERY PRIVATE AFFAIR

Bawa's private quarters in the Lunuganga Estate

Dedduwa, Bentota
80500, Sri Lanka

Geoffrey Bawa bought a 'small' rubber plantation of 7 hectares (17 acres) near the salty Dedduwa Lake in Sri Lanka, aspiring to create a luxurious garden with a house such as his brother, Bevis Bawa, had done with his Brief Garden. This purchase pivoted his life – he had studied to be a lawyer, but the estate ignited his latent love for architecture, leading him to the Architectural Association in London in the mid-1950s. Geoffrey Bawa became one of the more prolific architects in South Asia; his practice of four decades contributed to an international portfolio that furthered the discussion on Tropical Modernism. The estate was Bawa's lifelong project and reflected the changes in Sri Lankan politics and in his practice.

Since Bawa's demise, the estate has been managed by a trust that, in turn, entrusted it to the Teardrop Hotel group to run as a boutique hotel. In 2023, the trust opened Bawa's private quarters for booking on enquiry. These quarters are made up of a series of enfilade spaces, including two private courtyards that celebrate water in different ways. The first courtyard opens out from the bedroom and is structured around a minimal reflecting pool that radiates the ever-changing colours of the surroundings into the interiors. The second is attached to the bathroom and serves as an outdoor bathing area – it is equipped with a shower and a plunge pool. This small rectangular pool wedged into the corner of the courtyard is tiled in a hexagonal pattern of blue, yellow, white and black tiles, adding soft colours to the otherwise rustic space. Lunuganga is as much a celebration of water as it is of the lush green of the island country.

Though the quarters are largely left as they were in Bawa's lifetime, they have nevertheless been modernized. Additionally, many of the original artworks have been replaced. One of the additions appears to be an image of the 'Tomb of the Diver', which depicts a man diving into the waves. Though the meaning of this famous image is debated, it is considered evidence of the fact that ancient societies swam.

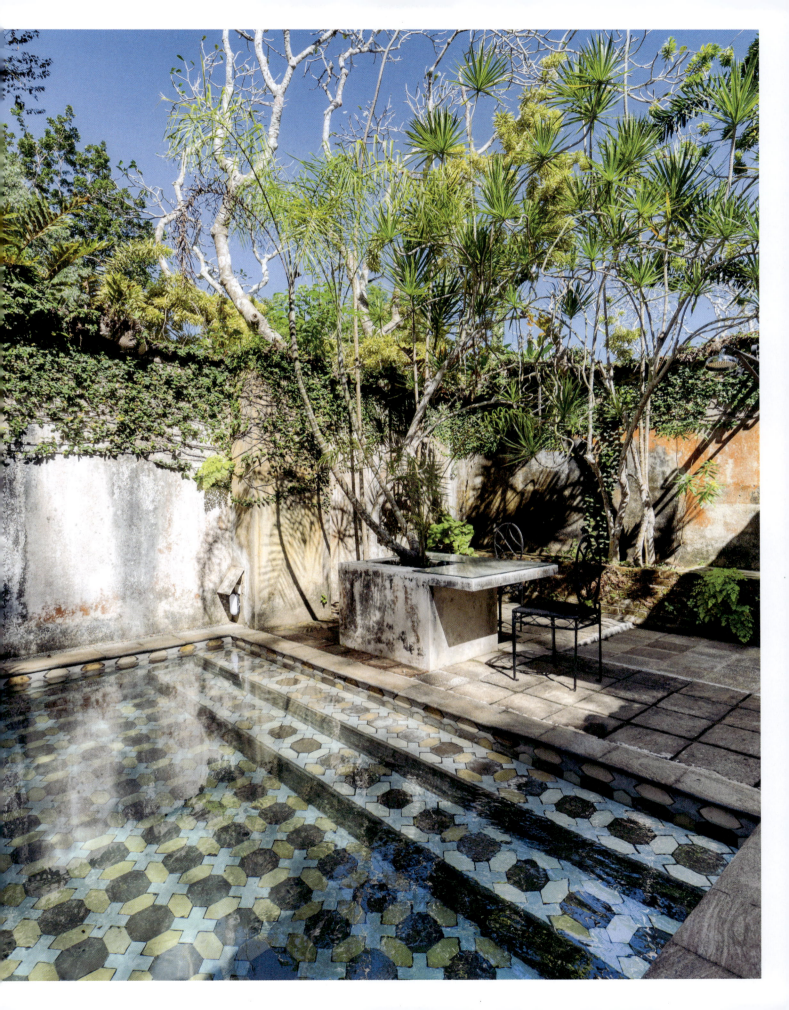

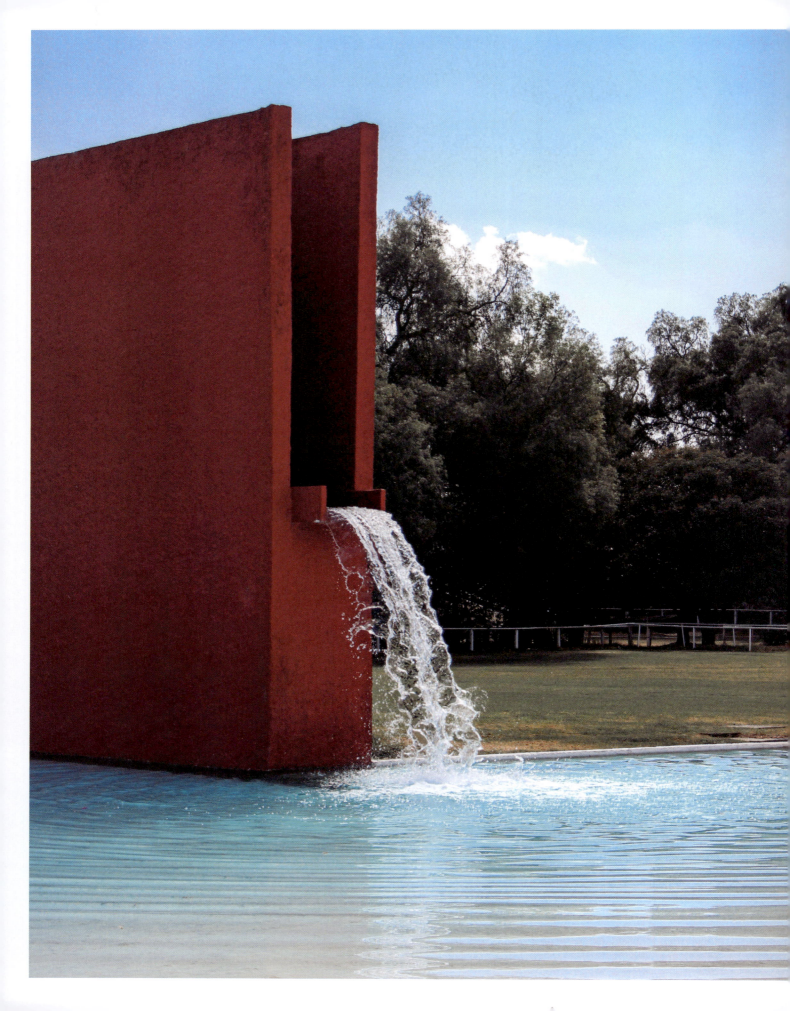

Cuadra San Cristóbal

Cda. Manantial Ote. 20, Mayorazgos de los Gigantes, 52957 Ciudad López Mateos, Mexico

Luis Barragán designed two L-shaped pools in Cuadra San Cristóbal for the Egerström family – the first is the camera-shy private pool attached to the family home; the second, on the other hand, is the celebrated pool for the thoroughbred racehorses that the family bred, which has been extensively photographed and is the poster image of the project. It is a project that is recognized as one of Barragán's more complex and accomplished pieces of work, connected to many ideas that he first tried in his own studio and home around two decades earlier. The two pools display the architect's mastery of colour, light and materiality as they generate diametrically different atmospheres for the intended lifestyle of their inhabitants.

The site is roughly divided into four quadrants, where three-quarters of the 3 hectares (7½ acres) is dedicated to the horses. The pool is part of a loop that connects the stables, the water troughs, running field, paddock and hay stores. Most of this loop is concealed behind brightly painted walls, which centres attention on the pool, fed by a fountain that gushes out of a rust-coloured spout. The fountain shatters the stillness of the water surface. Its ripples interfere with the soft undulations of the brown cobbled paving that gently slopes down to tile the bottom of the pool, generating a trembling, impressionistic reflection that brings the different colours of the walls, the water and the sky together. The white, unornamented house sits on the fourth quadrant of the site, with its swimming pool nestled in the corner, benefitting from the shade offered by the house, the tall white compound walls and the trees around it. The pool here, in contrast, is an oasis of calm as the water laps up against the patios, bracing for the occasional diver to jump off the springboard to momentarily shatter its brilliant blue surface.

The house is part of the tour that The Travelling Beetle offers in one of their Luis Barragán packages; however, it is only a lucky few who are allowed in the private garden of the family home.

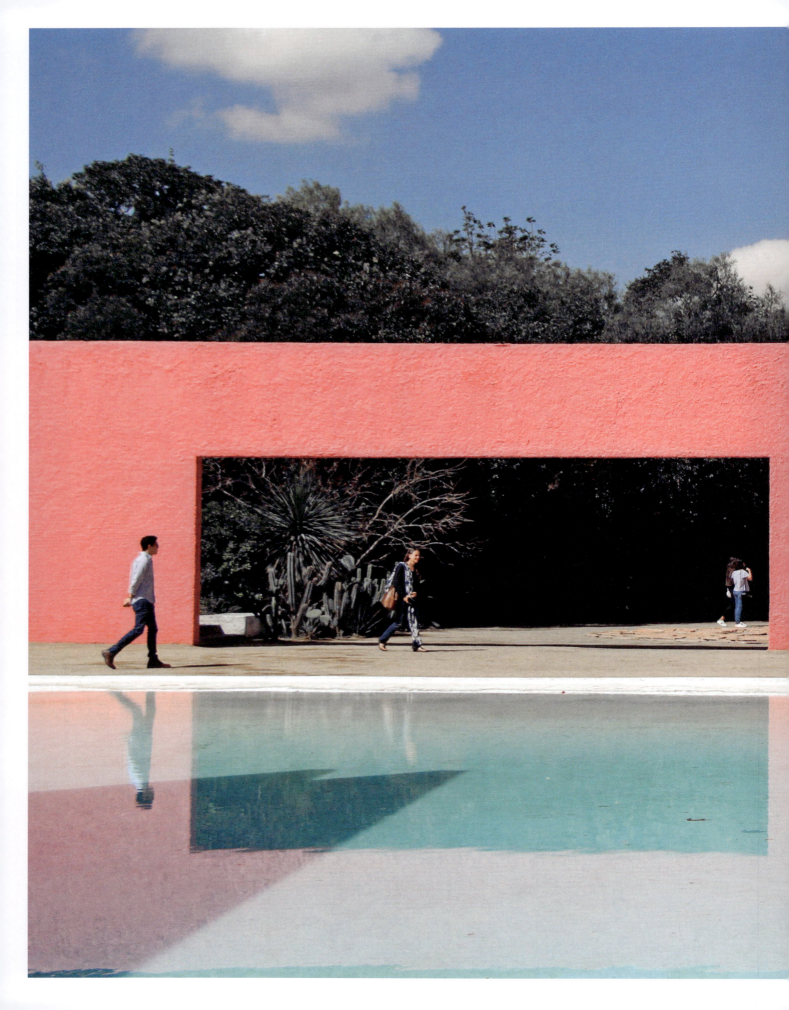

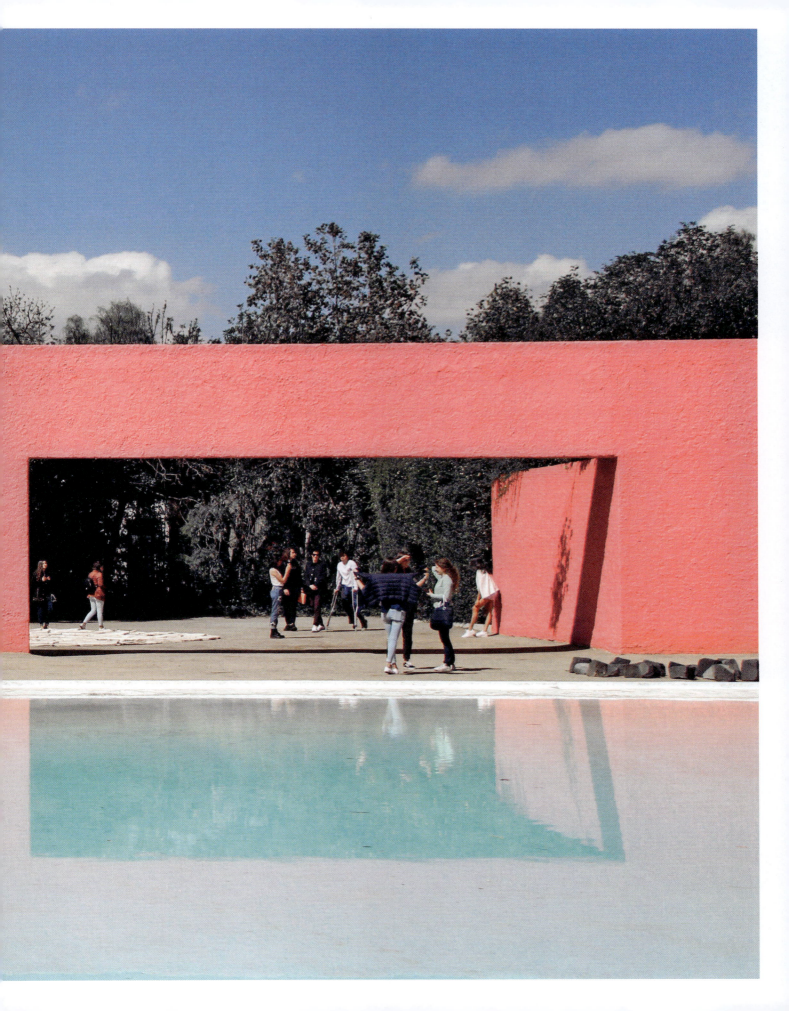

Dalí House-Museum

Platja de, 17488 Portlligat, Cadaqués, Spain

In 1930, Salvador Dalí with his muse/partner Gala moved into a white fisherman's hut in Portlligat on the Costa Brava in Spain. Over the next four decades the house transformed and grew with them, shaping and being shaped by their artistic impulses. Outside it looks like an assemblage of huts jostling for space, with windows that appear to be ad hoc; however, on the inside, it is a series of spaces that trace a way of living private to the couple, with windows that frame selected views over the cerulean sea. The house is a labour of life and love.

The swimming pool was one of the last additions to the premises and became the centre of their public life. In 1973, Dalí published *Les Dîners de Gala*, which was recently republished by Taschen as *Les Dîners*. The cookbook is clearly a nod to the parties hosted by the couple. Though there is no shortage of objects in the house that ooze desire, the pool surely was the pièce de résistance due to being shaped like the male genitalia. It cannot be ascertained if Dalí intended the shape to be anything but a playful provocation; nevertheless, it skilfully merges a pool for swimming lengths with a series of circular spaces – one on the tip and two at the base – equipped with underwater benches suitable for relaxation, socializing and more. Bricks in a chevron pattern line the edge of the pool, on top of which swan statues spout water. Dalí was allegedly fond of swans and even painted Gala as Leda. An unknown list of celebrities dipped their toes in the waters of this phallic basin, some of whom are immortalized on the inside walls that Gala decorated with photographs from these soirées.

With the death of Gala in 1982, Dalí abandoned the house, which is now managed by the Dalí Foundation and is open to visitors.

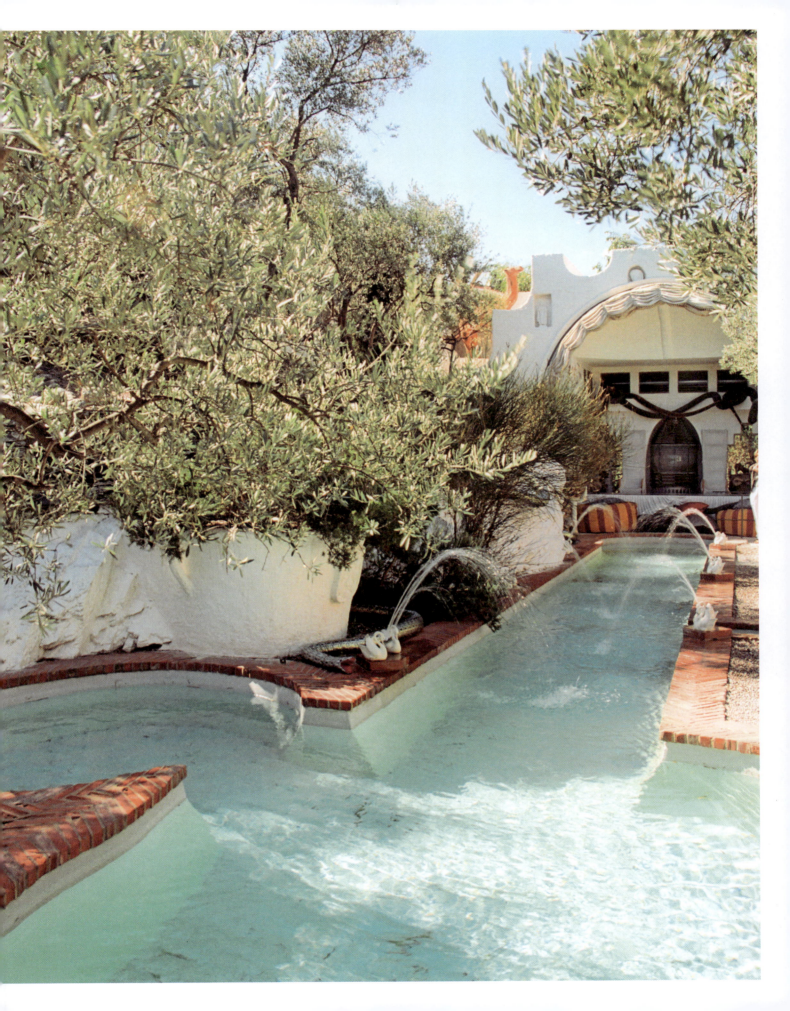

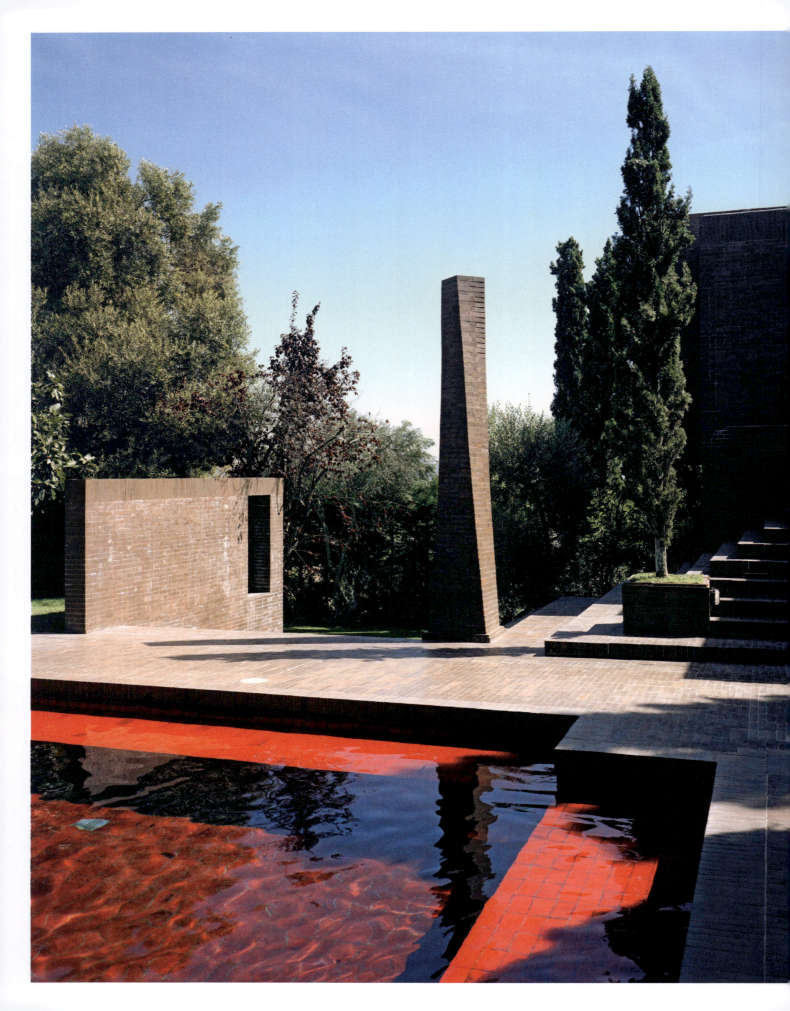

Bofill Family House

Mont-ras, Girona, Spain

Ricardo Bofill, a Catalan architect, built a summer house in 1973 in Mont-ras, a village in the Girona region of Spain, for his parents. He built the house with the help of Emilio Bofill, his father, who was an important influence in the architect's life and an early supporter of his son's practice. The house was integrated with the ruins of an old country house. Bofill was an early adopter of adapting disused buildings, using locally sourced material and challenging social and cultural norms – all of which are seen in the family house. He designed the private living spaces as independent pavilions to echo ideas of living together – but separately – to accommodate intergenerational living, bringing together his parents, himself and his two sons with their families in the same compound.

The swimming pool is a key element in the composition and along with the dining room acts as the focal point of the project. While the living spaces are built of pink brick, the pool and dining room are instead tiled in red porcelain sourced from La Bisbal d'Empordà – a key centre for ceramics in Catalonia known for their vivid colours. The red tiling from the pool basin bleeds onto the pool deck on three sides as an articulated edge to meet the terrace. Along the fourth edge the tiling continues to envelop the dining room, which is pierced with a large picture window fronted by two cypress trees that mediate the space between the pool and the dining room, throwing dappled light into the darker dining room and casting long shadows over the purple water body on a summer's day. A swimming pool is an artificial body of water and the red pool reinforces that, in turn forcing the viewer to continually confront their perceptions of the world around them.

If one desires to swim in a red pool there is one at the Library Resort in Ko Samui in Thailand, available for its guests, which is unfortunately not designed by Bofill. Bofill's house is private and currently not available for public visits.

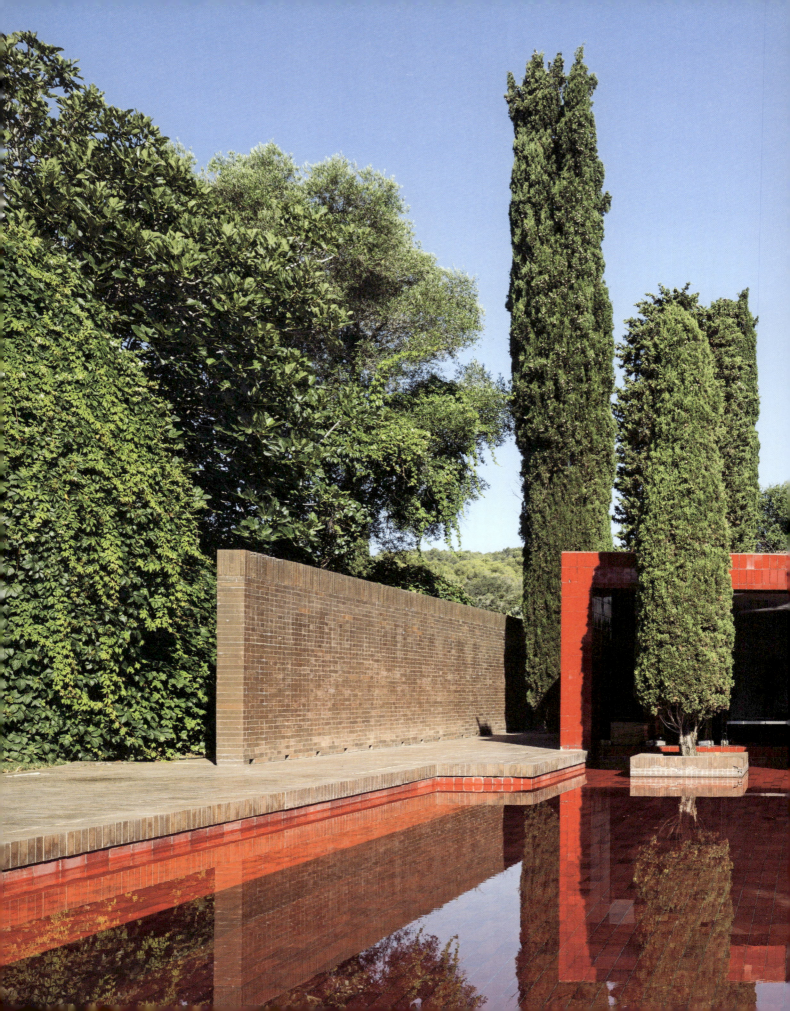

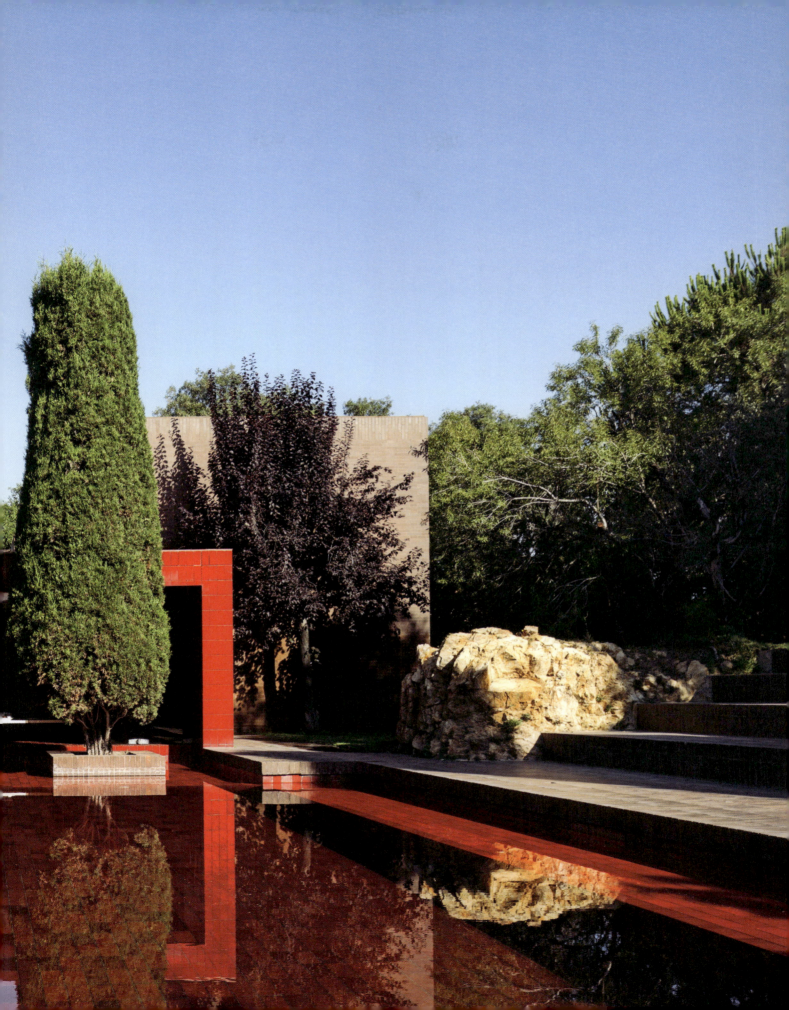

Palmyra House

Alibag, India

Bijoy Jain, founder of Studio Mumbai, is a professional swimmer who uses water as a contextual, ecological and cultural material and for phenomenological effect. Studio Mumbai is known for its ecological ambitions, which are manifested in the design of the project, the materials used and the method of building. This is particularly true for Palmyra House, which was built for Jamshyd Sethna and his family. The house is gently inserted into a coconut plantation south of Mumbai in Nandgaon, Alibag. The existing plantation determined that the construction needed to be done without the use of machinery. This little jewel of a project is handcrafted by artisans who work in close collaboration with Jain's studio.

The rectangular swimming pool sits in a wedge-shaped courtyard made by two airy but shaded cuboidal living spaces. Compositionally, in plan it appears to be approximately two-thirds of the size of one of those interior spaces, which asserts its importance as part of the daily rhythm of the inhabitants. The basin of the pool is finished with screed and is surrounded by an outer raised trough made up of stone, probably of the same basalt that is used in the rest of the project. It could be surmised that the basin is considerably deeper than suggested by the trough. The steps are submerged in the water, which is nearly the same level as the trough, leaving a swimmer with a direct view of the Arabian Sea gleaned through a forest of coconut trees. The architect was determined to work with the existing trees on the site, which is made explicit in the swimming pool. One of the straight edges of the rectangle is broken by a small semicircle to encompass a plant as part of its design.

An aqueduct connects the swimming pool back to the source of the water, displaying the interdependency of the water network – a strategy used by Jain in his other projects as well.

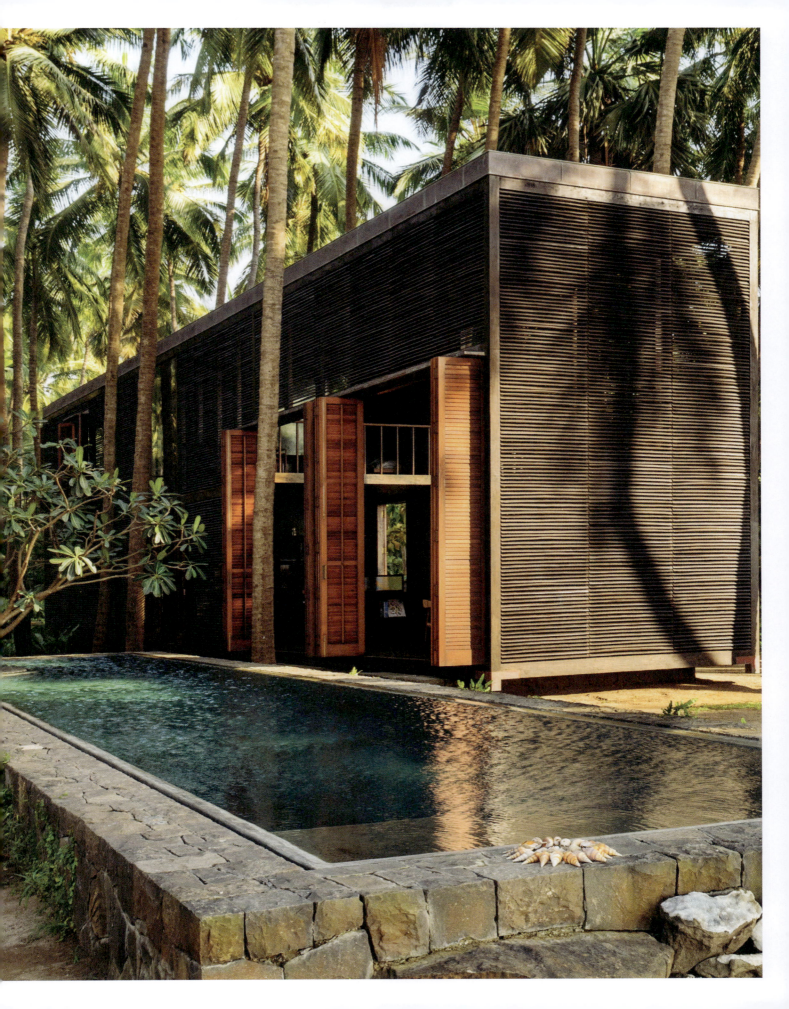

'NATURAL' POOLS

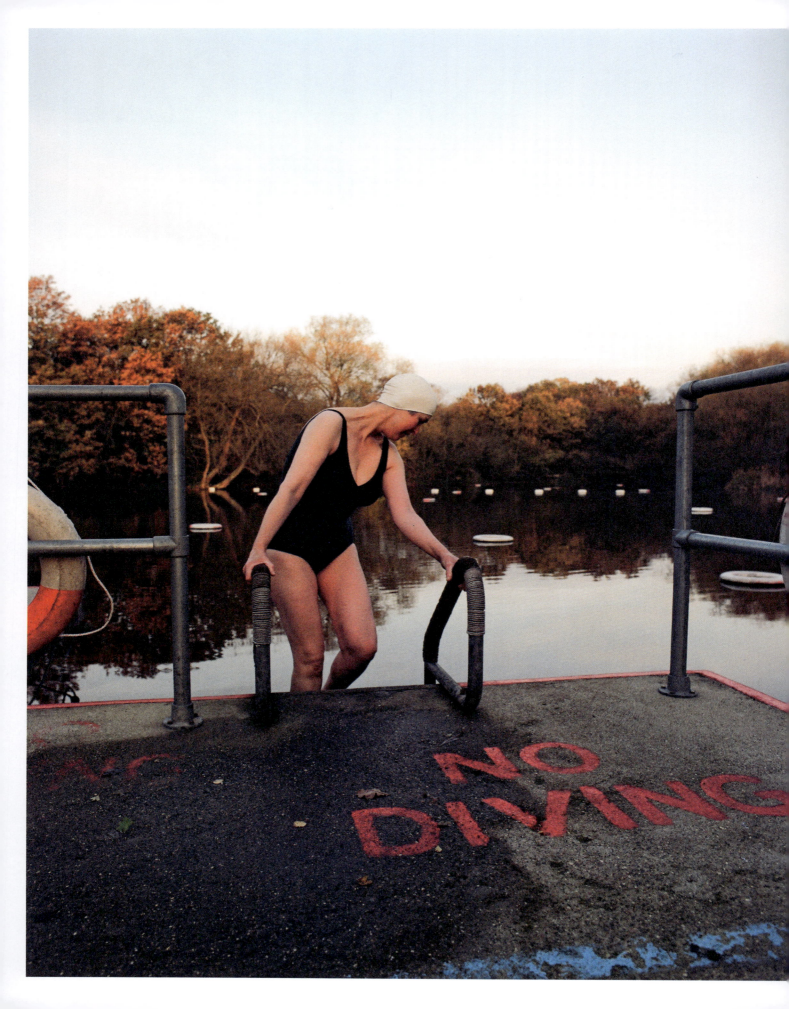

Kenwood Ladies' Pond

Ladies' Pond, Hampstead Heath, London, N6 6JA, England

The Ladies' Pond is part of a network of ponds dotted around Hampstead Heath, which are fed by a natural spring, which in turn feeds the Fleet – the lost river of London. With such an origin story it is but natural that the ponds – the Kenwood Ladies' Pond, the Highgate Men's Pond, the Mixed Pond and the Parliament Hill Fields Lido – would hold a magical place in the heart of the capital, gathering people from all over the city and beyond to bathe in its cold, unheated waters through the year.

The naturalness of the ponds is an essential component of its make-up that requires regular maintenance, de-muddying and re-shaping to retain its use as a swimming hole. It is quite particular – the water is described as having a thick, velvety feel and it is dark and dense; this means that it is not necessarily appreciated by everyone, which only adds to its charm. The 'ladies of the pond' – a nomenclature that invokes a legendary image – have strived to ensure that it remains a vital asset in the city for women ever since it opened in 1926. It lies at the tip of a long sausage-shaped body of water that is subdivided into five separate ponds, not all of which are used for swimming. It is shrouded in vegetation and equipped with very modern, Scandinavian-looking modular changing rooms, shower cubicles and a cabin for the lifeguards that floats on a platform, silently blending into the autumnal hues of the foliage come September. Beyond the water lies the other beating heart of the premises – the kidney bean-shaped meadow where generations of women have gathered on their own or in groups, enjoying the sun, a book, nourishment and the company of other women.

The Ladies' Pond is a part of the progressive rich history of swimming, Modernism and Hampstead.

Piscina das Marés
(Leça da Palmeira)

Avenida da Liberdade, 4450-716 Leça da Palmeira, Portugal

Álvaro Siza designed two swimming pools in Leça da Palmeira in Matosinhos near Porto in Portugal in the 1960s. The first is the famous pool in the sea, or more precisely in the Atlantic Ocean, and the second is the lesser-known pool in the park – Quinta da Conceição. These two pools are diametrically different from each other, and they display Siza's sensitivity towards site, material and function even in the same building type.

The pool in the ocean was a continuation of a way of working on-site that began in the Boa Nova Tea House, which Siza designed with Fernando Távora and others. The ensemble – the main pool, the children's pool and the changing rooms – was designed to respond to the natural topography with minimal visible interventions. The pools, the rocks and the sunning plateaus appear seamless, ancient and natural. Siza's command of spatial hierarchy is best appreciated in the journey from the road to the pool via the changing rooms. The changing rooms run parallel to the highway, hugging the retaining wall between the beach and the road. When one is inside this dark, low, black timber-roofed building, the external environment is dulled, and for a few moments one is released from the grasp of the Atlantic. This silence only serves to intensify the experience as one leaves the changing rooms – the exit frames a picture-perfect view that cuts diagonally across the two pools towards the crashing foamy Atlantic and bright sky beyond.

The swimming pool in the park is a far less dramatic affair, and Siza adopted cues from the nearby Távora-designed tennis courts. Where the pool in the sea strives to become one with nature and embraces the roughness of the rocks, this pool in the park, to the contrary, revels in its artificiality and smoothness. The white of the walls and the red of the lean-to roofs set off the blue of the water perfectly. A visit to Matosinhos would not disappoint a swimmer for the differences that these two Siza pools offer.

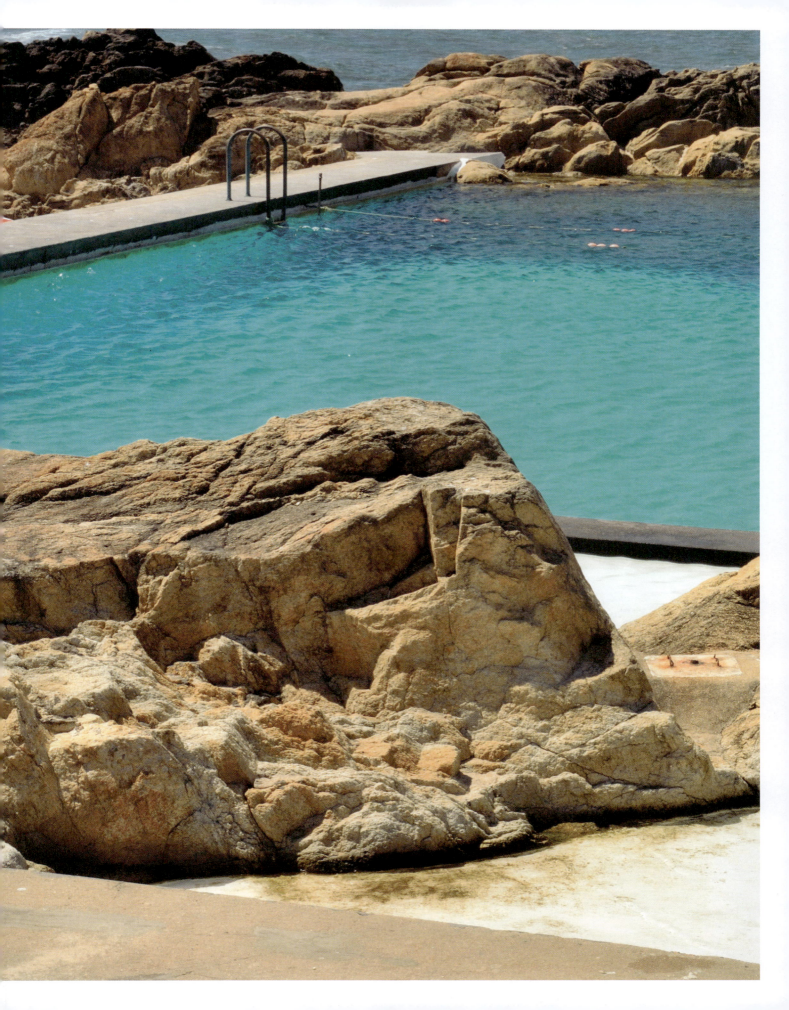

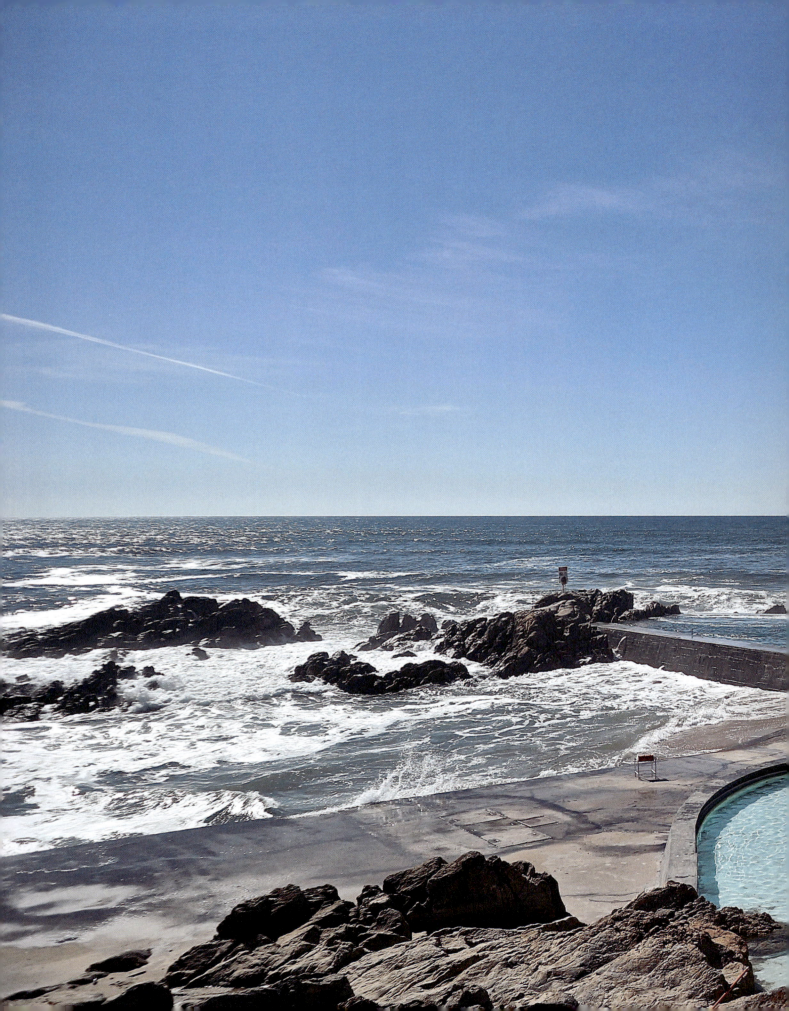

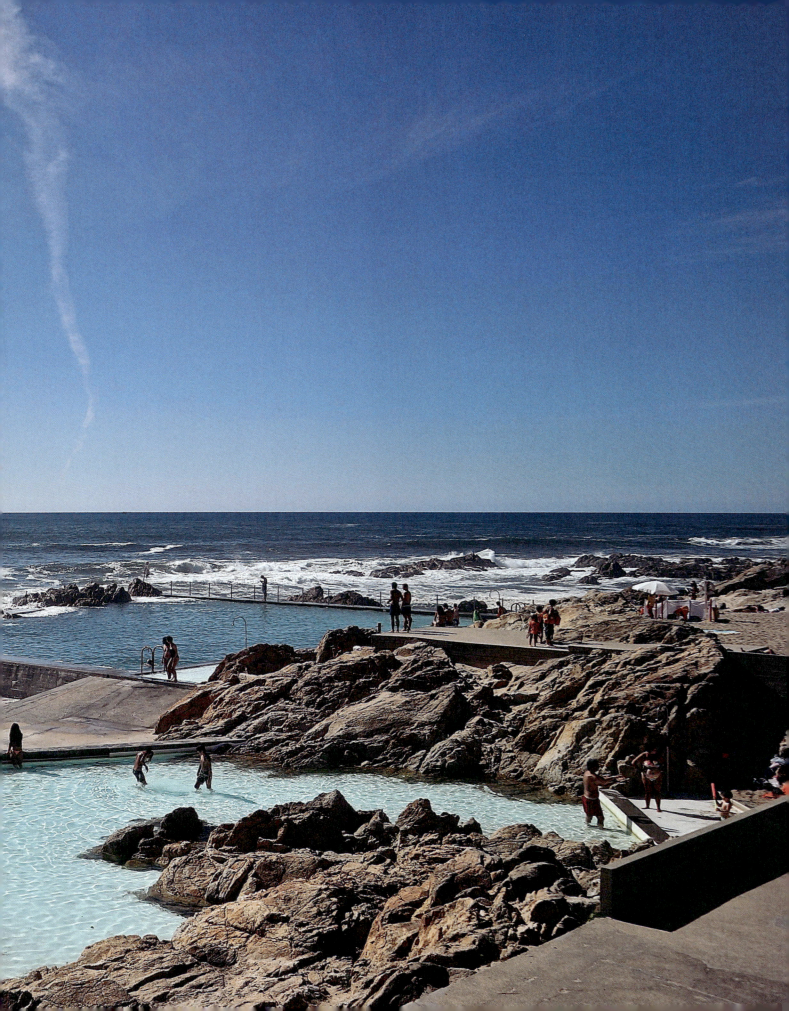

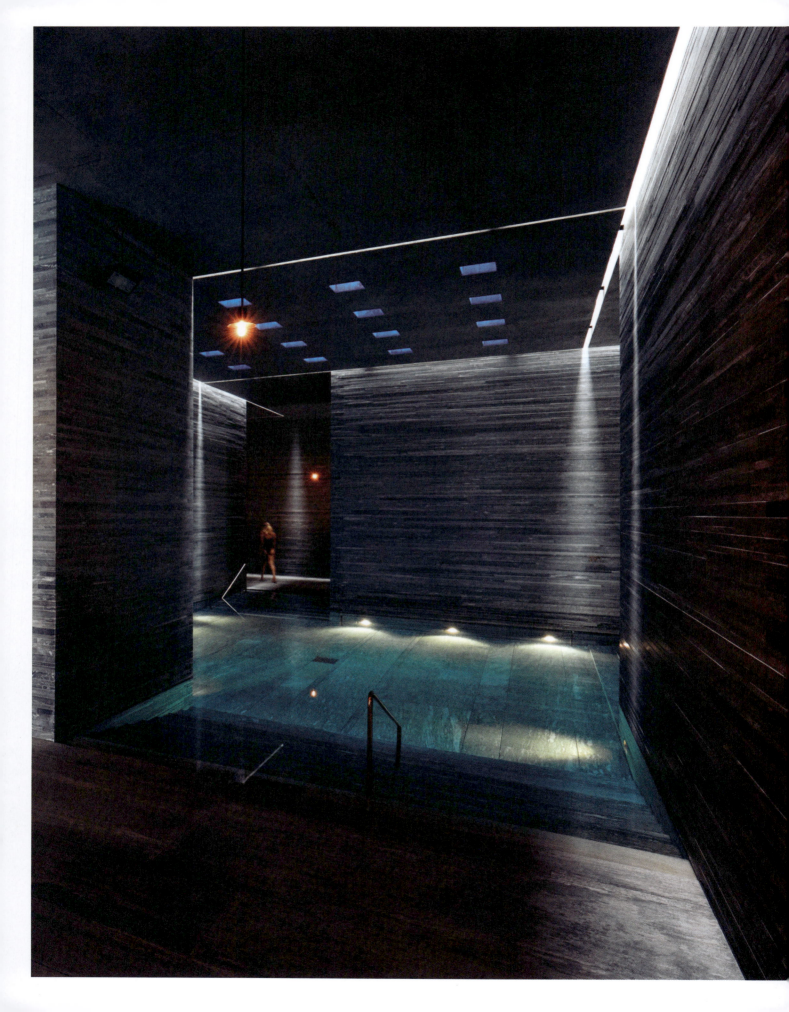

Thermal Baths in Vals

Poststrasse 560,
7132 Vals,
Switzerland

Some of the more iconic photographs of the Thermal Baths are by Hélène Binet, a celebrated architectural photographer who has managed to capture the enigma of the project and in turn, through her photographs, further contributes to it. The Thermal Baths in Vals is a sensuous building that evades a singular description. Towards this end the architect Peter Zumthor has deployed several design strategies so that reason is teased into the background, allowing body and mind to submit to the sensations of water, stone and light.

The Baths is one of Zumthor's early projects and it achieved considerable fame even before it was completed. Although it is an object of considerable mass, most of its bulk, topped by a green roof, dissolves into the hillside that it straddles. The extensive use of locally quarried gneiss rock and the thin fissures in the roof allow daylight to trickle down the vertical surfaces, amplifying the sensation of being in the bowels of a mountain. The two swimming pools – the indoor square pool with steps on its four sides arranged in a pin-wheel pattern and the outdoor pool that sits on a terrace overlooking the mountains – are clad with the same gneiss rock and appear as if they are excavated from the earth to reveal the hidden source of the ancient thermal springs of the area. Several intimate treatment and hydrotherapy rooms divide the cavernous space; each of them have very different architectural and ambient qualities that allow a visitor to trace their own sensorial path, ensuring that every visit is unique.

The baths began as a community project by the town of Vals. For a short while they were sold to a private entrepreneur. However, in 2022, they were bought back by the community while being managed by 7132 Hotels, which prides itself on a portfolio of spaces designed by world-renowned architects.

Kastrup Sea Bath

Amager Strandvej 301, 2770 Kastrup, Denmark

White Arkitekter designed the Kastrup Sea Bath in 2004 off the coast of Copenhagen in the Øresund strait that separates the Atlantic from the Baltic Sea, not far from the Øresund link bridge that connects Copenhagen to Malmö. The sea bath exemplifies the ethos of the practice – social sustainability is listed as one of their core tenets, which aims to foster healthy communities in relationship with ecological sensitivity. Though the project intervenes minimally in the sea, it nevertheless foments an exponentially large benefit. The bath has injected life into the strip of beach around the brownfield area, while fostering a diverse community of outdoor swimmers who have been given a protective shell that is free for all, designed to be always open to the public and for those who are differently-abled.

The structure is designed as a continuous sweeping arc constructed of azobé, which is an extremely durable African hardwood especially used for construction in water. It begins as a 100m (328ft) long pier that leads swimmers away from the gravel beach towards the amphitheatre-like structure that delineates a body of water from the rest of the strait, carving out a protective space for swimmers to feel at ease with the knowledge that they are being watched. The bath is about three-quarters of a circle that is made up of a wall and a platform. As the circle traces its arc from the pier, the wall starts rising, lifting the platform so that it encompasses changing rooms below. On axis with the pier, the wall of the structure is perforated with large openings to allow an unobstructed view of the horizon beyond, reconnecting the lost visual connection across the strait.

It is a very simple architectural gesture that does not try to tame nature, but instead invites people to engage with nature in a safe and controlled manner. Denmark is cold water and outdoor swimming friendly – a quick search would result in a plethora of harbour baths, each providing a novel experience.

White Arkitekter have also designed a harbour bath at Hasle on the Baltic, which they claim has some of the finest sunsets on view.

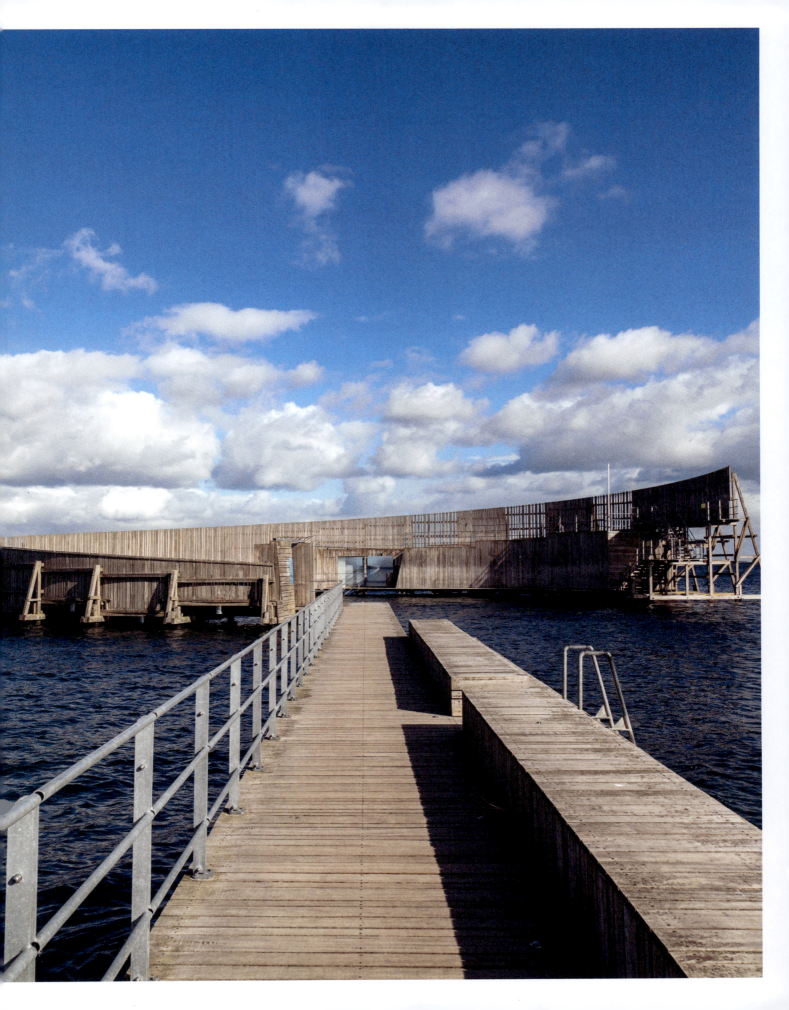

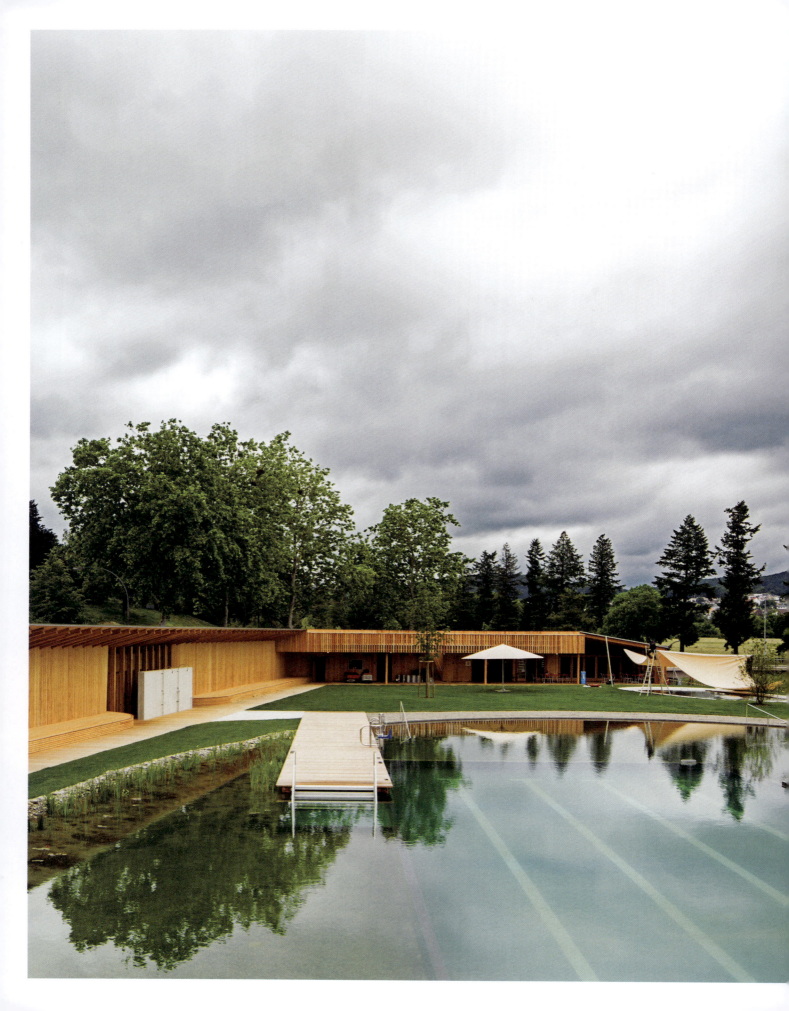

Naturbad Riehen

Weilstrasse 69,
4125 Riehen,
Switzerland

Jacques Herzog and Pierre de Meuron started their architectural practice in 1978 in Basel. Though the architects are internationally renowned, nonetheless, they continue to remain local, contributing to the architectural culture of Switzerland and Basel. It is quite likely that this Naturbad was one of their first few commissions – they won the competition in 1979 – however, this project was started in 2007 and completed in 2012. The project changed unrecognizably in the three decades in between, not least because the culture of swimming pools and their relationship to their context has diametrically evolved since the 1970s.

In an earlier version of the design, the outdoor swimming pools were meant to occupy two different sites, which the architects joined with a raised walkway that connected the pool deck of the larger pool with the green spaces between the other two pools. The composition is scattered. Additionally, the pools appear more conventional – there is what looks like a formal 50m (164ft) long pool with a diving pool attached to one of its sides, a smaller 25m (82ft) pool and what looks like a paddling pool. The pools are disconnected from each other and do not make any gesture towards the River Wiese, which flows close to the site. The Naturbad, to the contrary, is founded on the historical *badis*, or inserted basins, that populated Swiss rivers. The main body of water is conceived as a 'constructed' wetland that is shaped as a distorted ellipse in which rectangular basins are inserted. The project is visually opened towards the river, and a perimeter wall of changing rooms and other functions constructed out of larch wood screen the pool from the road.

The conflation of a lake-like atmosphere, with regulated spaces for lane swimming, builds upon the way that the Swiss take to their inland waters. It also harks back to the 19th century and the history of floating swimming pools.

Borden Natural Swimming Pool

7615 Borden Park Road NW, Edmonton, Alberta T5B 4W8, Canada

The Borden Natural Swimming Pool, designed by gh3* architects in 2018, is a chlorine-free public pool in Edmonton in Canada. Canada has some of the most stringent hygiene regulations in the world for water quality in public pools. The Borden pool met the standards through a layered series of filtration beds, which includes a crushed granite bed and hydrobiological 'constructed' wetlands that feature water lilies, rushes and microscopic marine animals. Chlorine is one of the known inactivators of the polio virus and has been a staple disinfectant in public swimming pool waters since the early 20th century. The move to natural filtration clearly benefits the ecological system; however, it demands a behavioural change from the users. The rules for this pool are very specific and depend on a conscientious public who are asked not to use the pool if they have been unwell or wounded in the two weeks prior. Furthermore, before entering the pool, they are required to wash thoroughly and are requested to use only phosphate-free sunscreen.

The swimming pool has a concrete edge that meets pale wooden decking which, in turn, is surrounded by light brown sand to create the feeling of being at the beach. The sanded area has a volleyball court among other typical beach play equipment. The main pool is flanked on either side by a children's pool and the wetlands. The latter is cordoned off with a glass parapet, allowing it to be visible but remain uncontaminated. A dark, low-slung building constructed with gabion walls filled with limestone contains the changing rooms and parts of the services, including the pump room and a water testing lab. The gabion walls continue along one of the shorter edges of the pool complex, giving way to a light fencing that physically separates the pool from the rest of the park but keeps it visually connected.

The project is porous – in the relationship that it sets up with the park, its material language and in the use of filtration beds – lending to a feeling that it is integrated within the local natural system as air and water circulate through it.

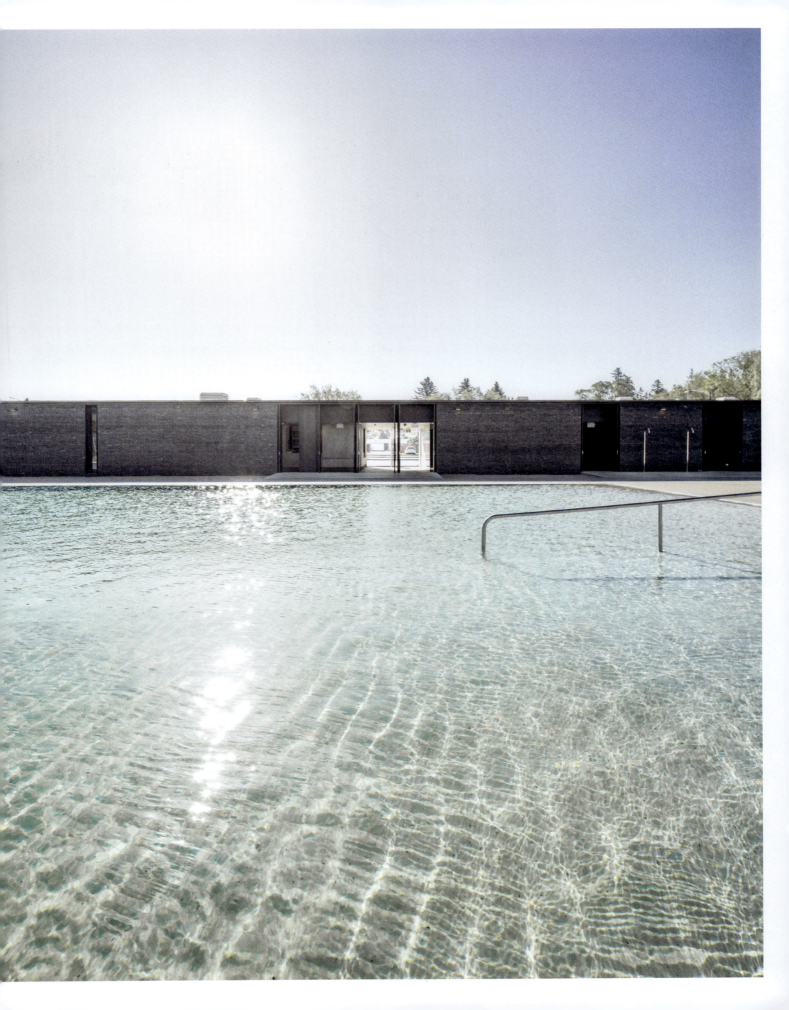

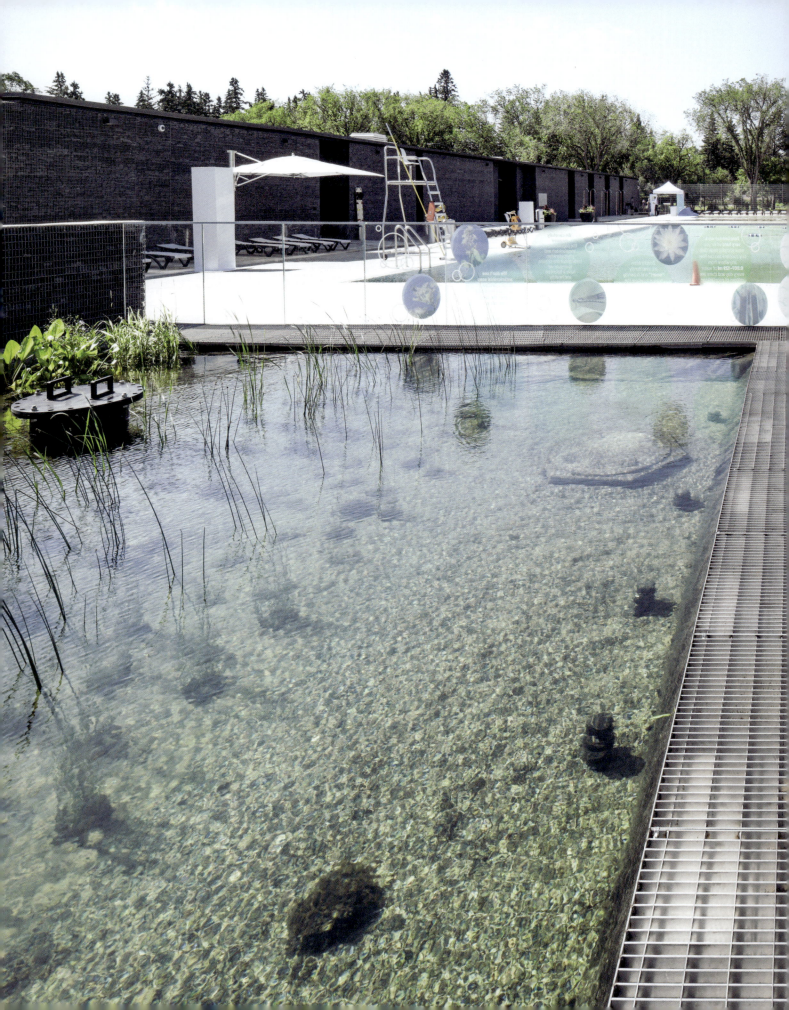

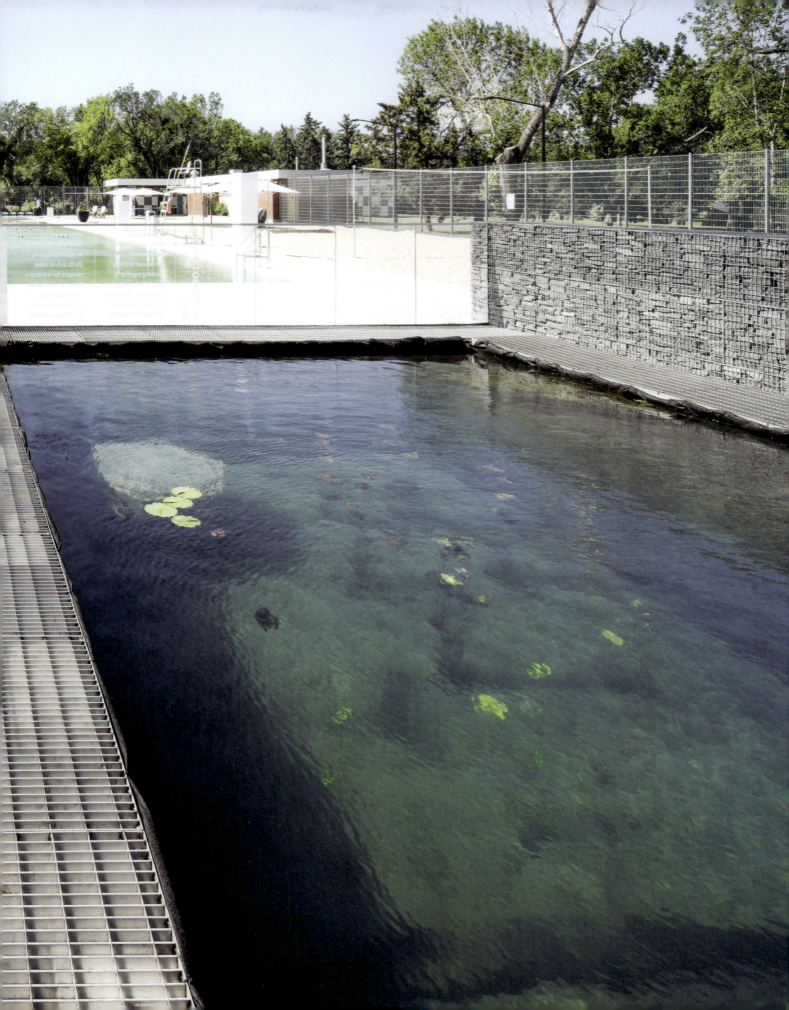

6

FREE FORM, FREE FROM

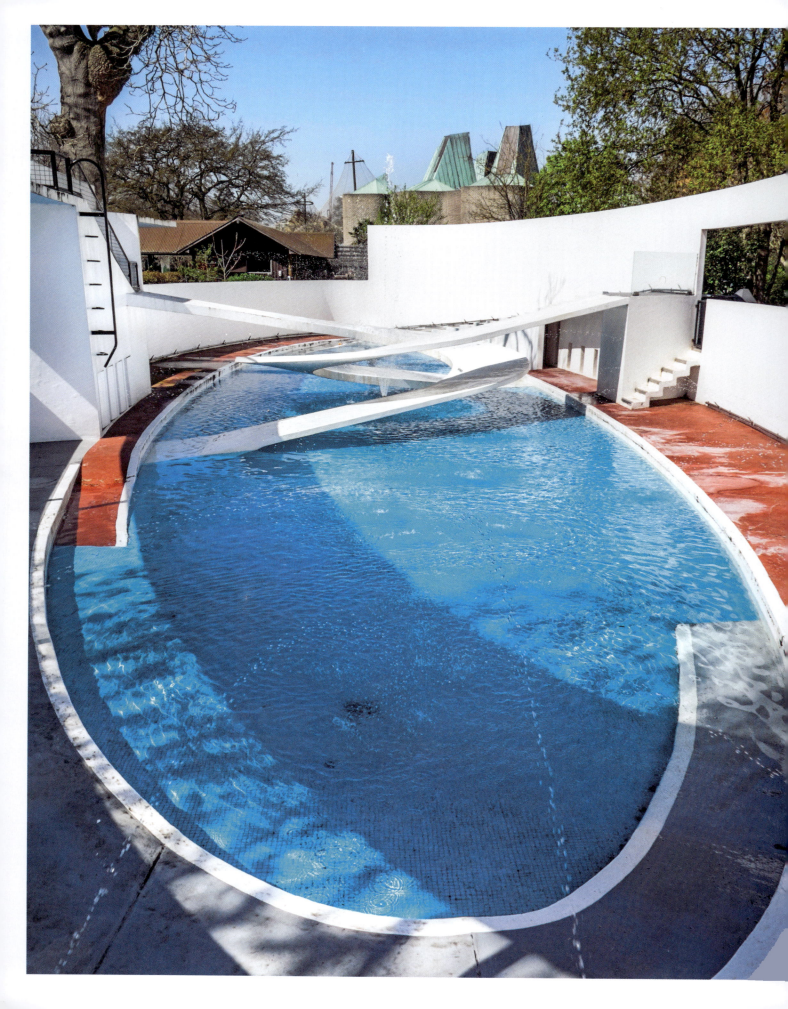

Penguin Pool

*London Zoo,
Outer Circle,
London NW1 4RY,
England*

Though it lies unused today, the Penguin Pool, designed by architect Berthold Lubetkin in collaboration with the group Tecton and the Danish structural engineer Ove Arup, was once heralded as a paradigm of modern architecture in Britain. In 1938, four years after it was opened, the penguins were surprised by a visit from the young Princesses Elizabeth and Margaret. It was a piece of architecture-sculpture that was dear to children – several photographs display children leaning into the enclosure as they try to get a glimpse of the antics of its inhabitants diving into the pool or waddling comically along the cantilevered helical ramps.

The penguins have now been moved to another enclosure that is more suitable for them based on the knowledge and ethics that the Zoological Society practises today; nonetheless, the Penguin Pool was a considered piece of architecture that was designed for the comfort of its inhabitants, even if it was arguably envisaged as an abstracted interpretation of their natural environment. For its size it is an extremely detailed object that served as a theatre for viewing and engaging with its inhabitants. The outer wall of the pinched ellipse is perforated with long horizontal openings. Inside, the ellipse is centred around a diving pool, which is painted a bright blue, from which emerge two concrete ramps that coil in opposite directions – adding even more dynamism to a design that celebrates movement and multiplies the joy of watching the penguins from above and below as they move around the three-dimensional planes.

It was a well-intentioned prized piece of architecture; however, like some of the other structures that were designed for the London Zoo and other zoos in England, it lies empty and has not aged well. Nonetheless, it is exemplary in its design, its structural resolution and the many thoughts that provoked such an intricate piece of work.

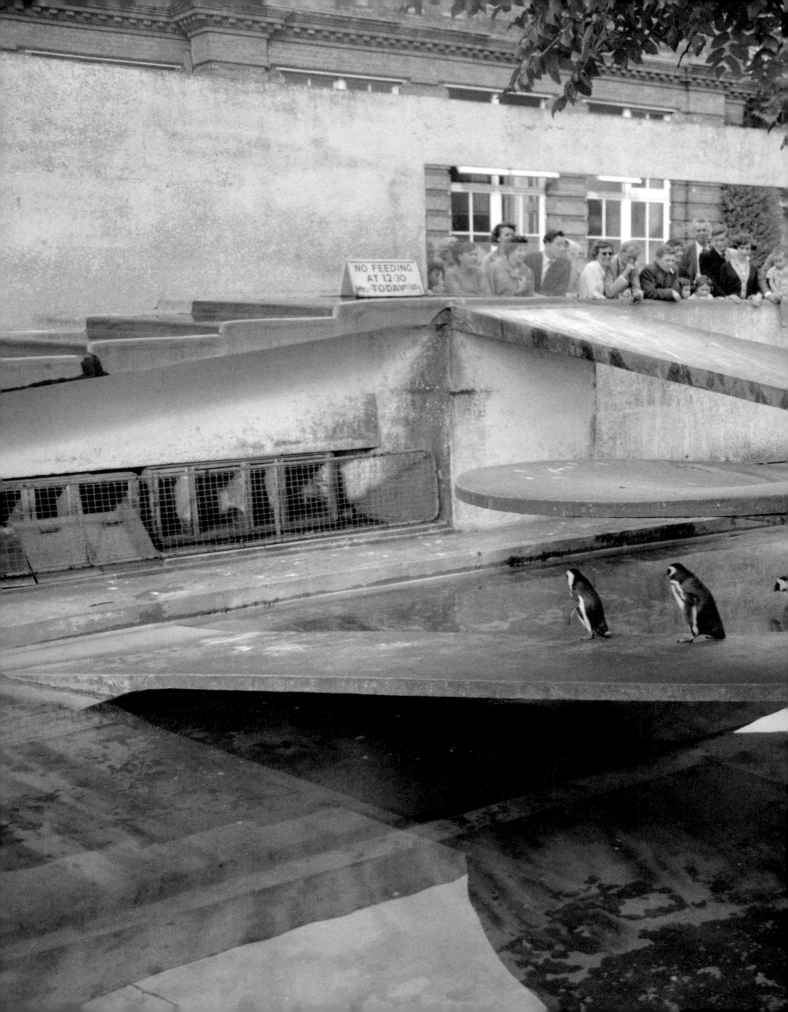

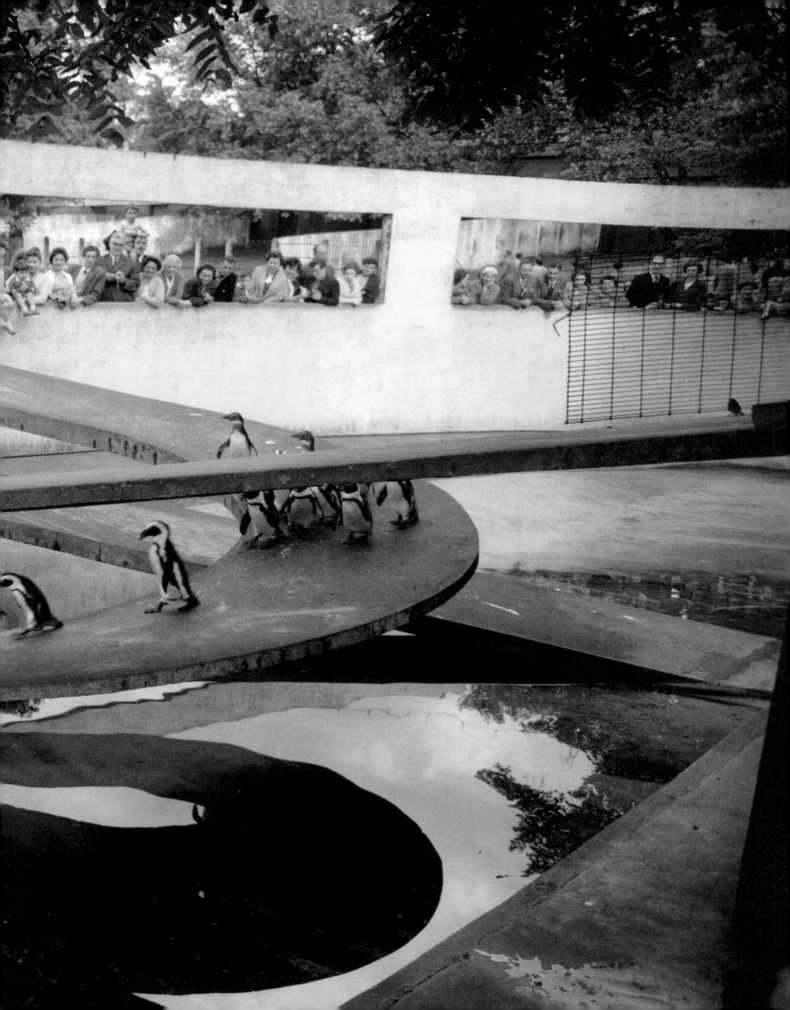

Villa Mairea

Pikkukoivukuja 20,
29600 Noormarkku,
Finland

Aino and Alvar Aalto were an architect couple. Each had their speciality – the husband was more involved in the design of the structures, while the wife focused on the interiors, furniture and landscape; however, such a simple division of labour does not do justice to the more probable synergetic relationship that the couple shared. Aino headed the drawing office of their furniture company, Artek, and was the avid gardener, but they both designed furniture for their projects and they were equally invested in designing the garden, both as a space and in relationship to the interior spaces of their buildings.

The swimming pool in the Villa Mairea is a counterpoint to the L-shaped villa. The villa and the pool trace the limits of the garden, which is surrounded by pine-covered slopes in the Noormarkku municipality in western Finland. The pool looks like a natural lake – there is a thin border of dressed stone that delineates it from the grass. In true Finnish tradition there is a sauna at the bottom of the garden that is anchored to this 'lake' in the forest. Wooden decking connects the sauna to an edge of the pool where two planks seamlessly continue beyond the boundary of the water. One is a springboard and the other grips a wooden step ladder – the former to catapult into the freezing water and the latter for those who prefer to ease themselves into the cold. The pool is always cold even in the summer and is experienced best as the counterpart to the extreme heat of the sauna.

The villa is a complete piece of work – every aspect of the house is a continuation of another and together all the parts form an indivisible whole. Harry and Maire Gullichsen, who owned the villa, were financially and ideologically invested in Artek and modern design, believing it to be the path towards a progressive society.

Donnell Garden Pool

27235 Arnold Drive, Sonoma, CA 95476, USA

The Donnell Garden is one of the classics of modern architecture and a mature example of Thomas Church's work. The pool was inspired by the one in the Villa Mairea (see page 130), designed by Aino and Alvar Aalto – it is believed that it was on the drawing board, quite literally, when Thomas and Betsy Church went to Finland in 1937. It is one of the early kidney-shaped pools in the United States that was built using sprayed concrete which, in turn, led to a series of biomorphic bowls that connects the world of swimming and skateboarding. The novelty of the shape inspired the sculpture by Adaline Kent that lies in the centre of the basin – it is rumoured that she worked through several versions to complement the pool.

Adaline Kent was an artist who worked in the San Francisco Bay area and, like many female artists of the era, was lost to history until recently. Kent's sculpture in the pool, which is around 2.75m (9ft) high and iceberg-like, is two-thirds underwater. In the empty pool it stands tall, but once submerged it appears more horizontal. Protean, it is continually transforming depending on the viewing angle and the shadows and reflections it casts below and on the water surface. Kent's work has been associated with forms of Mount Sierra that she skied down, the female form and her love for the infinity symbol – all of which can be seen in the sculpture. It is a slippery, playful piece that avoids description but invites engagement – tempting adventurous swimmers to snake through the voids its form creates. From certain angles it even looks like a floating chaise longue, inviting swimmers to rest on it.

In contrast to the exuberance of the sculpture, the diving board appears almost invisible on the concrete decking in front of the lush landscape that cascades down into the bay. Though it is private, the garden and its pool can be visited by appointment.

Concrete, Tiles and Coping: *How Skateboarders Fell in Love with the Swimming Pool*

Iain Borden

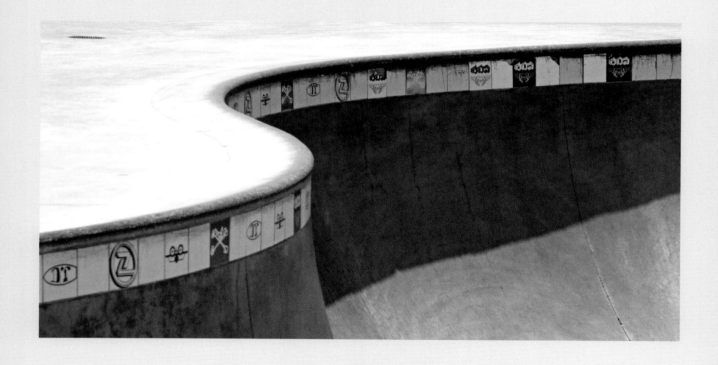

For most people, swimming pools are all about the water. The shapes of the pools, sunbathing areas, surrounding buildings, gardens and landscapes are undoubtedly important, but in the end what matters most are the seductive blues, the reflections and shimmers, splashes and ripples, the luxurious sense of cool liquid against skin when diving and swimming. For skateboarders, it's the opposite. It's about the concrete, tiles and coping, with the very absence of water allowing for an extraordinary pool-based sensation to occur. Indeed, the pool has become a kind of Garden of Eden for many skateboarders, as the place where expressive skateboarding first appeared and which most encapsulates its renegade spirit, and which has now become a kind of holy altar at which riders worship. Which begs the question, just how did this peculiar inversion – the pool without water – arise?

Villa Mairea

To unravel this mystery, we need to go back over 80 years and travel to Noormarkku in western Finland, about 250km (160 miles) north-east of Helsinki. Here, in 1939, the internationally renowned Modernist architects Alvar and Aino Aalto designed a house – the Villa Mairea – for two wealthy friends, the industrialists and art collectors Maire and Harry Gullichsen, who had requested an experimental residence. For Alvar (whose involvement included the gardens, while Aino focused on the villa interiors), this meant not only producing a unique house but also extending his creativity into the gardens – and the swimming pool. Until the Villa Mairea, all swimming pools had been rectangular in plan, or variations on that orthogonal theme. Admittedly, in 1935 the artist and landscape designer Isamu Noguchi had proposed a curvilinear pool for the Von Sternberg House designed by Richard Neutra, but it never featured in the final building. So Aalto's amoeba-cum-kidney-shaped pool at Noormarkku was a revelation, a startling invention of sweeping curves that nestled against the L-shaped plan of the main house. Furthermore, it was one of the very first private swimming pools to offer both a shallow end and a deep end – another innovation which, as we shall see, was to prove

particularly attractive for skateboarders. In short, Aalto transformed the swimming pool from a kind of sharp rectilinear contrast against a garden into an organic shape which integrated harmoniously within its surroundings.

The Villa Mairea and its pool and landscaping proved to be enormously influential, gaining widespread international recognition, and promoting the Aaltos' unique fusion of ecological, Finnish and Japanese sentiments across a global stage. One of those who appreciated this revolutionary design approach was the American landscape architect Thomas Church, who visited Finland in 1937, knocked on the door of the Aaltos' Munkkiniemi studio, and struck up a life-long friendship. Now, while we have no idea whether Church saw any preliminary designs for the Villa Mairea during his visit, we do know that he was enormously influenced by what he saw, his own work soon shifting away from his conventional Beaux-Arts training and a preference for classical right-angles to more environmental sensibilities and softer curves. In *Gardens Are for People*, published a few years later in 1955, Church proffers four principles for landscape design, including function, simplicity, scale and unity, variously covering such themes as the integration of a house with its gardens, the free flow of space, outdoor rooms, a sense of movement and multiple viewpoints – all of which could be readily associated with Aalto-esque design sensibilities. 'The lines of the modern garden,' asserted Church, 'must be moving and flowing, so that it is pleasing when seen from all directions […] Rhythm and movement are essential.'[1]

Donnell Garden

Following Church's career takes us to the next stage of this transatlantic journey. Around 1946–47, a pair of moneyed North Californian ranchers, Dewey and Jean Donnell, asked Church to create a new garden in a favoured part of their Sonoma County estate. Very unusually, this garden pre-dated by four years the house that would eventually arise nearby, and so Church had considerable freedom to explore aspects of view, terrain and social function. In particular, while, in the immediate aftermath of World War II, house construction was being severely curtailed by the limited availability of building materials, swimming pools were easier to build, and indeed were being encouraged as a

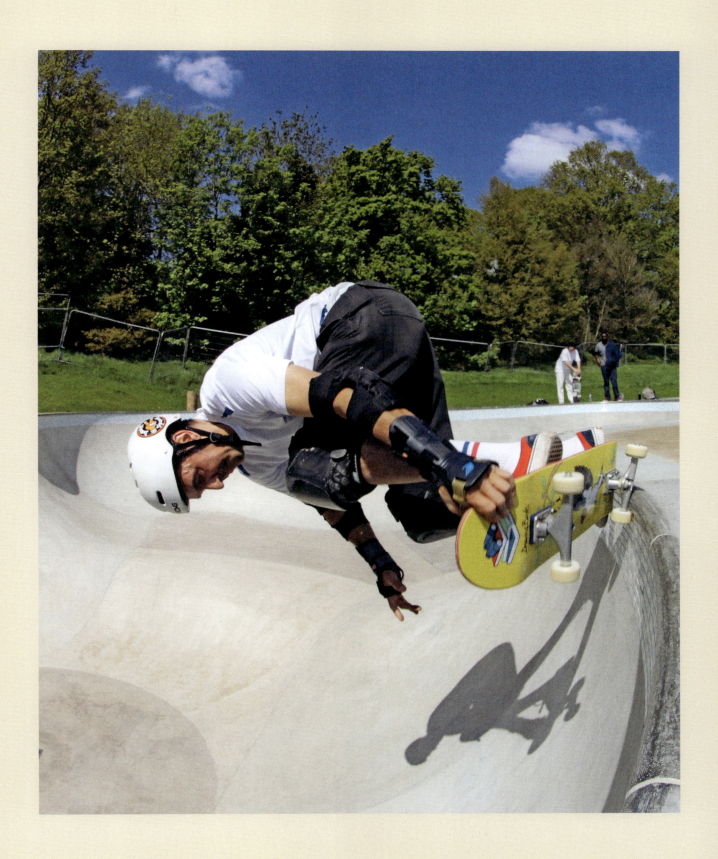

way to store water in case of the need to fight summer-time brush fires. Consequently, from the very first drawing, an Aalto-esque pool was included by Church in his garden designs.

Working collaboratively with the clients and fellow landscape architect Lawrence Halprin, Church completed his pool in the summer of 1948, its kidney-shaped composition derived partly from the winding shapes of nearby creeks, partly from artists such as Joan Miró, Salvador Dalí, Yves Tanguy, Jean Arp and Isamu Noguchi, and of course partly from the Villa Mairea. The result, according to historian Marc Treib, was 'more than any other landscape in the world […] the preeminent icon of modernity' with the pool itself being 'arguably the most celebrated swimming pool in mid-century landscape architecture'.[2]

Above all, the shapely pool was more than just a thing in itself – a mere facility for swimming – but was a focus for outdoor living, sunbathing and a new kind of integrated landscape. The Donnell pool suggested a new way of being in the Californian landscape, a way to express the human self in relation to the surrounding environment. This was not landscape as abstraction, theory or formal shape, but a place where people were a key ingredient in a dynamic creation – this much is revealed in section as well as in plan, combining a deeper diving section with a shallower children's play area and a 30m (100ft) open length for swimming. Famously, an island concrete sculpture by Adaline Kent provided an additional location for sunbathing, incidental meeting and – through its lower orifice – underwater games. The Donnell pool was undoubtedly 'serious', but also a place of fun and pleasure, something to be encountered, explored and enjoyed.

Californian Suburbia

Certainly other American non-rectangular pools pre-dated the Donnell Garden, including famous examples in San Simeon (1924) by architect Julia Morgan, the Zublin house (1931) in Bel Air by architect Paul Williams, and Olivia de Havilland's house (1945) in Beverly Hills, as well as innumerable

lesser-known versions illustrated in the pages of publications such as *Popular Mechanics*, *House Beautiful* and the *Los Angeles Times*. However, the sylph-like curves of the Donnell pool – in stark contrast to simpler circles, arcs and ovals – were particularly unique, and undoubtedly had an enormous impact on the collective psyche of American suburbia; in Treib's words, the Donnell 'biomorphic pool became the quintessential element of the quintessential Californian garden'. Inspired by this seductive prototype, and aided by factors such as movie star connotations, federal loans, reduced costs, sprayed concrete construction and maintenance benefits – rounded sides reduced cracking and leaks – the backyard suburban pool (often in a Donnell-esque curved profile) became an attainable aspiration for many homeowners. In particular, the pool supported a 1950s domestic narrative of being able to mix privately with friends and family in a carefree indoor-outdoor sunshine setting. *House Beautiful* magazine was an especially powerful promoter of this ideology, and used California as its pre-eminent example, often with gardens designed by Thomas Church. By 1955, half of all American pools were being built in that state, with one in every 40 of its houses – no matter how small – including a pool.[3]

Appropriation

Not everything, however, was perfect in this apparent utopia. Although the backyard pool continued to be a common feature of Californian house construction during the 1960s and 1970s, it also began to lose some of its glossy allure. Tainted by concerns around the environment, the Vietnam War, civil rights and the 1970s oil crisis, the residential architecture of suburbia – including its totemic pool – was being increasingly challenged, re-thought and re-used. Nowhere did this become more apparent than during the great drought of 1976–77, when California's water supply infrastructure was severely tested, rationing and usage restrictions were imposed, and economic losses totalled over $1 billion. As a result, many thousands of backyard pools were left unfilled, and drained of water, hope and promise. For that moment at least, the future of the pool looked decidedly uncertain.

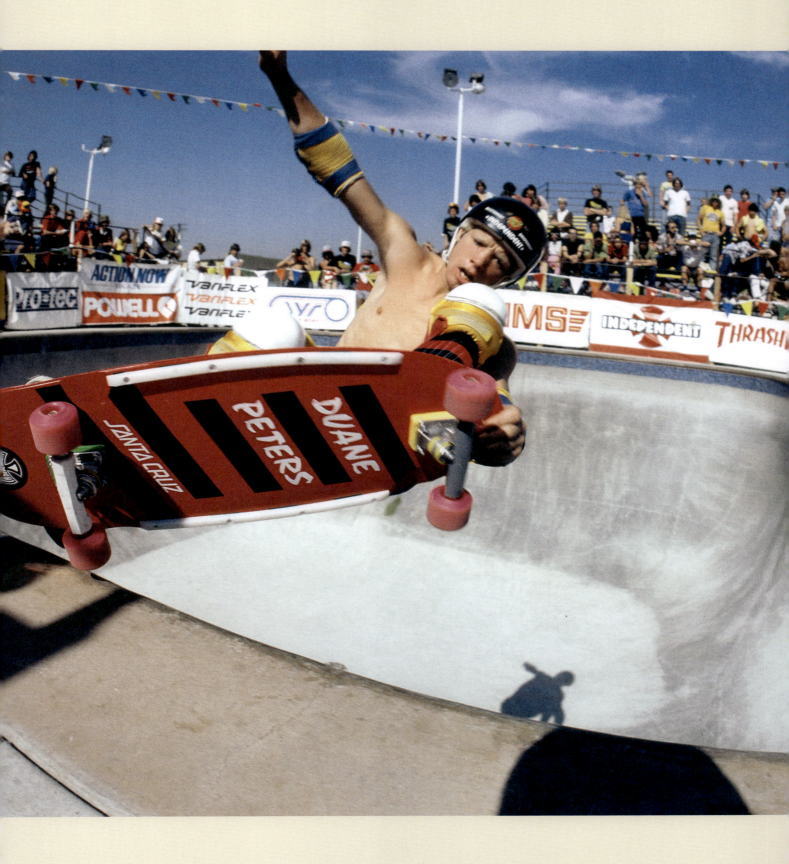

Into this empty space rode skateboarders. Fuelled by recent advances in their equipment – notably faster and grippier polyurethane wheels equipped with sealed bearings and mounted on stronger and more responsive trucks – these riders were already exploring the ditches, drainage pipes, reservoirs, suburban asphalt roads and schoolyard banks of the Californian landscape. But the swimming pool offered something distinctively challenging – a place to emulate surfing-inspired moves such as carves and kickturns, while also inventing new moves such as aerials, as well as creating a whole new social space in which adventurous teenagers could bond in their common assault and exploration. Skaters identified backyard locations all over California, sometimes in the grounds of abandoned residences or illegally, without the permission of temporarily absent owners. Although pools were undoubtedly skated in many other American locations, Los Angeles lays best claim to being skateboarding's 'pool capital' at this time, particularly in the moneyed Hollywood Hills, Beverly Hills,

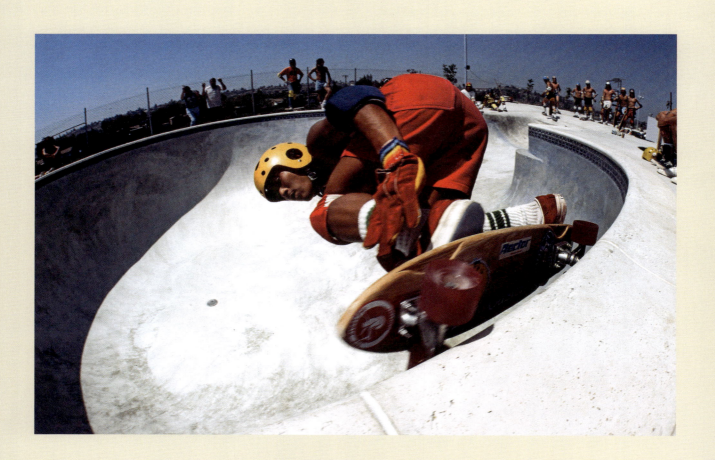

Malibu, Pacific Palisades and San Fernando Valley, where luxurious private pools abounded. Many were only ridden for short periods of time and were known by idiosyncratic labels, such as Adolph's, Dog Bowl, Fruit Bowl, Gonzales, Kona, L-pool, Manhole and Soul Bowl. One professional rider, Stacy Peralta, estimated that he rode over 100 of these pools during the two-year drought.

These pools also offered a unique challenge, for the drop down from shallow end to deep end (as inaugurated at the Villa Mairea) gave skateboarders a rapid acceleration, the tight curvatures allowed for dramatic sweeping turns, blue tiles yielded a rasping staccato sound, and the protruding stone coping blocks allowed skaters to generate high speed metallic grinds as their trucks scoured sideways. Even more dramatically, the same coping blocks also allowed the most advanced skateboarders to get a kind of backwards 'bonk' as they flew up above the pool, turn around in mid-air, and then return to the bowled surface below. As one rider later described it, 'Round pools with fat coping and wide-open shallow-ends. The faster the better. Go over the light, then the love-seat, through the shallow, carve-grind the deep-end pocket and ride that hip that tips past vert. Are you scared to frontside grind over the death-box? Haul ass!'[4]

The pool was now fully appropriated from a place of relaxing watery swimming into aggressive concrete skateboarding. Empty of liquid, full of gravitational possibility, the pool was a whole new thing – a place in which skateboard, rider and architecture combined to create an intense explosion of energy. It even created a legendary myth, the story of 'Dogtown', centred around Venice Beach in Los Angeles, where riders such as Tony Alva, Jay Adams, Shogo Kubo, Stacy Peralta and Peggy Oki helped pioneer the new approach to skateboarding. The aim, explained Peralta, was 'to project yourself through the bowl continuously, forever doing off-the-lips, from one wall to another'.[5] Reported in the pages of *SkateBoarder* magazine by maverick writer-photographer Craig Stecyk, and later celebrated in Peralta's renowned documentary *Dogtown and Z-Boys* (2001) and the fictionalized *Lords of Dogtown* (directed by Catherine Hardwicke, 2005), the pools of Dogtown are still today held up as one of the original birthplaces of skateboarding, where its central moves, attitudes and culture were first inculcated.

Simulation

Backyard pools continue to be ridden today, everywhere from Arizona to Australia. But perhaps their biggest legacy for skateboarding lies in the way they have been further translated into the global architecture of the skatepark. Unsurprisingly, this leg of our journey also begins in California, with the creation of the first proper skateparks – large-scale concrete facilities expressly designed for the act of skateboarding – from 1976 onwards. At first, skateparks such as Carlsbad in north San Diego county and SkaterCross in Reseda were essentially undulating runs, like a surfer's wave remodelled into concrete forms, and while initially popular they lacked the tiles and coping of authentic backyard pools. And so as competition increased from other skateparks and skaters' moves became more advanced, many ventures incorporated pool-style elements. One of the first was the Fruit Bowl pool at Anaheim's Concrete Wave skatepark in mid-1977. In the same year, Skateboard Heaven skatepark at Spring Valley, San Diego, based its new pool on a popular fraternity house backyard pool – known by skaters as the 'Soul Bowl' – including its shallow-end coves and love seats. Skateboard Heaven's version, however, offered more relaxed transitions, reduced amounts of vertical wall and a new coping profile, all of which were precisely tuned for skateboarding; according to Peralta, it was the 'first real pool for skateboarding'. Other skatepark pools were monstrously dramatic evolutions, with dizzyingly deep elements, elevated vertical walls and, in the case of the infamous Combi-Pool, added to Pipeline skatepark in the San Bernardino Valley in 1979, a complex square-plus-circle arrangement.[6]

From this time onwards, almost every single one of the tens of thousands of skateparks that have been constructed worldwide has incorporated some kind of pool (curved sides, tiles, stone coping) or pool-like bowl (curved sides, no tiles, metal coping). Some are even directly based on their Californian predecessors. For example, for the 2.9m (9½ft) deep pool at Venice's own skatepark (2009), the amoeba shape, white tiles and stone coping blocks all make explicit reference to 1970s pool-riding and the exploits of its local Dogtown riders. In many of the recent post-2000 skateparks, such pools often incorporate a 'waterfall' element – a sharp downslope connecting the shallow end to the deeper end, which allows the

rider to generate even more speed. The Venice version, however, foregoes any such waterfall, instead following the model of real swimming pools (and their 1970s skatepark simulations) by using only a more gradual descent to provide additional speed and depth.

This simulation process also occurs overseas. To identify but a few examples, in the United Kingdom the late 1970s G-Force series of skateparks at places like The Barn (Brighton), Black Lion (Gillingham), Mad Dog Bowl (London), Rom (Hornchurch) and Solid Surf (Harrow) all incorporated a centrepiece pool that had been directly copied from Skateboard Heaven, itself based on the local Soul Bowl – meaning that a specific Californian backyard pool had now been transplanted across the Atlantic. Similarly, when in 2017 I helped skatepark constructors Canvas to design the multi-shape pool at Crystal Palace, south-east London, this was directly influenced by Pipeline's Combi-Pool, where different shapes allow for complex lines, vectors and speeds to be drawn out across the concrete curves. Swimming pool-style blue tiles and protruding stone coping help to complete the homage.

Similar stories can be told of thousands of other riders as they traverse the bowls and pools of their own local skatepark; somewhere, in their own minds, they are replicating the joys of Dogtown and the concrete shapes, tiles and coping of backyard pools. And, in doing so, they are also unconsciously going back still further in time, connecting to 1940s Sonoma County and 1930s Noormarkku, and releasing the hidden potential of the Donnell Garden and Villa Mairea pools. For skateboarders, when empty of water, concrete curvature is a truly wonderful thing.

Casa das Canoas

2310 Estrada da Canoa, São Conrado, Rio de Janeiro, 22610-210, Brazil

Oscar Niemeyer organized an exhibition for Alfredo Ceschiatti's sculptures in 1956 at the Casa das Canoas. A photograph of Ceschiatti that is probably from that evening shows him standing beside Niemeyer, who is leaning against the giant boulder that is the heart of this project. Several figurines of women in brass and stone by Ceschiatti pepper the terrace around the swimming pool. A reclining nude female form is poignant, as Niemeyer was partial to curves in his design, inspired by the female body and the natural landscape of Rio de Janeiro. The Casa das Canoas is exemplary – it is a rare depiction of sensual Modernism defined by curves, interpenetration of the natural and the man-made, and colour.

The Casa das Canoas was Niemeyer's third house for his family in ten years and the pool was the focal point of the brief. The pool and the pavilion are inextricably intertwined by a boulder that was part of the site. The rock face bleeds down along the only near-right-angle corner of the swimming pool like solidified lava interfering with the spearmint blue of the rectangular tiles in the pool. The pavilion and the pool are designed to fit in, while clearly articulating their unnaturalness, in the clearing of the forest. The walls of the pavilion are painted a muted green to resonate with the lush green tropical foliage that has grown even denser under the curation of the Niemeyer Foundation, which permits visitors. This is an architecture that neither mimics nor tames nature, but penetrates it.

It was one of his important projects that showcased his talent to the national and international world. Niemeyer was part of the group that designed the United Nations headquarters in New York and other significant buildings in Brazil; however, this house won him the reputation of being a master of Brazilian modern architecture. He was awarded the commission to design Brasilia at the after-party of Ceschiatti's exhibition.

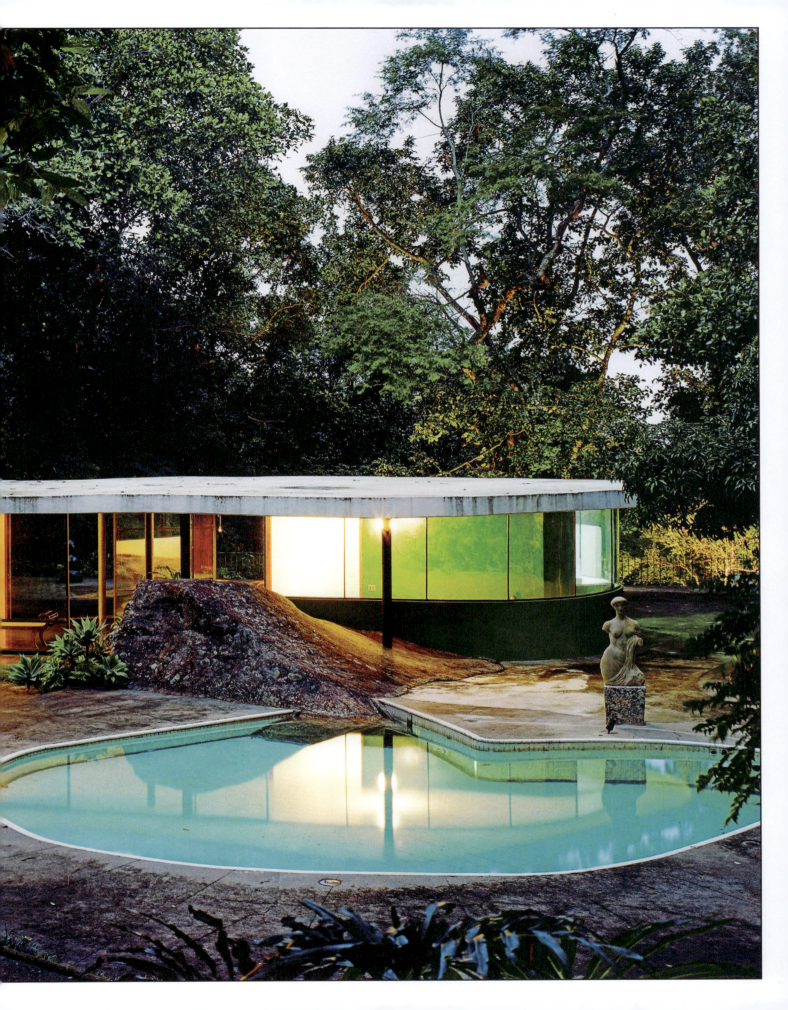

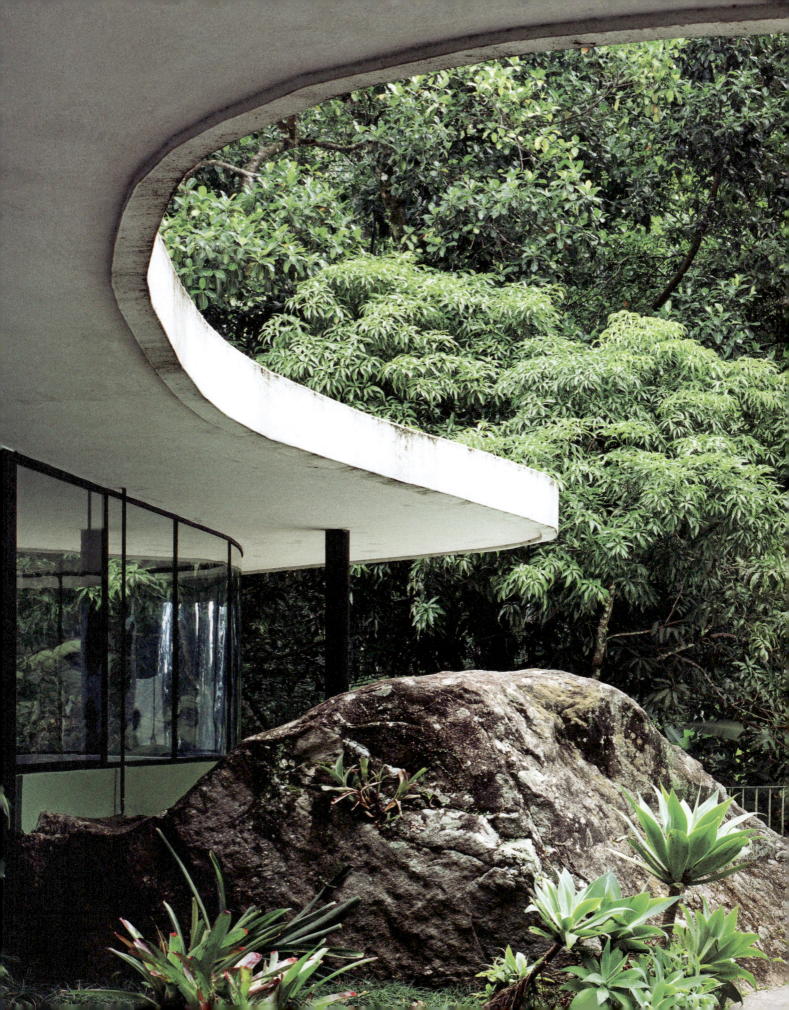

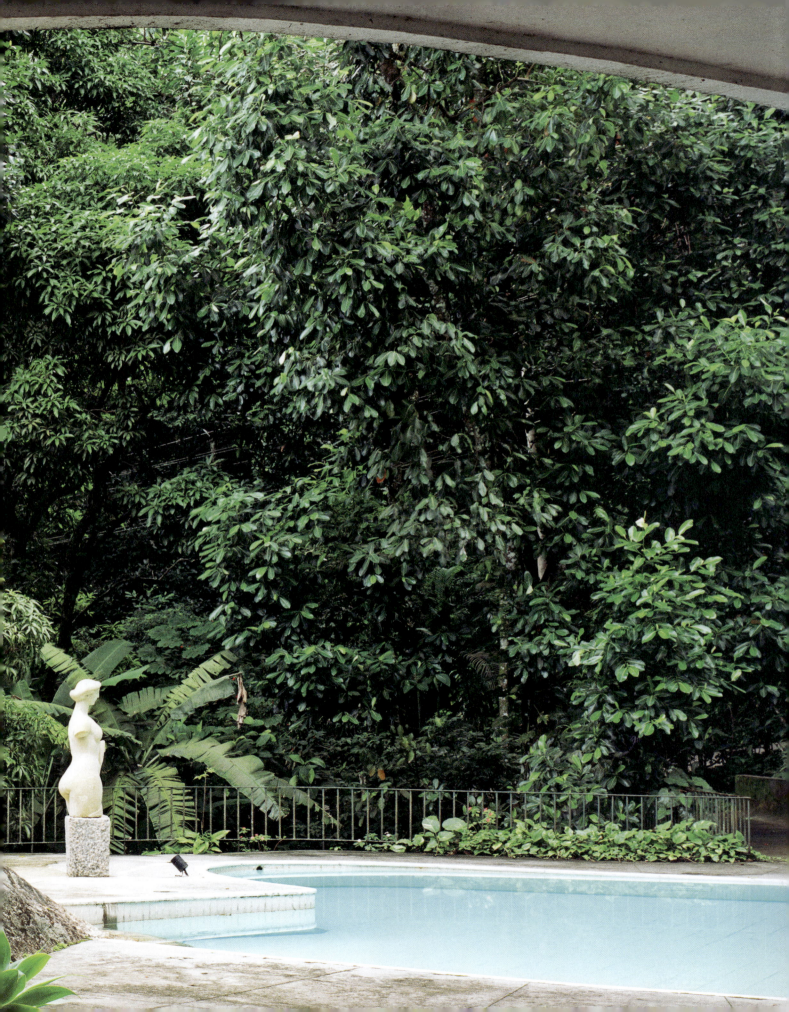

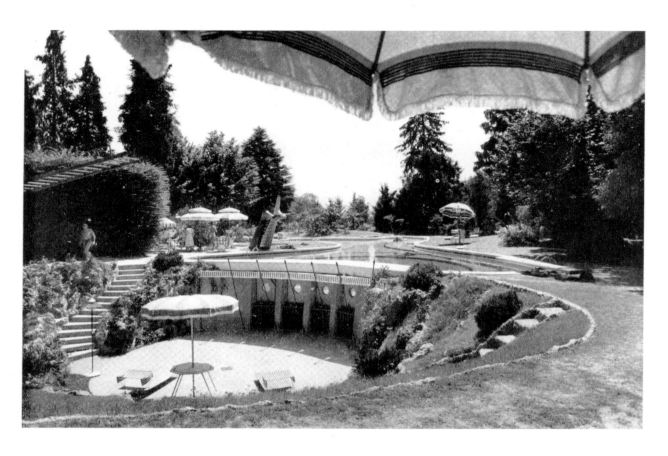

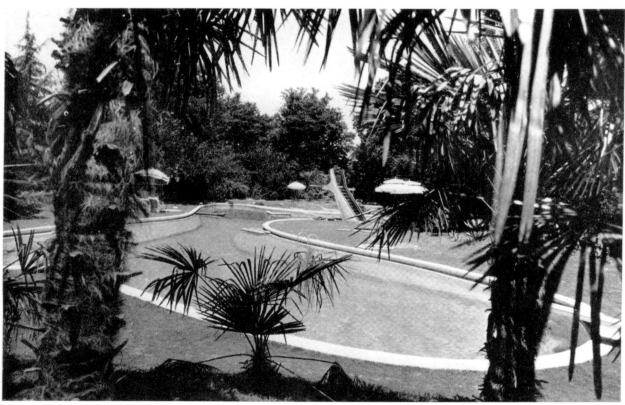

Sporting Club of Monza

Viale Brianza 39,
20900 Monza MB,
Italy

Giulio Minoletti designed the swimming pool in Villa Tagliabue for oilman Ettore Tagliabue and his consort, Elena Giusti, in 1951. It is obviously inspired by the Donnell Garden pool; nevertheless, it took the ideas much further, creating a fantasy pool that celebrated the magic of being underwater. Though Minoletti is less well-known in the architectural world outside Italy, this pool has received considerable attention from historians because of the way it imagines water as a space that changes the way that bodies move and relate to each other in three dimensions. Gio Ponti, who himself had designed several swimming pools, appreciated this project.

The pool's shape can best be described as a dog bone that has been elongated, bent and squeezed. To some it appears as two hearts that are connected by sweeping curves. Its vivid blue colour can be attributed to mosaic tiles in different shades of blue that increases in intensity in the deep end of the pool. The pool has two sculptures – the first is a dolphin by Lucio Fontana in red-glazed ceramic closer to the shallow end, and the second is a polychromatic ceramic piece that alludes to a coral by Antonia Tomasini that is placed in the deep end. Tomasini's sculpture echoes that of Adaline Kent's in the Donnell pool; however, less of it is visible on the surface of the water. The sculpture is an integral component of the design, contributing to the fantastical quality of the pool. The deeper bowed end of the pool is pierced with portholes through which underwater swimmers and their flowing dance around the sculpture are clearly framed, generating a panoramic backdrop to the open-air courtyard which abuts the viewing gallery that is wedged on the lower level of the garden. The courtyard was used for dances.

The villa is now a part of the Sporting Club of Monza, which is unfortunately open only to members.

7

POOL
CULTURE

Victoria Baths

Hathersage Road, Manchester, M13 0FE, England

Victoria Baths in Manchester was designed by the city architect Henry Price in collaboration with Thomas De Courcy Meade and Arthur Davies in 1906. When built it was described as a 'Water Palace' because of its rich material palette and the generosity of the bathing facilities, which included a Turkish bath. Manchester was the industrial centre of the country and, though initially reticent to adopt the Bath and Washhouses Act, when it finally did, it elevated the standard for the building type. The building is adorned by some of the best that industry could offer – glazed brick partition walls, wired glass in skylights, terrazzo floors, mahogany railings and balustrades, porcelain slipper baths and vintage green Pilkington Art Nouveau tiles. Additionally, it was lavishly decorated with mosaics and stained-glass windows.

The three 23m (75ft) long pools have their own entrances, which are clearly marked on the banded brick and terracotta façade. One entrance is for women, and the other two are for men, further sub-divided into first and second class, which is reflected in the grandeur of the premises and the cost of entry. In practice, the women's facilities in other baths were often noticeably smaller than the male facilities; however, in the Victoria Baths the women's bath was only 1.5m (5ft) less wide than the second-class men's bath. The Gala Bath, or the male first-class bath, is a 23m x 12m (75ft x 40ft) white basin with green tiles used to divide lanes and highlight edges. A skylight traverses the length of the basin along the ridge line of the roof, flooding the space with sunlight on a rare sunny Manchester day.

The Baths was an early adopter of mixed bathing – once a week on Sundays. This progressive attitude probably helped to create a large patronage for the institution, further helped of course by the generous sprinkling of slipper baths around the building, which were useful at the time when most houses were not equipped with bathrooms. The Baths closed in 1993 but in the three decades since, it has functioned as a thriving event space in the city, managed by a trust constituted of proactive volunteers. In 2003, viewers of BBC's *Restorations* voted for the Victoria Baths as the recipient of a Heritage Lottery Grant of £3m for the restoration of the Turkish Bath, which is underway.

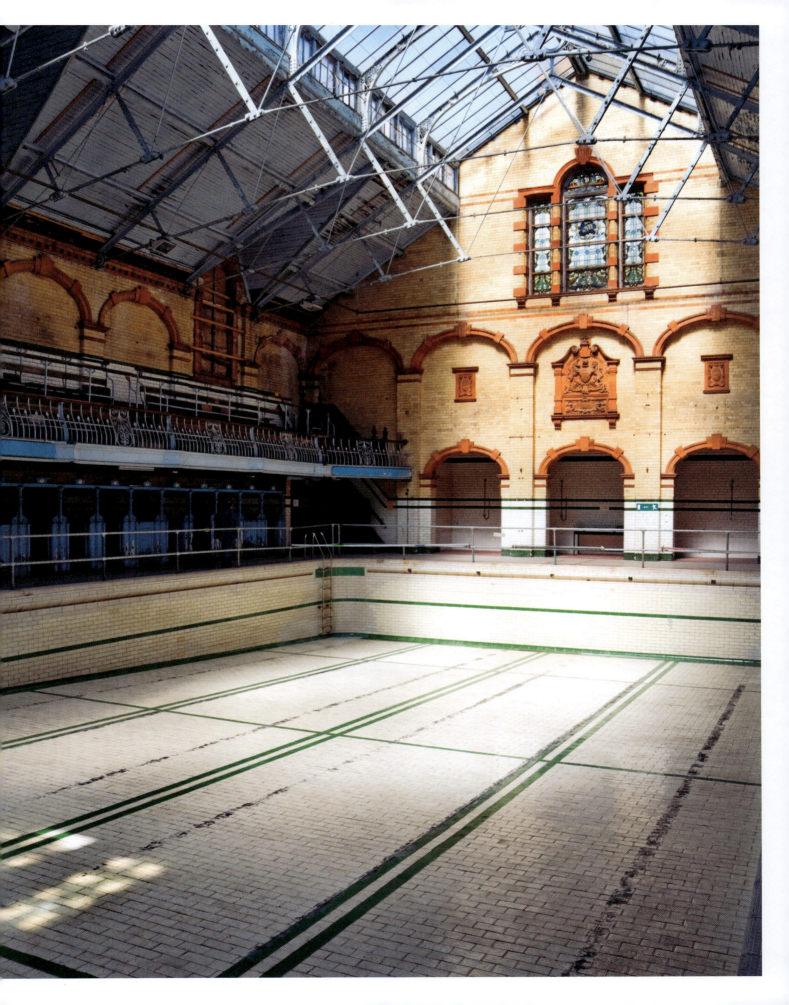

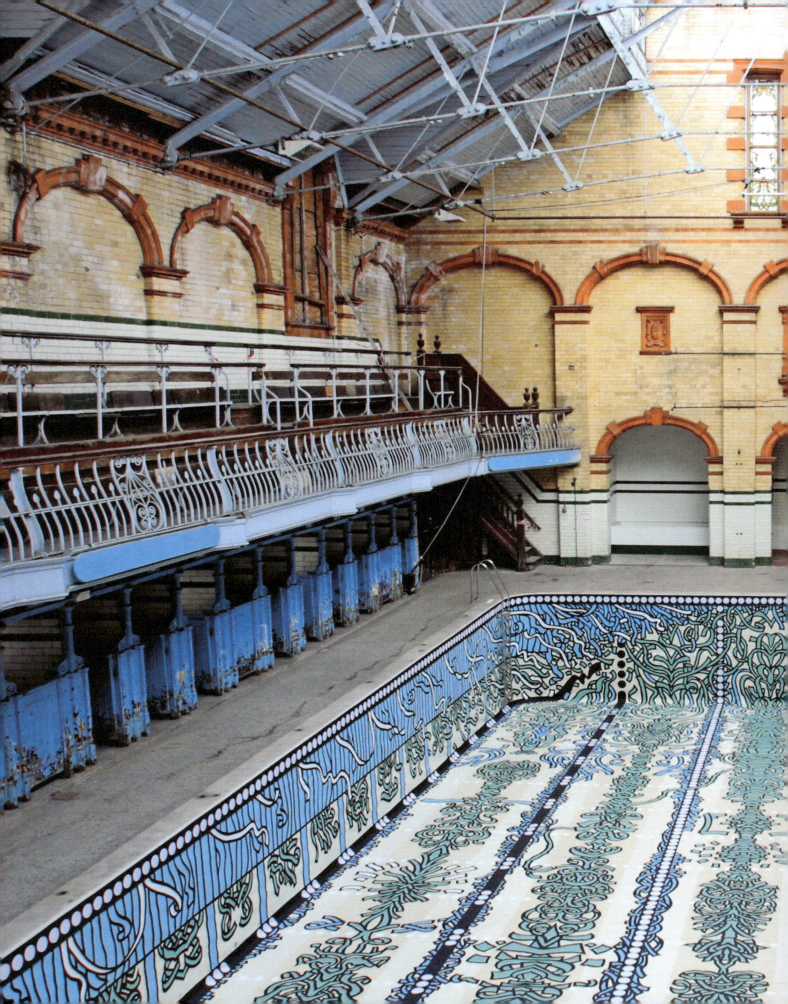

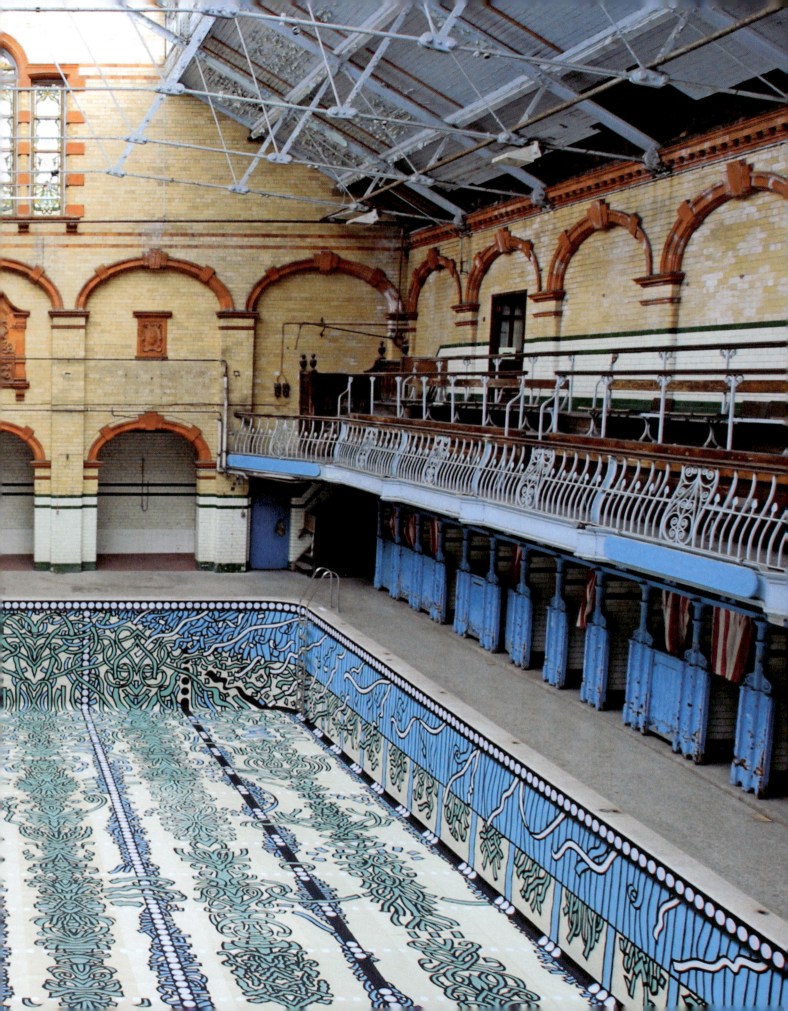

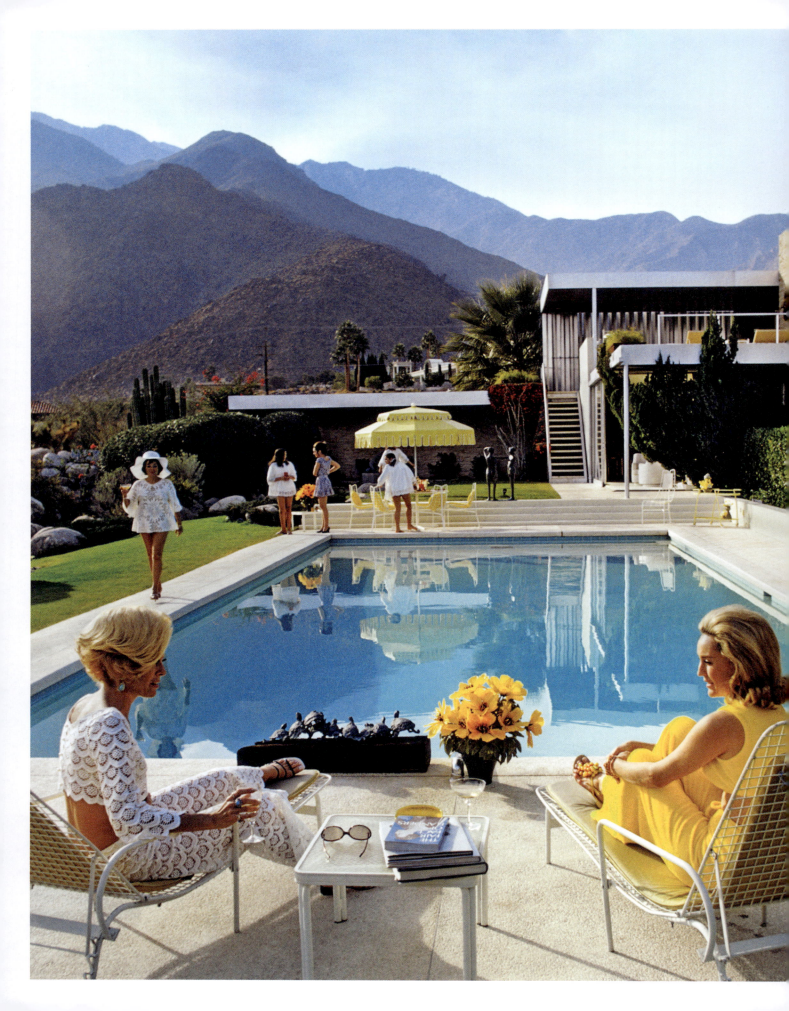

Kaufmann Desert House

470 West Vista Chino, Palm Springs, CA 92262, USA

Richard Neutra designed the 'desert' house in 1946–47 for Liliane and Edgar J. Kaufmann – a formidable power couple who owned a thriving department store in Pittsburgh. Frank Lloyd Wright had designed a weekend retreat – 'Fallingwater' in Bear Run, Pennsylvania – for them a decade earlier, and with this project they reiterated their commitment to the International Style in the United States. The couple entertained regularly. The desert house was designed as their holiday home, meant to be occupied for a few months in the year by them and their invited guests.

Neutra designed the house for the extreme weather of Palm Springs. The swimming pool was placed in the east, benefiting from the protection and beauty of the looming Mount San Jacinto in the west. It has a simple rectangular profile with an edge that stands out in a darker brown stone compared to the rest of the decking, which was heated and cooled with circulating water, so that it was comfortable in the bitter cold or scalding heat. Though Liliane Kaufmann was partial to 'Fallingwater', she loved to swim and was involved in the planting of the gardens. It is fitting that her presence in the house is immortalized in Julius Shulman's famous photo of the house, where she is hidden in plain sight – she appears back-lit and sphinx-like reclining beside the pool. When she was alive, it is possible that she felt unseen in this very house where her husband paraded his lover.

After Edgar's death, the house was bought by Nelda and Joseph Linsk, which resulted in another equally celebrated photograph by Slim Aarons titled 'Poolside Gossip' (opposite). Olivia Wilde, the director of *Don't Worry Darling*, observed that it was this very photograph that ultimately led to this modern masterpiece playing a seminal role in her film. Though the pool is private, it is nevertheless a celebrated icon of modern history etched in the collective imagination.

Tropicana Pool, Hollywood Roosevelt Hotel

7000 Hollywood Boulevard, Hollywood, Los Angeles, CA 90028, USA

It is rumoured that on a beautiful day in 1988, David Hockney came to the drained Tropicana Pool at the Roosevelt Hotel and, using blue paint and a paint brush attached to a broom, painted his famous blue comma graphic until it covered the entire basin of the pool. There was a drought in LA that year, which changed the fate of many pools in the city. Today this recently restored million-dollar Hockney mural lies underwater for the enjoyment of hotel guests.

The swimming pool was a motif that Hockney had dabbled with ever since his first trip to LA in 1963. The city was dotted with private swimming pools, beautiful bodies and sunshine. Furthermore, it was more accepting of homosexuality than his stifling British hometown. His paintings celebrated the masculine body and the gaze, as much as they celebrated the effects of light in water, which he captured in photographs to use as a reference for his paintings.

In the 1970s Hockney experimented with paper pulp as a medium, creating large tableaus, slowly developing the minimal graphic that would be seen in the Tropicana Pool. Hockney designed two posters – one for the troubled 1972 Munich Olympics and the other for the 1984 Los Angeles Olympics. The former portrays a diver about to enter the water, which is displayed using waves that were seen in the paper pulp paintings. The latter shows a swimmer doing the crawl with the movement of water captured as line waves and blue commas, similar to those seen on the bottom of the Tropicana Pool.

This pool is an artwork where the virtual and the real are intimately connected. On immersion, the movement of water is exaggerated by the painted basin. In effect, the representation of water interferes with and transforms the actual perception of water.

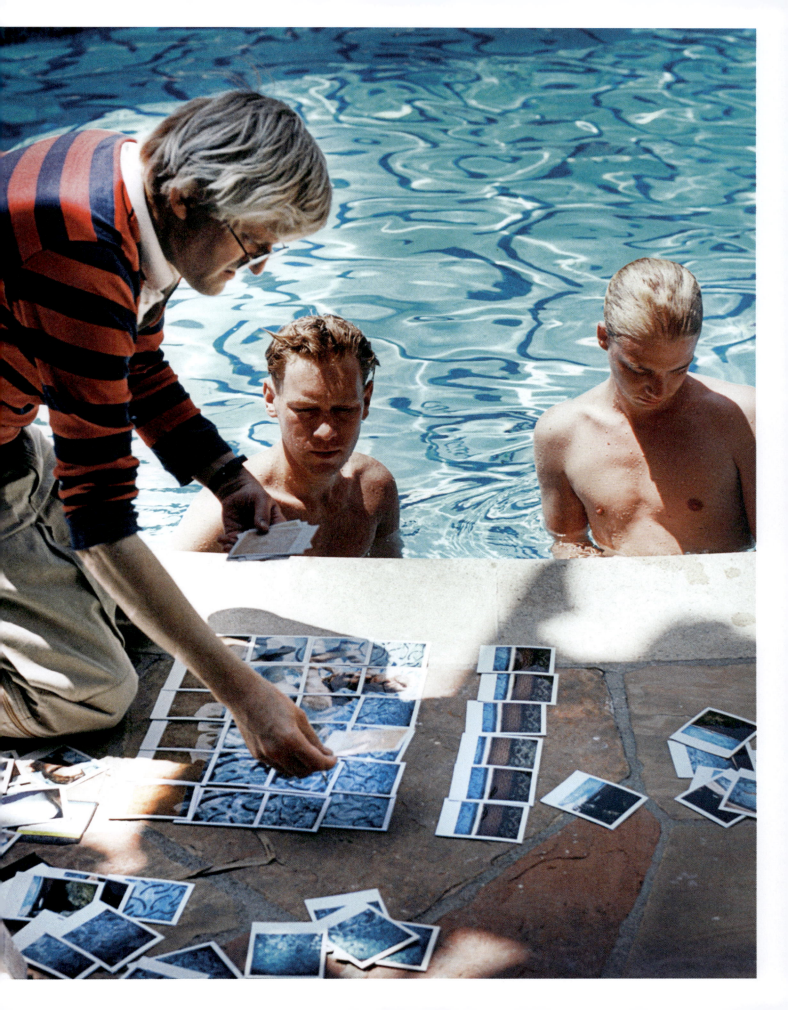

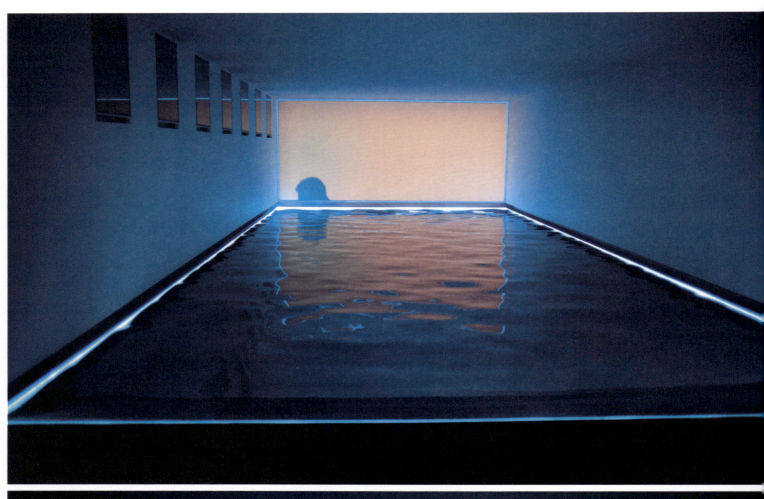
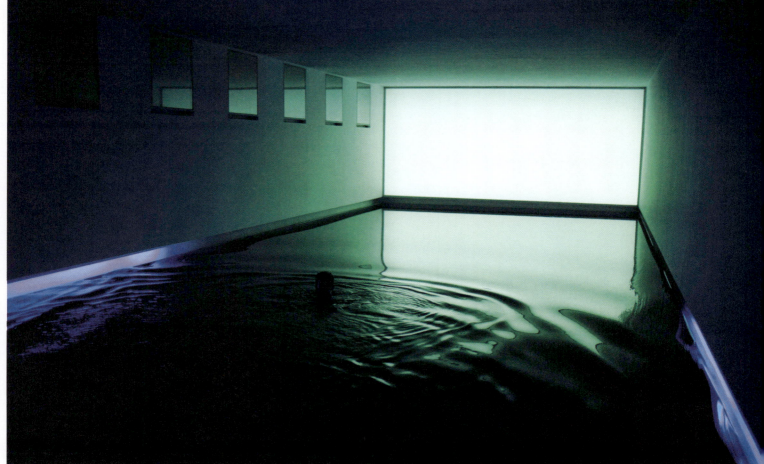

Bakers' Pool

Greenwich, CT, USA

Lisa Baker is the director and chief curator of the HBC Global Art Collection and, with her husband, shares an enviable art collection which includes a swimming pool designed by James Turrell, who is internationally renowned for his 'Skyspaces'. Turrell's work explores the interrelationship between perception, space and light. His 'Skyspaces' are architecturally scaled pavilions or follies that, as suggested by their name, call for a prolonged contemplation of the sky; however, his series of pools, which is relatively recent in his repertoire, blurs the line between art and architecture.

The Bakers' barn was designed by Roger Duffy and Walter Smith from SOM (Skidmore, Owings & Merrill) and is an accomplished piece of work built from salvaged building materials. It is a playhouse – a space for sport, physical culture and entertainment – that is typical of the architectural vocabulary of the wealthy in the United States since the 19th century. However, there is nothing typical about this swimming pool, which sits in a darkened room where a thin beam of light traces the edge of the water. The pool is 15m (49ft) long and as wide as the room. The wall at the far end glows dully and the lights are programmed to change colour to create different atmospheres. The water looks black and viscous as the light plays off it, bathing the room and the swimmer in an eerie glow.

Turrell's pools demand perceptual and physical immersion to engage with the work. In Heavy Water (1991) and Stone Sky (2007) viewers are asked to enter the water and submerge themselves before they can experience the 'Skyspace'. However, in the House of Light (2000) and the Bakers' Pool, or Water's Edge (2008), art and architecture meld into one another as the viewer-user bathes in light. While the Bakers' Pool is less accessible, the House of Light, to the contrary, is designed as a meditation centre in Japan that encourages visitors to stay for at least a night, for a price, to holistically engage with the work.

Swimming Pool, 21st Century Museum of Contemporary Art

1-chōme-2-1 Hirosaka, Kanazawa, Ishikawa 920-8509, Japan

Swimming Pool is installed in one of the courtyards of the 21st Century Museum of Contemporary Art in Kanazawa. On the face of it, the installation appears mundane – it is a pool that is inserted into the courtyard with a beautiful limestone edge detail. However, the complexity of the installation arises the minute those who are looking down into the water see people who are fully dressed, submerged underwater while standing and even walking on the floor of the pool – actions that one can instantly recognize as impossible. Those in the pool, on the other hand, not only see those above, but are captivated and bathed by the changing effects of light on water.

Leandro Erlich is an Argentinian artist known for work that makes spectators question what they are seeing. The artistry of this installation relies on the precision of the design of the water surface – a 10cm (4in) thick volume of water that is incessantly moving, sandwiched between two transparent planes of acrylic. Additionally, the pool is painted somewhere between a sky and an arctic blue to get the right shade of the water. Erlich originally conceived this work in the early 2000s when he visited the Duplex space of MoMA PS1 in New York; however, it took around a decade before he had the opportunity to display his installation there. The installation in Japan is an older version that dates from 2004.

There is a sense that Erlich's Swimming Pool alludes to David Hockney's painting *Portrait of an Artist* (1972). In Hockney's painting, a man is standing at the edge of a pool looking down at a swimmer who is patterned in light as it penetrates the water. Erlich's installation appears to re-enact the painting, allowing viewers to inhabit both the spaces.

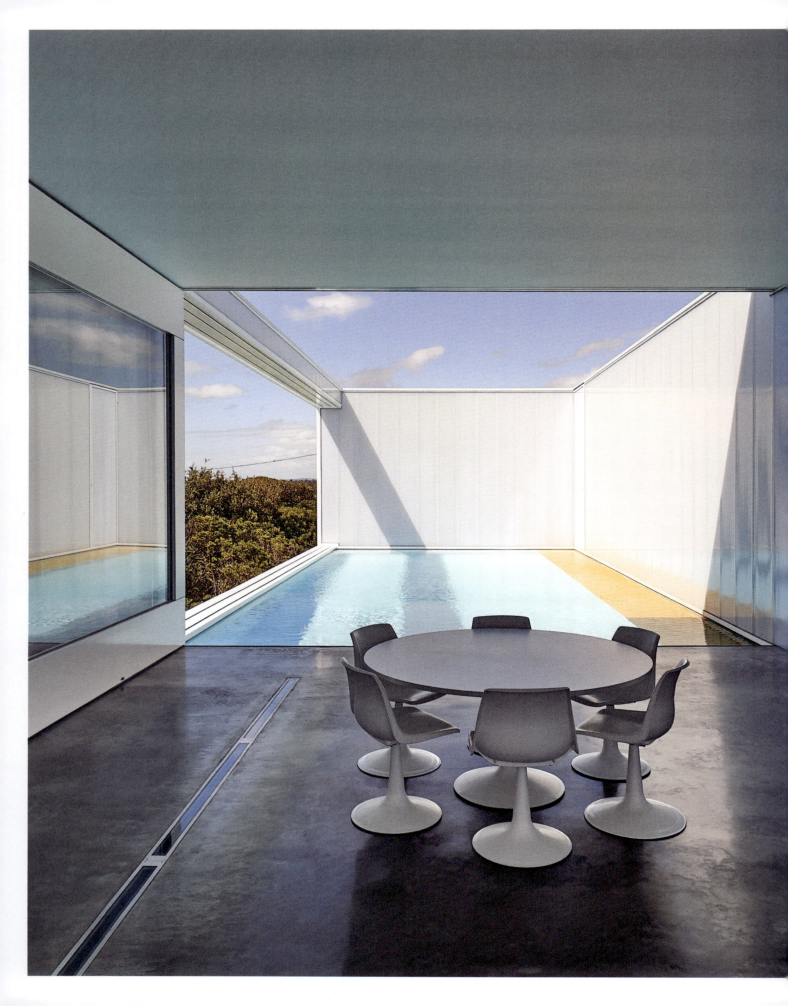

Villa Marittima

Ocean Drive
St Andrews Beach,
Victoria, Australia

Australian architect Robin Williams designed the Villa Marittima on Ocean Drive along the coast of the Bass Strait in Victoria's Mornington Peninsula for his partner Donald Cant and himself. Cant is an opera singer and the couple spend a considerable amount of time travelling for his performances. The villa is both a beach house and their permanent home. Williams took nearly a decade to complete the project and it displays an artistic preoccupation in the way that it acts more like an installation for contemplation of the light and the views. It is an atypical home – the bed floats in the centre of a ramped floor that flows from the entrance to the terrace – and demands a revision of preconceived ideas of lifestyle.

 The swimming pool sits outside on a terrace at one end of a rectilinear tube-like space that contains the living and dining room and the minimal kitchen. At the other end, there is a platform/balcony with ocean views. The glass doors to the balcony and the swimming pool are the entire width of the tube and, when opened, they can pivot 90 degrees to sit flush against a wall, thereby creating a seamless space that extends from the far end of the pool to the horizon. At sunset the light plays off the polycarbonate interior of the space, painting it in a gradation of rose-orange hues from the ocean towards the pool. Though open-to-sky, the pool is surrounded by high white walls. It occupies the entire space of the courtyard and is laid out such that its shallow end is furthest from the house. The only way to get to it is either by swimming across the pool or by walking on the floating yellow walkway. The deep end of the pool has a transparent wall and from the floor below one gets an aquarium-like view of swimmers' dangling legs and the rising section of the pool floor. At sunrise, one can imagine that the pool acts as a water lantern dispersing soft dappled light in the room below.

 Williams was inspired by the Laban Dance Centre designed by Herzog & de Meuron in the east end of London. Though the villa is private and cannot be accessed, the dance centre, on the other hand, has a café for public use where one can appreciate some of the material qualities that inspired Williams.

Repton Park

Virgin Active Repton Park, Repton Park, Manor Road, Woodford Green, IG8 8GN, England

Today Repton Park is a gated community preferred by footballers and actors, but in another life it was the Claybury Mental Hospital, designed by renowned English Victorian hospital architect George Thomas Hine. The grounds, when part of the Claybury Estate before it became a hospital, were planned by landscape architect Humphry Repton. There is a natural affinity between the architectures of segregation and those of seclusion.

The chapel that served the mentally unwell is used today as a temple for wellness in quite a different way. It was carefully restored to accommodate a swimming pool in the nave, and a jacuzzi and sauna in the apse. The rituals of immersion and cleansing acquire a different tone in this space. Stepping down the wide steps laid in between the columns to enter the pool from the aisles on either side of the nave feels less sporty and more spiritual. In contrast to the brightly lit nave and warm water, the aisles are in shadow and are lit by deeply recessed stained-glass lancet windows. The pool is tiled with 5cm x 5cm (2in x 2in) white tiles, with a band of ink-blue tiles mediating the water basin and the original flooring of the chapel. The edge of the basin disappears as the water surface shines a bright azure from the light from the clerestory stone traceried Gothic windows. The experience is ethereal, and even avid front crawlers are more likely to be swimming on their back or using the breaststroke with their head out of the water to better appreciate the soaring majesty of this unexpected space from this rare point of view, which is bound to be even more Gothic on a dark winter afternoon.

While the swimming pool is not easy to access, it is not impossible, either, as it is run by a standard health club chain in London. The effort has a sense of a pilgrimage befitting the destination.

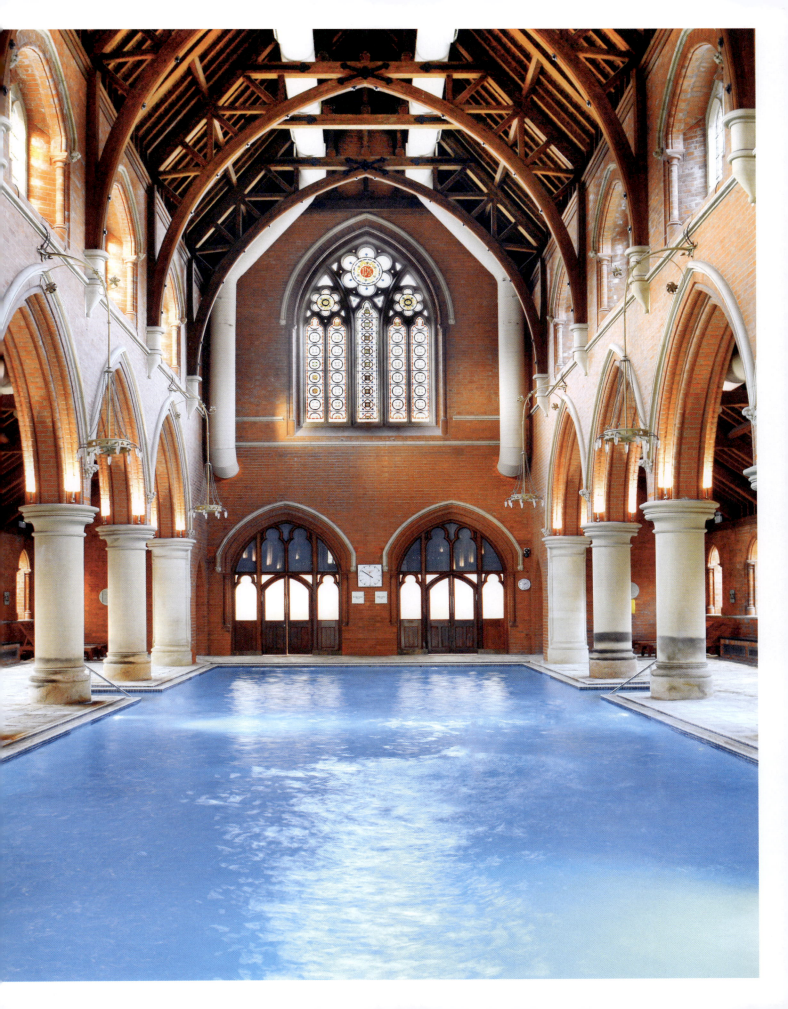

8

IN SUSPENSION

Villa Noailles

47 Montée de Noailles, Hyères, France

Robert Mallet-Stevens designed the Villa Noailles from 1925–33 as the winter home for the newlywed Charles and Marie-Laure de Noailles. The villa was an embodied canvas for modern art, design and architecture, establishing its owners as patrons of the arts. It was a playhouse for the French avant-gardes, akin to the mansions of the turn-of-the-century American industrialists, who contributed to the stories of the villa through their work and play.

The swimming hall was part of the villa's 400 square metre (4,300 square foot) sporting facilities, which included a squash court and a gymnasium and came equipped with a fitness instructor. Marie-Laure was absorbed with modern art; Charles, on the other hand, was obsessed with his body, and the Villa Noailles brought the two interests together. The monastic guest rooms, each with a private terrace, had striped swimsuits and exercise pants for their guests to use. The centrality of the sporting facilities in the life and art of the villa is documented in the movies by Jacques Manuel and Man Ray titled *Biceps et Bijoux* and *Les Mystères du Château de Dé*. The pool is small at 7m x 15m (23ft x 49ft); nevertheless, it was equipped with a diving board, a swing and a trapeze that celebrates the movement of the body in water and in air, which is momentarily captured in the mirror fitted on the shorter wall below the clock designed by Francis Jourdain. The surface of the water is further animated by its intricate ceiling – a series of concentric rotating rhomboids that are inserted with a grid of square perforations fitted with glass blocks.

After the death of Marie-Laure, Charles de Noailles left the villa to the city of Hyères. Following a lengthy restoration, the swimming hall was stripped of its equipment, and the basin was covered by a glass floor, thereby rendering the emptiness visible as part of the many fashion shows that grace the old swimming hall. The villa functions as a cultural centre with a roster of public events along four main trajectories: art and fashion, design, photography and architecture – a nod to the ambitions of the couple a century earlier.

Kursaal Piscina

Lungomare Lutazio Catulo, 36-40, 00122 Lido di Ostia RM, Italy

Pier Luigi Nervi was an architect-engineer whose work is within a lineage that spans from Filippo Brunelleschi to Frei Otto and, to some extent, more recently, Santiago Calatrava. Nervi's architectural practice was forged in the era between the wars when Italy was under the political leadership of Benito Mussolini. Rome has several noted architectural works that were commissioned under the fascist regime; however, while their problematic history is not forgotten, the buildings have been recognized as exceptional pieces of architectural endeavour. Nervi's work is notable for the beauty, efficiency and precision of his working process and structural aesthetic that can be compared to the beauty seen in natural forms.

The Kursaal bathing complex in Ostia, which is a suburb of Rome and an old port, was designed in 1950 by Attilio Lapadula in collaboration with Pier Luigi Nervi. Nervi's structural expression can be experienced in the restaurant-bar and the *trampolino* (diving structure) that abuts the 50m (164ft) long rectangular saltwater pool faced with deep-azure tiles. The diving structure is a vertical circle held taut by two symmetrical bow-shaped members that together support diving boards at different heights, ranging from 1m (3ft) to 10m (33ft), along with staircases leading to each of the diving boards. The whole ensemble reads as a unified object. Different elements of the ensemble are painted either an orange-red, white or pale blue that distinguishes the structure clearly against the blue of the Mediterranean sky and sea beyond and the pool below. The *trampolino* casts a signature shadow on the otherwise simple rectangular pool, acting like an enormous logo – from a distance it reads as the initials O and K to refer to the establishment – and in fact, the form of the diving board has been adapted as the graphic for the establishment.

It is one of the few diving structures of the 20th century that is still in use, even if it has been rebuilt relatively true to the original.

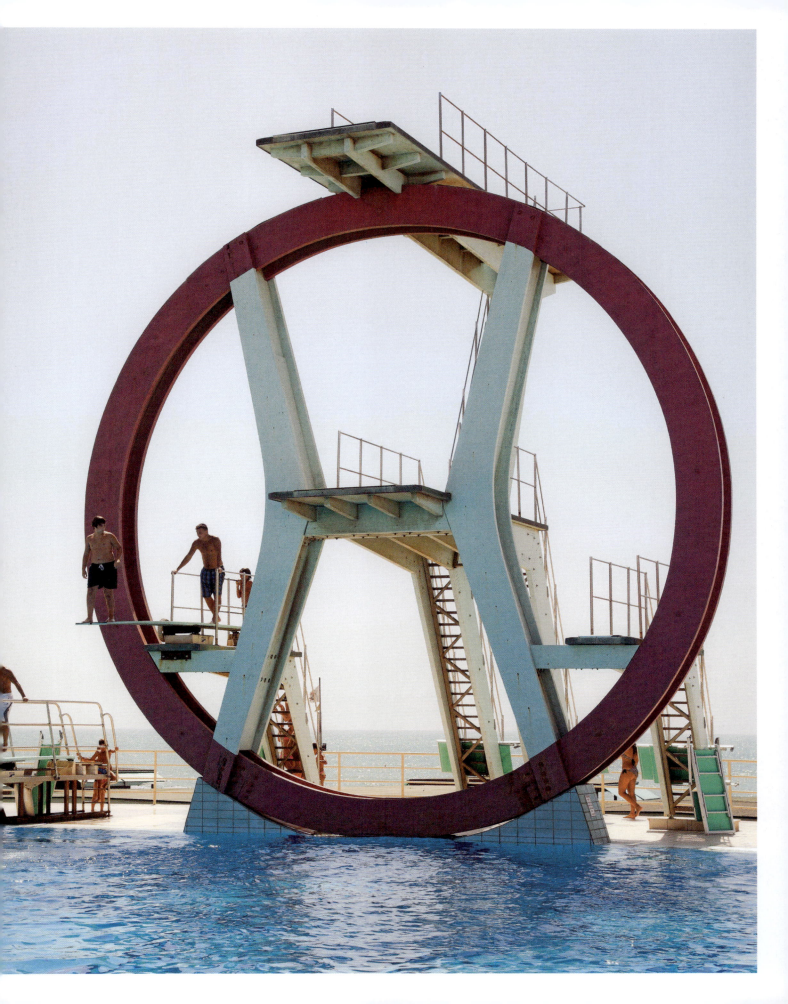

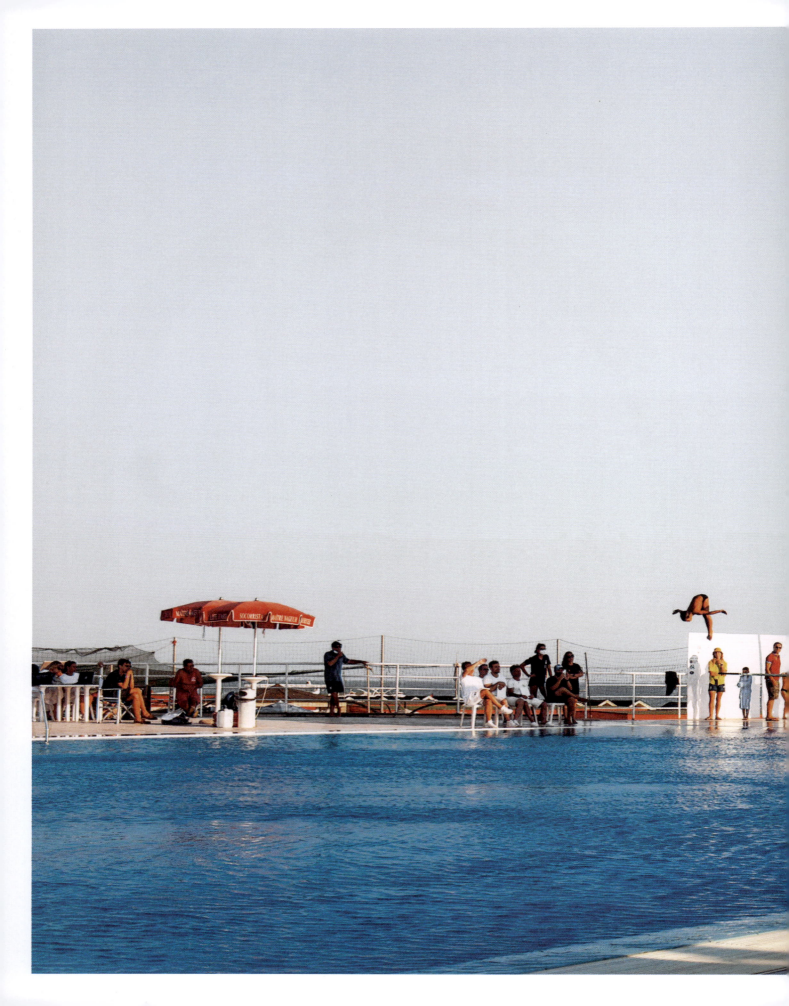

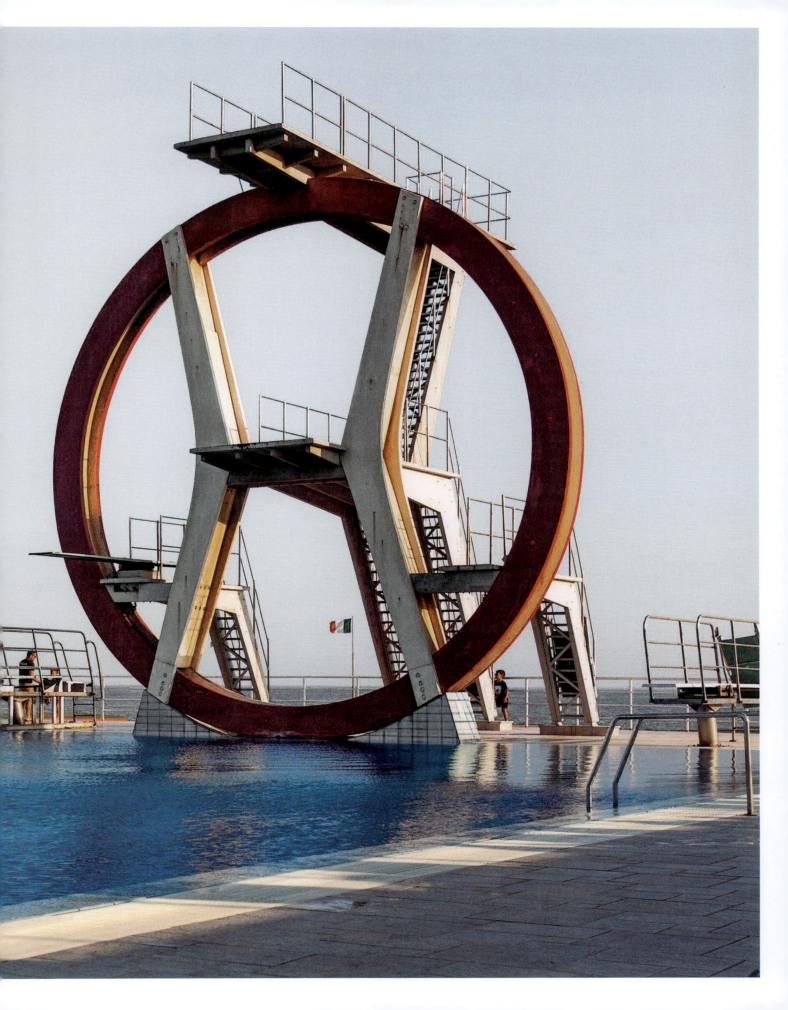

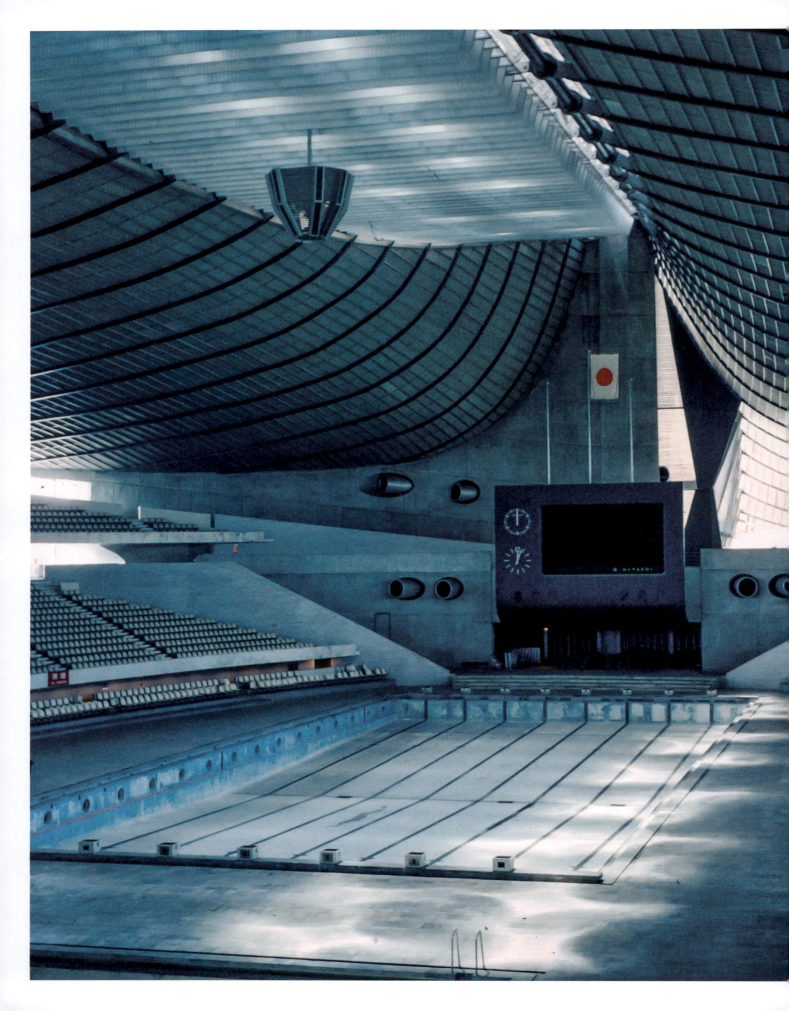

Yoyogi National Gymnasiums

2-chōme-1-1 Jinnan, Shibuya City, Tokyo 150-0041, Japan

The Yoyogi National Gymnasiums were designed by Kenzō Tange for the 1964 Olympics in Tokyo. Tange was the force behind the post-war Metabolist movement that harnessed the power of architecture towards creating a vision, identity and programme for modern architecture in the country. It is one of the more radical movements, comparable to that of the Soviet avant-gardes in the first half of the 20th century. Yoyogi propelled a new role for stadium architecture in the Olympics repertoire – as a symbol of national pride, a feat of engineering-architecture and as an icon for the games.

The two gymnasiums share a vocabulary but are designed as two individual statement pieces within the complex. Gymnasium number 1 hosted the swimming competitions and was planned as two commas that have their tips facing different directions, which adds to the dynamism of the plan while also lending to the symmetrical planning of entrances on either side of the building. The spectator seating is arranged longitudinally in the space and every seat enjoys an unobstructed total view of the two 50m (164ft) long swimming pools that lie along the central axis of the gymnasium. The suspension roofs over each of the commas meet in the centre, separated by a catenary curve that bifurcates the interior space with a skylight that washes over the two pools, which was what probably compelled one American athlete poised on the diving boards to observe that he felt that he was in heaven. The upward sweep of the roof cables, the rising curves of the raking, the fins of the skylights and the tapering forms of the diving boards come together in a three-dimensional pattern of lines, movement and force.

In 2021, during the Covid-19 pandemic, Tokyo hosted a spectator-less Olympics. Paul Noritaka Tange, the son of Kenzō Tange, was awarded the commission for the new aquatic centre where greater care was spent on energy-efficient heating solutions than on spectacular architecture. This heralded a new direction for the Olympics; in Paris 2024 the stress was on renewal and re-use of buildings.

Villa Capeillères

France
(private residence)

Alain Capeillères' pool is a gem hidden in plain sight. Capeillères is a lesser known figure in architecture and designed this pool for his wife, Lucie. In the 1970s the pool, which sits in a private park, was accessible to the local inhabitants of the area. Capeillères was certainly not averse to having his pool photographed and invited Martine Franck to photograph it when she was working in the South of France. Franck had been commissioned by the Fondation Nationale de la Photographie to contribute to a series about the French during holidays to document the legacy of the Matignon Accord of 1936, which saw the start of paid holidays in the country.

The pool is visible on Google Maps – its white decking covers a substantial area that stands out in its otherworldliness from the natural vegetation of the area. It is rumoured that Alain used 128,000 tiles for the project, each measuring 15cm x 15cm (6in x 6in), separated by 3mm (⅛in) black grouting. The grid acts as a canvas for sharp shadows and lounging brown bodies in the bright Mediterranean sun. The swimming pool is 25m x 12.5m (82ft x 41ft) and is equipped with starter blocks and a recessed diving platform that frames the body, not unlike a lens, for a moment before it is lost to the water. The project celebrates the body – in rest and in motion – and uses subtle cues to guide it. Some parts of the decking are tiled with only the smooth white tiles, while other parts are interspersed with rough grey tiles, thereby delineating spaces suitable for leisure and others, more for exercise.

More recently, Jacquemus, the French brand, used this swimming pool as the setting for their Autumn 2023 collection 'Le Soir', where the white tiles act as a neutral to beautiful tanned and black bodies, almost in dialogue with Franck's photographs decades earlier.

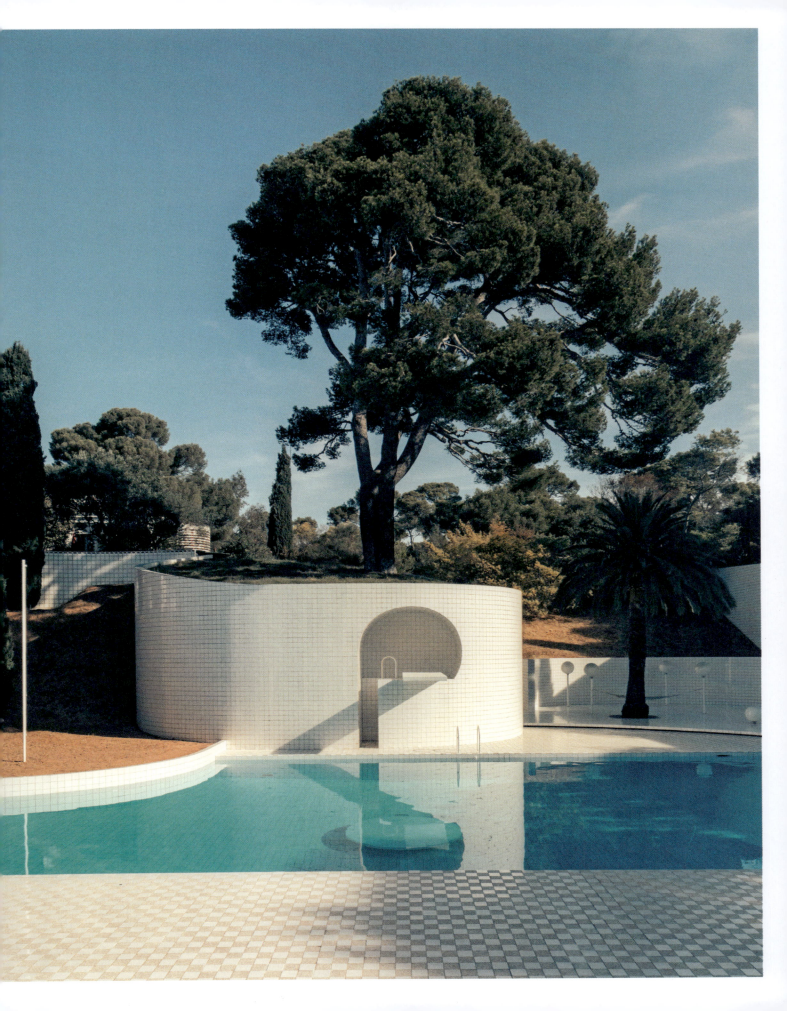

Domestic Monument

Mathilde Redouté

In France today there is currently one private swimming pool for every 20 people, bringing the tally up to 3.4 million *piscines privées* across the country, placing France at the highest rate of pool ownership in the world. This result is partly due to the persuasive marketing strategy of the brand Desjoyaux to democratize this object by targeting the middle classes. The accumulation of artificial abundance is perverse in an environment where resource scarcity is a reality on a seasonal basis. The pool is thus controversially perceived as a sign of both wealth and waste, leading the French newspaper *Le Parisien* to attempt to dissipate its symbolic content by arguing that France's entire stock of private swimming pools uses 'only' 0.15 per cent of the country's water consumption. This number, which assumes that the water in the pool is renewed once every five years, led them to conclude that a swimming pool requires virtually no water. The rhetoric evokes an emptiness. Even the French singer Serge Lama would sing that 'People in private swimming pools, are depriving themselves of the sea, depriving themselves of France, (…) depriving themselves of hope'. The disconnection between the growing numbers of private pools and the way that they are perceived in the public consciousness begs the question: why are they still the centre of private fantasy?

The answer might have to do with the notion of order, or 'control over the uncontrollable', as Joan Didion wrote in her essay 'Holy Water' in 1977. The object of a pool became the reification of a tangible manifestation of a force that only quite recently became controllable. A pool is a chance to assert domination over nature; a sanctuary that soothes the Western eye. That could also explain why mainland French citizens still feel the need to privately possess water, even though we have free access to 17,659km (10,973 miles) of public coastline. I must shamefully confess that I also am in this position, enjoying the peaceful dip in the pool that follows the salty one at sea. In fact, there's something distinctly French about the notion of immersion, not just in language, but in the way we perceive our environment. Following French Existentialism philosophers such as Jean-Paul Sartre and Maurice Merleau-Ponty, this concept encompassed the visceral engagement and construction of the self with the material world that goes beyond mere intellectual contemplation, and defines our sensible relationship to the built reality, and ultimately ourselves. It's as if we are perpetually playing with the world around us, constantly blurring the lines between the tangible and the ephemeral, to question the limits of our environment, and our body. When it comes to giving

shape to the paradoxical realities of our symbolic and material existence, the Alain Capeillères swimming pool, a private grid-based landscape facing the Mediterranean, perfectly captures this ambiguous geometry of life, where abstraction meets bodies, where fluidity takes shape, where the horizon lies at our feet – a place where the surface tells a story that runs much deeper. To explore it, I was lucky to interview the architect Sébastien Martinez Barat, who co-curated an exhibition called 'Domestic Pools' and I visited the exhibition twice to meet the architect. This essay is based on his memories, with details provided by others, including an article that was published in *Domus* magazine and a foreword written by John Berger for Martine Franck's *One Day to the Next*.

Son of antique dealers, Alain Capeillères fell in love with architecture the day he fell in love with his wife, an opera singer, heir to Rothschild. At that time, he was living in Marseille, and she came to visit him to ask if he could redecorate her house in Brussels. But she never went back to Belgium. Instead, they started looking for a place to stay in the South of France. Being from Greece, she found in the enchanting backdrop of Six-Fours-les-Plages an arid and wild resemblance to her country of origin. Together, they bought a 3 hectare (7½ acre) property, with an existing – and according to her, ugly – house of 600 square metres (6,500 square feet), facing the Mediterranean. The first action of Alain Capeillères was, however, not on the building, but on the garden, and more precisely on the World War II bunker located at the bottom of his field. In 1972, he blew it up. This explosive gesture had the twofold effect of quickly announcing his presence to the neighbourhood, with a concrete jet that rained down on the surrounding houses, and excavating a big portion of the ground. This performance also marked the starting point of the first and most well-known project of Alain Capeillères. His own pool. His personal dream.

For a reverie to gather enough constancy to produce a constructed work, so that it is not simply the vacancy of a fleeting hour, it must find its materiality. The one that gives the vision its own substance, its own rule, its specific poetics. For architect-in-the-making Alain Capeillères, it was the 15cm x 15cm (6in x 6in) white tiles. He, in fact, bought the whole stock of ceramic pieces produced by the English firm H&R Johnson to make sure that every broken piece could be replaced over time, so that his idea would last. He ended up with a collection of more than 100,000 white square tiles. Having achieved this second remarkable performance, he could start the project. With the same

affection that Marcel Proust describes Vermeer's small section of yellow wall, Capeillères crafted his domestic landscape, carefully placing ceramic tile after ceramic tile, leaving a hollow joint between each square of earthenware. This void – which is not bigger than a few millimetres – is the most important entity of the pool. It is the constructive imperfection that allows each tile to have a reflection of its own. All the same, they all behave individually, creating a shiny grid of infinite reverberation.

But this architectural mirage wasn't just a swimming pool; it was an open-air building, a chirurgical tapestry crafted from Capeillères' wildest obsession. Not one tile had to be cut. Every element placed on the ground must have completed the others, in the most perfect, and rigid, way. The tiling landscape was thus composed with a symphony of objects; adjacent to a retaining wall, in which the changing rooms and designed machinery are located, is the pool house. The P-shaped sculpture, dug into the vertical thickness of the garden earth, crowned with a tree, holds the diving board. From the top, suspended in the air, a few metres above water, the sparkling of the ceramic merges with the sun's reflections on the waves. There, with the broadest view on a sunny day, it is impossible to define precisely where the pool, the sea and the sky meet. They become a whole, the simplest, the freest in appearance, the most changeable in the entire extent of their immense unity, and yet those most similar to themselves; the most visibly forced to return, when the sun hides behind the cloud, to the same states of calm and torment, confusion and formal limpidity. It is at this moment that the vision of the architect really takes shape – when the poetic architecture descends deep enough into the germ of being, to find the solid constancy and beautiful monotony of the tiles. This project, which takes its strength from the absolute action of a substantial material, both flourishes and adorns itself, to embody the exuberances of a gridded beauty.

The scale of the project knew no bounds – it defied visible limits, and the code of a private property. Enveloping the rectangular Olympic-sized pool, the initial curved terraces offered a sweeping vista of the boundless ocean, adorned with spherical lampposts. The only difference with the ones that can be found in the streets, which is a detail imperceptible in photography, lies in the adjustable height of each one. Hanging from one of them, a hammock sways gently in the breeze, gazing out towards the vast expanse of the sea. Nearby, a series of starting blocks are discreetly placed along the pool's

edge, eagerly awaiting prospective competitors. These meticulously designed components, right down to the pristine white tiles, drew inspiration from traditional aesthetics of public swimming pools. In that case, form follows function. According to the architect Sébastien Martinez Barat, the garden of the house was open to all: neighbours, tourists, friends, even the curious anonymous arriving from the sea. Everyone was welcome to enjoy this crafted landscape, transcending the realm of the ordinary, and holidays. The ultimate embodiment of private fantasies and shared memories. An immersive folie.

This is how, in 1976, Martine Franck discovered this place. At the time, she had been commissioned by Magnum to produce a photographic study on French holidays. When wandering in the south of the country, she found herself captivated by this hedonistic project. Painfully shy, positioning herself as a witness of the world, she already had a deep connection to landscape, fostered during her childhood in the Arizona desert. A place qualified by the writer John Berger as 'the end of the earth', a place where you cannot go any further. A strong ski racer, she confessed her steadfast connection to solid ground. Despite her extensive portfolio of coastal photography, she never could conquer her fear of the sea, this 'unpredictable' element. Her affinity for arid landscapes, a sentiment shared with Capeillères' wife, and her fear of unexpected situations, could be read as an anticipation, a 'leap ahead', in Berger's analysis of her work, crafting her path to discover the white pool. Across the years, she remained an intrepid seeker, bravely courting the unforeseen, like an adventurer finally daring to capture those impending moments, seeing the beauty everywhere.

Her picture of Alain Capeillères' pool embodies this sense of marvelling. The weary silhouettes in the sun stand out against the white, squared-off surface of the poolside. In the foreground, an adolescent, seen from behind, reclines in a hammock, an oasis of tranquility amid the pool's vibrant commotion. In the heart of the scene, a woman lies with her head gently inclined towards her partner, engaged in graceful gymnastics. In the background, two children appear suspended in their playful antics, seemingly defying gravity on the swaying surface of another hammock. Within this frame, the pool's water nearly vanishes, retreating into the distance. Only an inflatable seat evokes the pop culture of the era. The black and white photograph is dominated by a grid, which is so present that it contradictorily becomes abstract, fading into

the background in favour of the formal beauty of the bare and bronzed bodies. The heat appears all-encompassing, with the midday sun, slightly westward facing, accentuating the dance of shadows on the tiled canvas. Everything here seems within reach, a triumph of the corporeal over the material, the transient over the substantial. As Martine Franck stated, 'It wasn't only the French who were on holiday, but France itself.'

The cliché, a perfect synthesis of the utopian and futuristic images that were driving European architecture at the time, is effortlessly reminiscent of those of its neighbours, the Italian radicals such as Superstudio. Three years earlier, in 1969, the Florentine group of young architects had imagined a continuous monument, taking the shape of a mega structure encompassing 'things, the body, the Earth', before dissolving all materiality. This anticipation of an absolute world stood as an exorcism against confusion and superfluous consumption, a myth, however, personified by the symbol of the swimming pool, the ultimate embodiment of the capitalist way of life. Despite this paradox, it is astonishing to observe that Alain Capeillères' work shares with them the aesthetic of repetition. According to MBL Architects, while Capeillères never explicitly aligned himself with any group, it's worth noting that this erudite yet not fully fledged architect was likely attuned to the neighbouring European movements. This assumption was reinforced by their visits to his studios in Marseille and Brussels, where several magazines, such as *Domus* and *Casabella*, bore the images of the Italians.

This masterpiece, gradually forgotten following the death of the architect's wife, has been rediscovered by the astute curiosity of Sébastien Martinez Barat and Benjamin Lafore. This dynamic duo of French architects, who champion architecture as investigation, eclecticism over style and enthusiasm after doubt, have also been working for several years with the Villa Noailles (see page 175). This art centre, designed by the architect Mallet-Stevens for the family of collectors of the same name, is in Hyères, South of France. As part of the exhibition 'Domestic Pools', the architects, fascinated by this photograph by Martine Franck, embarked on a journey to rediscover the architectural gem. After a quick analysis of the title of the photograph, 'Le Busc, 1976', and a swift Google Map search in which a large pixelated white spot quickly appeared at the indicated location, they rang the doorbell of the estate. They were greeted by Ildeu, the barefoot guardian of the place, who drove them in

a Renault 4L through a grove of majestic pines to the main residence. There, they found Alain Capeillères, surprised but delighted to be able to share his project. The initial visit was followed by a second one for a proper swim, this time accompanied by the Villa Noailles team and photographer Romain Laprade, commissioned for the occasion. His colour photographs, shown in this section, bear testimony to the enduring poetry of this remarkable place, where nothing had technically changed, apart from this truncated palm tree. But the pool, now bereft of its throngs, had become a sanctuary of solitude, where the elements' shadows linger, and the proprietor's rhythmic presence alone enlivens its depths.

From the roaring seventies' daily life of the pool, there resides only the original cliché by Martine Franck, under which we can mischievously read: 'To Alain Capeillères, who gave me this image'. For them both, this pool marked the genesis of their creative journeys, bearing the weight of dreams, aspirations and boundless potential. The picture embodied the infinite instant when these two complementary forces merged to shape a sense of marvelling. A tense future, as John Berger would say. A hydrant psyche, in Gaston Bachelard's words. As in his 'Material Imagination', this encounter, between the one that gives life to the formal cause and the one that gives life to the material one, still retains a ballast, a density, a slowness, a germination, carried through emotion.

Between illusion and immersion, pools represent the place of all the fantasies. Dependent, yet detached from the external world, their functions are as diverse as their shape. Far from the common misapprehension of this artefact as a trapping of affluence, real or pretended, and of a kind of hedonistic attention to the body, Alain Capeillères' pool is freeing its environment. As a trace of a past, it has marked its time but also the present and the future, by carrying an emotional charge. In that sense, the architect's pool is a domestic monument. Timeless, infinite, formal, functional and perpetual in its essence, the gridded pool, empty of its inhabitants, is now serving its most absolute purpose: a place of all possibilities.

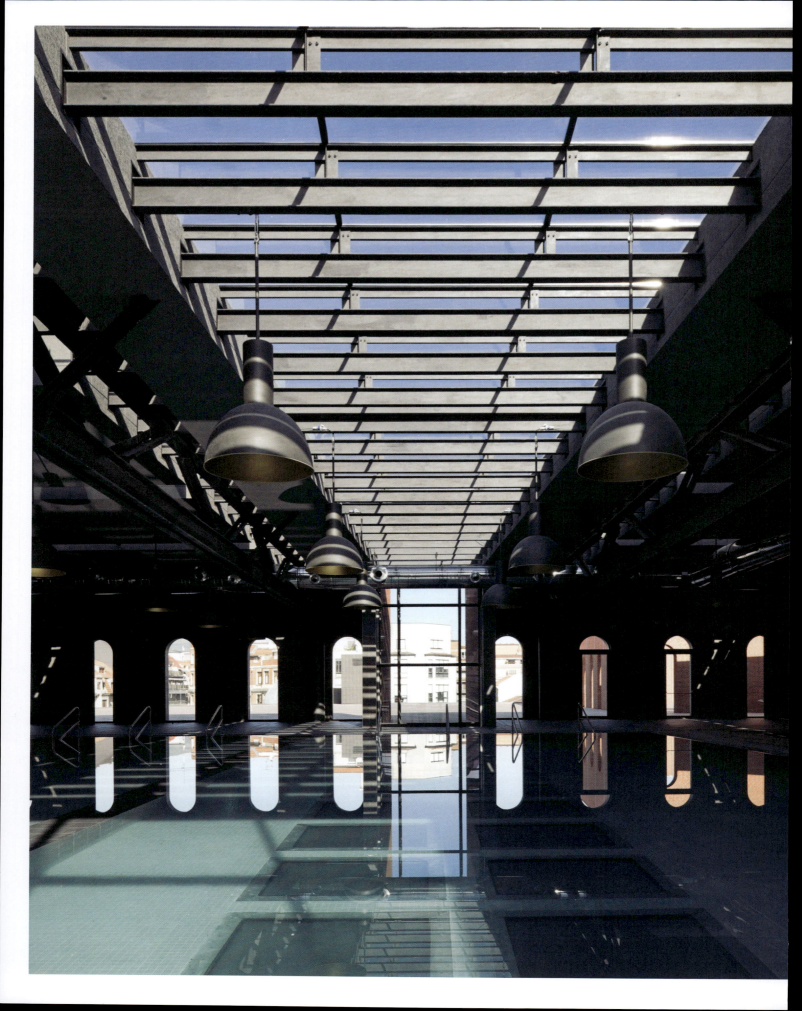

Azkuna Zentroa
(Alhóndiga Cultural and Leisure Centre)

Arriquíbar Plaza, 4, 48010, Bilbao, Spain

Philippe Starck, the architect-designer, was commissioned to design this project as a centre with three interlinked themes – knowledge, well-being and health. This is one of the few Starck projects that is public in nature. The new buildings sit in an older block designed in 1905 by Ricardo Bastida, a preeminent Basque architect, to house wine, oil and pickles. Bastida's architecture is a graceful brick, concrete and steel synthesis of modern architecture with Basque flourishes. The original building both retains its exterior presence and exerts its influence on the new interventions; however, Starck's additions, while responding to the older structure, do so in his characteristic humorous manner, generating spaces that are playful and engaging.

The swimming pool is on the top floor and opens onto a lavish sun terrace through slender stilted arches that resonate with the original building. The arches continue along the other walls in the interior of the swimming hall and are either fitted with doors or with mirrors, contributing to surprise in the space. The swim hall is stark and appears more horizontal than vertical. The ceiling is populated with exposed beams, glazing, industrial pendant lights and silver ducts that respond to and visually interfere with the lines under and on the surface of the water, creating patterns that change with the light. One of the lanes of the two pools is designed like a magic lantern with a glazed ribbed ceiling and a complementary gridded glazed floor that projects swimming silhouettes to animate the entrance atrium below.

The Azkuna Zentroa lies on the same axis as the glistening titanium-clad Guggenheim Museum designed by Frank Gehry, which propelled Bilbao to instant fame. However, this project, unlike the museum, which was about attracting tourist revenue, is focused on the people of the city. It was awarded the Urban Land Institute's Global Award for Excellence in 2017 for its contribution towards creating a thriving sustainable community.

Sky Pool at Embassy Gardens

3 Viaduct Gardens,
Nine Elms,
London,
SW11 7AY,
England

The Sky Pool by HAL Architects, which was engineered by Eckersley O'Callaghan Architects as part of the EcoWorld Ballymore development, is a feat of engineering-design that essentially lifts a shark aquarium up in the air, bridging two buildings. It inverts the traditional idea of a pool as an interior object that rests on the ground by exposing the pool and its inhabitant, the swimmer, to the public gaze suspended between the city and the sky. The 20cm (8in) thick acrylic frame has the added benefit of having a refractive index similar to water, thereby reducing the amount that light distorts as it passes through nearly 3m (10ft) of water and a 30cm (12in) thick acrylic base, contributing the desired transparency of the pool and, surely, amplifying the drama of suspension that a swimmer feels while in the pool.

The façades of the two ten-storey buildings are clad with a dark green glazed tile in two lengths that are laid in a staggered manner with white joints. The moist look of the tile, its size and the laying pattern creates a sense of an undulating texture almost like a basket weave. The shadows cast by the pool animate this face further as the sun arcs across the summer sky. The sky-blue hovering aquarium is clearly reflected on the face of the buildings and participates in the drama of the interiors of the apartments through the two windows on these faces.

The buildings are connected by two more bridges – one runs parallel to the pool at rooftop level and the other runs closer to the ground below the pool, leading to a composition that sensitively frames the US Embassy, which was recently relocated to the area. However, the development is less considerate of its less wealthy neighbours – the plans of the area are unequivocally designed to segregate and divide predicated on wealth. It is questionable if the exclusivity of the experience adds to its value or in fact diminishes it, simply because it is so unattainable.

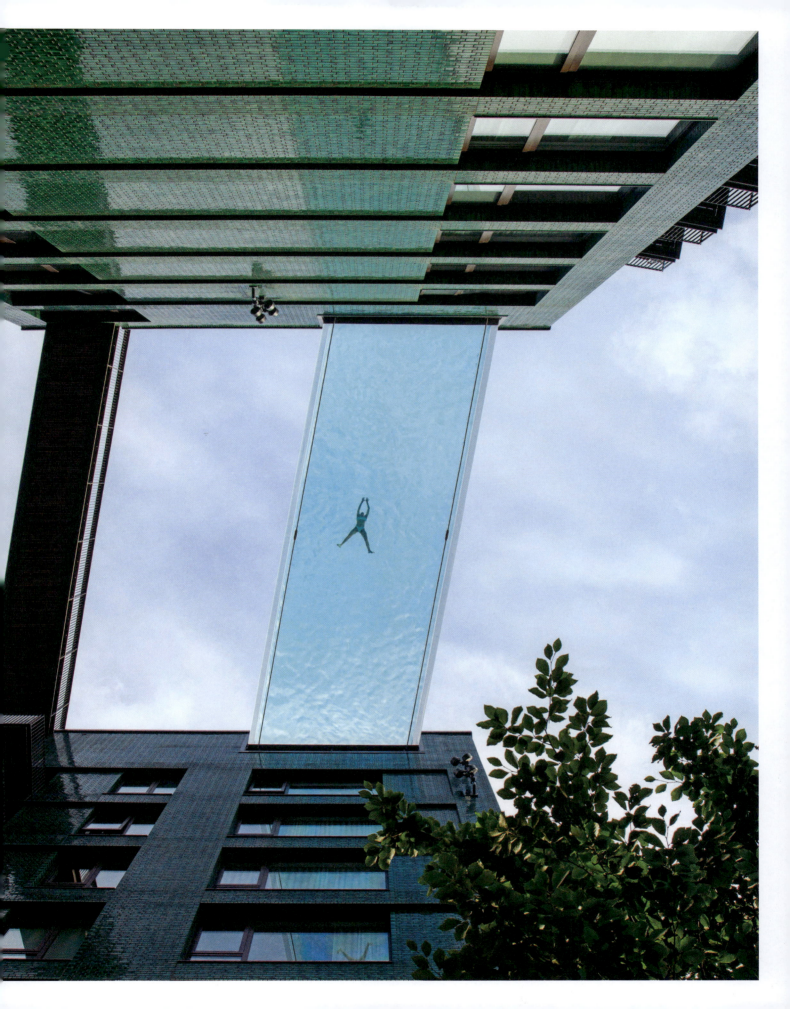

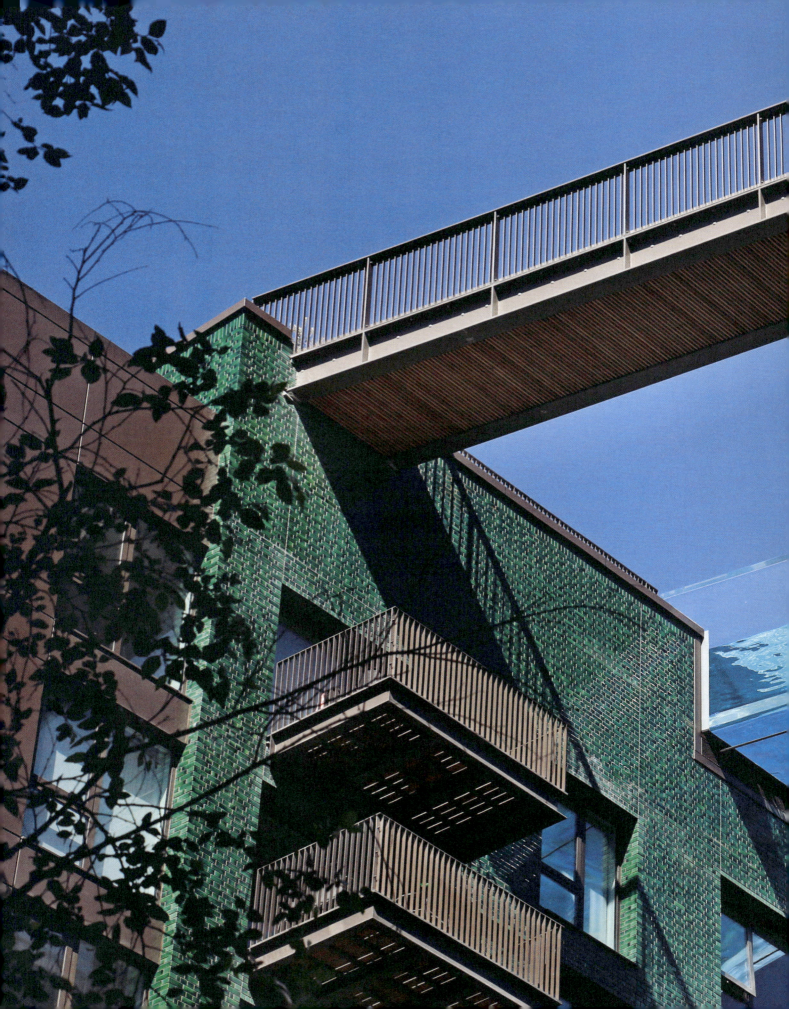

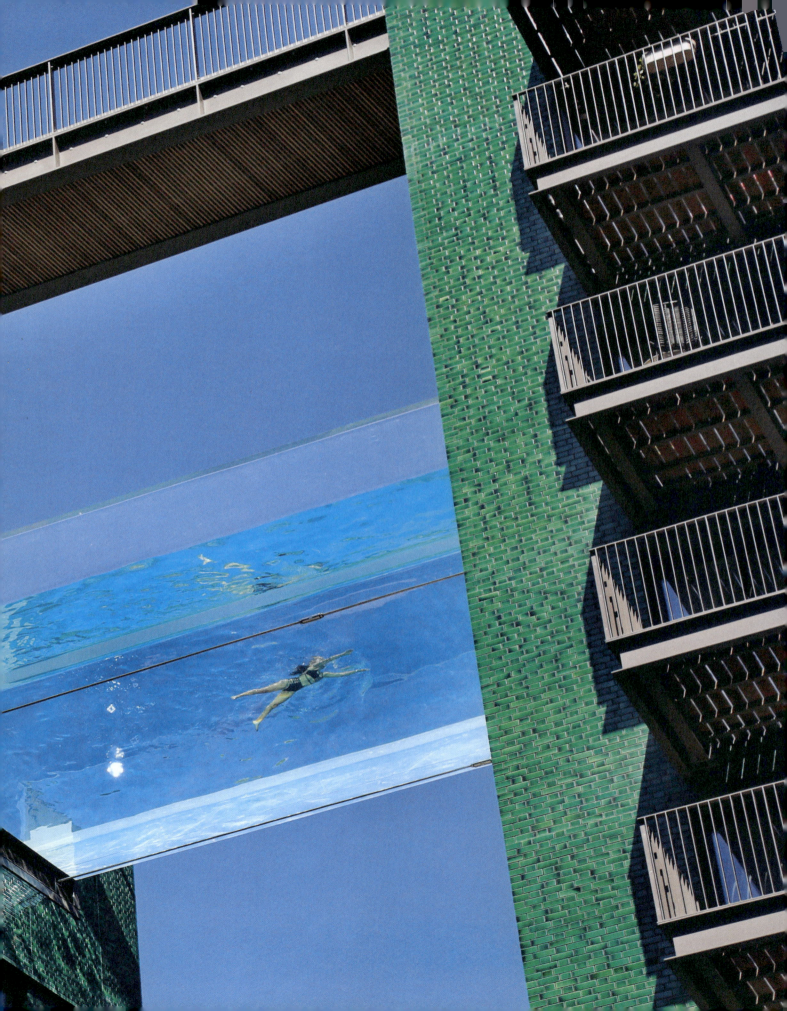

Where to find the pools

Australia
Centenary Pool (page 50)
Villa Marittima (page 168)

Brazil
Casa das Canoas (page 146)

Canada
Borden Natural Swimming Pool (page 120)

China
The National Aquatic Centre (The Water Cube) (page 54)

Denmark
Badeanstalten Spanien (page 14)
Kastrup Sea Bath (page 116)

England
Kenwood Ladies' Pond (page 108)
London Aquatics Centre (page 56)
Parliament Hill Fields Lido (page 24)
Penguin Pool (page 126)
Repton Park (page 170)
Sky Pool at Embassy Gardens (page 194)
Thermae Bath Spa (page 76)
Victoria Baths (page 154)

Finland
Villa Mairea (page 130)

France
Les Bain des Docks (page 32)
Paddling Pool, Unité d'Habitation (page 28)
Piscine Pontoise (page 22)
Tournesol swimming pools (page 30)
Villa Capeillères (page 182)
Villa dall'Ava (page 64)
Villa Noailles (page 174)

Hungary
Alfréd Hajós National Swimming Stadium (page 38)

India
Palmyra House (page 104)

Italy
Kursaal Piscina (page 176)
Palazzo delle Terme, Foro Italico (page 40)
Sporting Club of Monza (page 150)

Japan
Swimming Pool, 21st Century Museum of Contemporary Art (page 164)
Yoyogi National Gymnasiums (page 180)

Mexico
Casa Monterrey (page 80)
Cuadra San Cristóbal (page 94)

Portugal
Piscina das Marés (page 110)

Scotland
Royal Commonwealth Pool (page 52)

Singapore
Marina Bay Sands Hotel (page 84)

South Africa
Silo Hotel (page 86)

Spain
Azkuna Zentroa (page 192)
Bofill Family House (page 100)
Dalí House-Museum (page 98)
Piscina Municipal de Montjuïc (page 66)

Sri Lanka
Bawa's private quarters in the Lunuganga Estate
 (page 92)

Switzerland
Naturbad Riehen (page 118)
Thermal Baths in Vals (page 114)

United States
Bakers' Pool (page 162)
The Berkeley City Club Pool (page 18)
Case Study House #22 (page 62)
Donnell Garden Pool (page 132)
Kaufmann Desert House (page 158)
Tropicana Pool, Hollywood Roosevelt Hotel
 (page 160)

Index

Aalto, Aino and Alvar 130–1, 133, 135–6, 139
 Villa Mairea *(see entry)*
Aarons, Slim 159
Accidentally Wes Anderson 19, 52
Adams, Jay 143
Ai Weiwei 55
Aileen Sage Architects 51
Alfréd Hajós National Swimming Stadium 38–9
Alhóndiga Cultural and Leisure Centre 192–3
Alva, Tony 143
Ando, Tadao
 Casa Monterrey 80–3
Architectural Association 56, 92
Arp, Jean 139
Art Deco 22
Art Nouveau 154
Artek 130
Arts & Architecture 63
Arup 55, 84
Athens Olympics (1896) 39
Australia: Centenary Pool 50–1
 Villa Marittima 168–9
Azkuna Zentoa (Alhóndiga Cultural and Leisure Centre) 192–3
Azure 9

Bachelard, Gaston 191
Badeanstalten Spanien 14–17
Baker, Josephine 10
Baker, Lisa 163
Bakers' Pool 162–3
Bangalore 10
Barat, Sébastien Martinez 186, 188, 190–1
Barcelona 67
 Olympics (1992) 67, 69
Barragán, Luis
 Cuadra San Cristóbal 94–7
Bastida, Ricardo 193
Bath and Washhouses Act (1846) 154
Bawa, Bevis 92

Bawa, Geoffrey
 Lunuganga Estate 92–3
Beaux Arts 136
Beijing Olympics (2008) 55
Berger, John 186, 188, 191
The Berkeley City Club Pool 18–21
Better leisure centres 56
Biceps et Bijoux 175
Binet, Hélène 115
Binoche, Juliet 22
Birrell, James
 Centenary Pool 50–1
Black Lion 145
Bofill, Ricardo
 Bofill Family House 100–3
Borden Natural Swimming Pool 120–3
Brazil, Casa das Canoas 146–9
Breuer, Marcel 39
Brunelleschi, Filippo 176
Brutalism 52
Burle Marx, Roberto 51
Burnell, Soo 52

Calatrava, Santiago 176
Californian suburbia 139–43
Canada, Borden Natural Swimming Pool 120–3
Canevari, Angelo 40, 46, 47, 48
Cant, Donald 169
Canvas 145
Capeillères, Alain 186–91
 Villa Capeillères 182–3
Capeillères, Lucie 182, 186, 188, 190
Carey, Peter 76–9
Carlsbad 144
Casa das Canoas 146–9
Casa Monterrey 80–3
Casabella 190
Case Study Houses (CSH) programme 63
 Case Study House #22 (Stahl House) 62–3
Centenary Pool 50–1

Ceschiatti, Alfredo 146
China: The National Aquatic Centre 54–5
China State Construction Engineering Corporation 55
China State Construction International Design Co. Ltd 55
Church, Betsy 133
Church, Thomas 136, 140
 Donnell Garden Pool 132–3, 136–40
Claybury Mental Hospital 170
Cleveland Pool 76
Combi-Pool 144, 145
Commonwealth Games 52, 56
Concrete Wave skatepark 144
Costantini, Constantino 40–9
Cuadra San Cristóbal 94–7

Dalí, Gala 98
Dalí, Salvador 75, 139
 Dalí House-Museum 98–9
Davies, Arthur 154–7
De Courcy Meade, Thomas 154–7
de Havilland, Olivia 139
de Noailles, Charles 175
de Noailles, Marie-Laure 175
Del Debbio, Enrico
 Fora Italico 40–9
Denmark: Badeanstalten Spanien 14–17
 Kastrup Sea Bath 116–17
Desjoyaux 185
Didion, Joan 185
Dogtown and Z-Boys 143
'Domestic Pools' exhibition (2018) 186, 190–1
Domus 186, 190
Donald Insall Associates 76–9
Donnell, Dewey 136
Donnell, Jean 136
Donnell Garden Pool 132–3, 136–40, 145, 151
Draiby, Frederik
 Badeanstalten Spanien 14–17

Duffy, Roger 163

Eckersley O'Callaghan Architects 194–7
EcoWorld Ballymore 194
Egerström family 94–7
EIAR (Ente Italiano per le Audizioni Radiofoniche) 44
Elizabeth I, Queen 76
Elizabeth II, Queen 127
Embassy Gardens, Sky Pool 194–7
Empire Swimming Pool 52, 56
England 109
 Bakers' Pool 162–3
 Kenwood Ladies' Pond 108–9
 London Aquatic Centre 56–9
 Parliament Hill Fields Lido 24–7, 109
 Penguin Pool, London Zoo 126–9
 Repton Park 170–1
 Sky Pool at Embassy Gardens 194–7
 Thermae Bath Spa 76–9
 Victoria Baths 154–7
Entenza, John 63
Erlich, Leandro
 Swimming Pool, Museum of Contemporary Art 164–7
Existentialism 185

FINA 56
Finland: Villa Mairea 130–1, 133, 135–6, 139, 145
Fondation Nationale de la Photographie 182
Fontana, Lucio 151
Foro Italico 40–9
France: Les Bain des Docks 32–5
 Paddling Pool, Unité d'Habitation 28–9
 Piscine Pontoise 22–3
 Tournesol swimming pools 30–1
 Villa Capeillères 182–3, 186–91
 Villa dall'Ava 64–5
 Villa Noailles 174–5, 190, 191
Franck, Martine 182, 186, 188, 190–1
Fruit Bowl 143, 144
Functionalism, Nordic 14

G-Force skateparks 145
Gathy, Jean-Michel 84–5
gh3* architects
 Borden Natural Swimming Pool 120–3
Gehry, Frank 193
Giusti, Elena 151
Grimshaw, Sir Nicholas
 Thermae Bath Spa 76–9
Gropius, Walter 39
Guggenheim Museum 193
Gullichsen, Harry 130, 135
Gullichsen, Maire 130, 135

H&R Johnson 186
Hadid, Zaha
 London Aquatics Centre 56–9
Hajós, Alfréd
 Alfréd Hajós National Swimming Stadium 38–9
HAL Architects
 Sky Pool at Embassy Gardens 194–7
Halprin, Lawrence 139
Hampstead swimming
 Parliament Hill Fields Lido 24–7
 Kenwood Ladies' Pond 109
HBC Global Art Collection 163
Hearst, Phoebe Appleton 19
Hearst, William Randolph 19
Heatherwick, Thomas
 Silo Hotel 86–9
Heritage Lottery Grant 154
Herzog & de Meuron 55, 169
 Naturbad Riehen 118–19
High Tech architecture 31
Highgate Men's Pond 109
Hine, George Thomas 170
Historic Scotland 52
Hockney, David 164
 Hollywood Roosevelt Hotel, Tropicana Pool 160–1
Holliday, Amelia 51
Hollywood Roosevelt Hotel, Tropicana Pool 160–1
House Beautiful 140
Hungary: Alfréd Hajós National Swimming Stadium 38–9

India: Palmyra House 104–5

International Style 159
Iofan, Boris 7
Italy 43–8
 Kursaal Piscina 176–9
 Palazzo delle Terme, Foro Italico 40–9
 Sporting Club of Monza 150–1

Jacquemus 182
Jain, Bijoy
 Studio Mumbai *(see entry)*
Japan: Swimming Pool, Museum of Contemporary Art 164–7
 Yoyogi National Gymnasiums 56, 180–1
Johnson-Marshall, Stirrat
 Royal Commonwealth Pool 52–3
Jourdain, Francis 175

Kastrup Sea Bath 116–17
Kaufmann, Edgar J. 159
Kaufmann, Liliane 159
Kaufmann Desert House 158–9
Kent, Adaline 139, 151
 Donnell Garden Pool 132–3
Kenwood Ladies' Pond 108–9
Kieślowski, Krzysztof 22
Koenig, Pierre
 Case Study House #22 62–3
Koenigsberger, Otto 10
Koolhaas, Rem 11, 56
 OMA *(see entry)*
Kubo, Shogo 143
Kursaal Piscina 176–9

La Piscine Tournesol 30–1
La Societé des Piscines de France 22
Lafore, Benjamin 190–1
Lama, Serge 185
Lapadula, Attilio 176
Laprade, Romain 191
Le Corbusier 51
 Paddling Pool, Unité d'Habitation 28–9
Le Parisien 185
Leeuwen, Thomas van 7
Les Bain des Docks 32–5
Les Mystères du Château de Dé 175

L'Esprit Nouveau 28
Linsk, Joseph 159
Linsk, Nelda 159
London Aquatic Centre 56–9
London Fields Lido 25
London Olympics: (1948) 56
 (2012) 52, 56
London Zoo, Penguin Pool 126–9
Loos, Adolf 10
Lords of Dogtown 143
Los Angeles Conservancy 63
Los Angeles Olympics: (1932) 43
 (1984) 160
Los Angeles Times 140
Lubetkin, Berthold
 Penguin Pool, London Zoo
 126–9
 Tecton *(see entry)*
Lunuganga Estate 92–3

Mad Dog Bowl 145
Magnum 188
Mallet-Stevens, Robert 190
 Villa Noailles 174–5, 190, 191
Manuel, Jacques 175
Margaret, Princess 127
Marina Bay Sands Hotel 84–5
Matignon Accord (1936) 182
Matthew, Robert 52–3
MBL 190
Melbourne Olympics (1956) 51
Merleau-Ponty, Maurice 185
Metabolist movement 181
Mexico: Casa Monterrey 80–3
 Cuadra San Cristóbal 94–7
 Mexico Olympics (1968) 31
Michelangelo 44
Mies van der Rohe, Ludwig 67
Millennium Commission 76
Ministry of Youth, Sports and
 Leisure, France 31
Minogue, Kylie 67
Minoletti, Giulio
 Sporting Club of Monza 150–1
Miró, Joan 139
Mixed Pond 109
Modernism 109, 135, 146
MoMA PS1 164
Monzó, Quim 75
Moragas, Antoni de
 Piscina Municipal de Montjuïc
 66–75
Moretti, Luigi
 Fora Italico 40–9
Morgan, Julia
 The Berkeley City Club Pool
 18–21
 San Simeon 139
Moskva Pool 7
Munich Olympics (1972) 160
Mussolini, Benito 40, 43, 46, 47,
 176
Mussolini's Boys 43

Natare Pools 84
The National Aquatic Centre
 54–5
National Recreation Centre 52
Naturbad Riehen 118–19
Nervi, Pier Luigi
 Kursaal Piscina 176–9
Neutra, Richard 135
 Kaufmann Desert House 158–9
Niemeyer, Oscar 32, 51
 Casa das Canoas 146–9
Noguchi, Isamu 135, 139
Nouvel, Jean
 Les Bain des Docks 32–5

Oki, Peggy 143
Olympic Games 43
 see also individual cities
OMA 56
 Koolhaas, Rem *(see entry)*
 Villa dall'Ava 64–5
Otto, Frei 176
Ove Arup
 Penguin Pool, London Zoo
 126–9

Paddling Pool, Unité d'Habitation
 28–9
Palace of the Soviets 7
Palazzo delle Terme, Foro Italico
 40–9
Palmyra House 104–5
Paris Olympics: (1924) 39
 (2024) 22, 181
Parliament Hill Fields Lido 24–7,
 109

Pécsi, Eszter
 Alfréd Hajós National
 Swimming Stadium 38–9
Penguin Pool, London Zoo 126–9
Peralta, Stacy 143–4
Perret, Auguste 32
Phelan, Robert 55
Phelps, Michael 55
Pipeline 144, 145
Piscina das Marés (Leça da
 Palmeira) 110–13
Piscina Municipal de Montjuïc
 66–75
Piscine Molitor 22
Piscine Pontoise 22–3
Pollet, Lucien
 Piscine Molitor 22
 Piscine Pontoise 22–3
Ponti, Gio 151
Popular Mechanics 140
Portugal: Piscina das Marés (Leça
 da Palmeira) 110–13
 Quinta da Conceição 110
Price, Henry
 Victoria Baths 154–7
Pripyat, Chernobyl 9
Pritzker Prize 56
Proust, Marcel 187
PWT Architects 55

Quinta da Conceição 110

Ray, Man 175
Reich, Lilly 67
Repton, Humphry 170
Repton Park 170–1
Restorations (BBC) 154
RIBA (Royal Institute of British
 Architects) 52, 67
Richards, John 52–3
RMJM
 Royal Commonwealth Pool
 52–3
Rom 145
Rosso, Giulio 40, 46
Rowbotham, Harry
 Parliament Hill Fields Lido
 24–7, 109
Royal Commonwealth Pool 52–3
Royal Portfolio Group 87

Rushdie, Salman 10

S&P Architects 52
Safdie, Moshe
 Marina Bay Sands Hotel 84–5
San Simeon 139
Sartre, Jean-Paul 185
Schoeller, Bernard
 Tournesol swimming pools 30–1
Scotland, Royal Commonwealth Pool 52–3
Serra, Albert 75
Sethna, Jamshyd 104
7132 Hotels 115
Shulman, Julius 63, 159
Silo Hotel 86–9
Singapore: Marina Bay Sands Hotel 84–5
Siza, Álvaro
 Piscina das Marés (Leça da Palmeira) 110–13
 Quinta da Conceição 110
Skateboard Heaven 144, 145
SkateBoarder 143
skateboarders 133, 140–5
SkaterCross 144
Sky Pool at Embassy Gardens 194–7
Smith, Walter 163
Smithson, T.L.
 Parliament Hill Fields Lido 24–7, 109
Solà-Morales, Ignasi de 67
Solid Surf 145
SOM (Skidmore Owings and Merrill) 39, 163
Soul Bowl 143, 144, 145
South Africa, Silo Hotel 86–9
Soviet Avant-Gardes 181
Spain: Alhóndiga Cultural and Leisure Centre 192–3
 Bofill family house 100–3
 Dalí House-Museum 98–9
 Piscina Municipal de Montjuïc 66–75
Sporting Club of Monza 150–1
Sri Lanka, Bawa's private quarters, Lunuganga Estate 92–3
Stahl, Carlotta 63
Stahl, Buck 63

Stahl House (Case Study House #22) 62–3
Starck, Philippe
 Azkuna Zentroa 192–3
Stecyk, Craig 143
Studio Mumbai
 Jain, Bijoy *(see entry)*
 Palmyra House 104–5
Superstudio 190
Svarbova, Maria 28
Swimming Pool, Museum of Contemporary Art, Japan 164–7
Switzerland: Naturbad Riehen 118–19
 Thermal Baths in Vals 114–15

Tabet, Michelle 51
Tagliabue, Ettore 151
Tange, Kenzō 39, 181
 Yoyogi National Gymnasiums 56, 180–1
Tange, Paul Noritaka 181
Tanguy, Yves 139
Távora, Fernando 110
Teardrop Hotel 92
Tecton
 Lubetkin, Berthold *(see entry)*
 Penguin Pool, London Zoo 126–9
The Story of the Pool 11
Thermae Bath Spa 76–9
Thermal Baths in Vals 114–15
Three Colours: Blue 22
Tokyo Olympics: (1964) 181
 (2020) 39, 181
Toland, Isabelle 51
Tomasini, Antonia 151
Tournesol swimming pools 30–1
Treib, Marc 139–40
Tropical Modernism 9, 92
Tropicana Pool, Hollywood Roosevelt Hotel 160–1
Turrell, James
 Bakers' Pool 162–3

Unité d'Habitation, Paddling Pool 28–9
Universal Exposition: (1929) 67, 69

 (1942) 40
Urban Land Institute 193
USA: The Berkeley City Club Pool 18–21
 Case Study House #22 (Stahl House) 62–3
 Donnell Garden Pool 132–3, 136–40, 145, 151
 Kaufmann Desert House 158–9
 Tropicana Pool, Hollywood Roosevelt Hotel 160–1

Venice Biennale (2016) 51
Vermeer, Johannes 187
Victoria Baths 154–7
Villa Capeillères 182–3, 186–91
Villa dall'Ava 64–5
Villa Mairea 130–1, 133, 135–6, 139, 145
Villa Marittima 168–9
Villa Noailles 174–5, 190, 191
Von Sternberg House 135
Vriesendorp, Madelon 11

the Water Cube 54–5
Weaire, Denis 55
White Arkitekter
 Kastrup Sea Bath 116–17
Wilde, Olivia 159
Williams, Paul 139
Williams, Robin
 Villa Marittima 168–9
Winter, Dr Pierre 28
Women's City Club 19
Wright, Frank Lloyd 159
 Kaufmann Desert House 158–9

Yoyogi National Gymnasiums 56, 180–1

Zaha Hadid Architects
 London Aquatics Centre 56–9
Zeitz Museum of Contemporary Art, Africa (MOCAA) 87
Zoological Society 127
Zublin house 139
Zumthor, Peter
 Thermal Baths in Vals 114–15

Further Reading

Beanland, Christopher. *Pool: A Dip into Outdoor Swimming Pools*. Rizzoli (2020).

Carr, Karen. *Shifting Currents: A World History of Swimming*. University of Chicago Press (2022).

Chaline, Eric. *Strokes of Genius: A History of Swimming*. University of Chicago Press (2017).

Means, Howard. *Splash: 10,000 years of Swimming*. Hachette (2020).

Pearson, Christie. *The Architecture of Bathing: Body, Landscape, Art*. MIT Press (2020).

Romer-Lee, Chris. *Sea Pools: 66 Saltwater Sanctuaries From Around the World*. Rizzoli (2023).

Tsui, Bonnie. *Why We Swim*. Algonquin (2020).

Van Leeuwen, Thomas A.P. *The Springboard in the Pond: An Intimate History of Swimming*. MIT Press (revised ed. 2000).

Wiltse, Jeff. *Contested Waters: A Social History of Swimming Pools in America*. University of North Carolina Press (2007).

Arnaud, Pierre (1998). "Sport – a means of national representation." *Sport and International Politics: Impact of Fascism and Communism on Sport*. Ed. Pierre Arnaud & James Riordan. Taylor & Francis Group, London & New York.

Cheever, John. "The Swimmer" in *The New Yorker*, 10 July 1964.

Dogliani, Patrizia (2000). "Sport and Fascism." *Journal of Modern Italian Studies*, 5:3, 326–348. DOI: 10.1080/1354571X.2000.9728258.

Gori, Gigliola (1999). "Model of Masculinity: Mussolini, the 'new Italian' of the Fascist era." *The International Journal of the History of Sport*, 16:4, 27–61. DOI: 10.1080/09523369908714098.

Gori, Gigliola (2003). "Mussolini's Boys at Hitler's Olympics." *The Nazi Olympics: Sport, Politics, and Appeasement in the 1930s*. 113–126. Ed. Arnd Krüger & William Murray. University of Illinois Press. JSTOR, http://www.jstor.org/stable/10.5406/j.ctt3fh62r.

Kirk, Terry (2014). "Image, Itinerary, and Identity in the 'Third' Rome." *Power and Architecture: The Construction of Capitals and the Politics of Space*. 1st edition. 152–177. Ed. Michael Minkenberg. Berghahn Books. JSTOR, http://www.jstor.org/stable/j.ctt9qd8m7.

"Los Angeles 1932 Medal Table." Last accessed 13 October 2023. https://olympics.com/en/olympic-games/los-angeles-1932/medals.

Marraffa, Roberto (1951). "Modern Architecture in Italy." *East and West*, January 1951, Vol. 1, No. 4. 231–239. Instituto Italiano per L'Africa e L'Oriente. Stable URL: https://www.jstor.org/stable/29753503.

Mendonca, Lisandra Franco de (2018). "Mussolini's Swimming Pool in the Former Palazzo Delle Terme (Current Edificio Delle 'Piscine Coni') at the Foro Italico, In Rome: Historical Analysis and Conservation." *PosFAUUSP* 25 (47):92-111. https://doi.org/10.11606/issn.2317-2762.v25i47p92-111.

Morgan, Sarah (2006). "Mussolini's Boys (And Girls) Gender and Sport in Fascist Italy." *History Australia*, 3:1, 04.1-04.12, DOI: 10.2104/ha060004.

Mosse, George L. (1996). "Fascist Aesthetics and Society: Some Considerations." *Journal of Contemporary History*, April, 1996, Vol. 31, No. 2, Special Issue: The Aesthetics of Fascism. 245–252. Sage Publications, Ltd. Stable URL: https://www.jstor.org/stable/261165.

Pooley, Eugene (2013). "Mussolini and the City of Rome." *The Cult of the Duce: Mussolini and the Italians*. 209–224.

Ed. Stephen Gundle, Christopher Duggan, & Giuliana Pieri. Manchester University Press. JSTOR, http://www.jstor.org/stable/j.ctt18mvkcv.

Riordan, James (1998). "Introduction." *Sport and International Politics: Impact of Fascism and Communism on Sport*. Ed. Pierre Arnaud & James Riordan. Taylor & Francis Group, London & New York.

Teja, Angela (1998). "Italian Sport and International Relations Under Fascism." *Sport and International Politics: Impact of Fascism and Communism on Sport*. Ed. Pierre Arnaud & James Riordan. Taylor & Francis Group, London & New York.

Testa, Judith (1998). "Mussolini's 'Third Rome'." *Rome is Love Spelled Backward: Enjoying Art and Architecture in the Eternal City*. 257–262. Cornell University Press. JSTOR, http://www.jstor.org/stable/10.7591/j.ctv177tbsm.

Tymkiw, Michael (2019). "Floor Mosaics, Romanità, and Spectatorship: The Foro Mussolini's Piazzale dell'Impero." *Art Bulletin*, 101:2, 109–132, DOI: 10.1080/00043079.2019.1527644.

Wecker, Regina (July 2005). "Eugenics, Genetics, and the Politics of Gender." Body Politics round table at CISH/ICHS.

Footnotes

Concrete, Tiles and Coping: How Skateboarders Fell in Love with the Swimming Pool (Iain Borden)
1. Thomas D. Church, *Gardens Are for People*, (New York: McGraw-Hill, second edition, 1983), p. 33.
2. Marc Treib, *The Donnell and Eckbo Gardens: Modern Californian Masterworks*, (San Francisco: William Stout, 2005), pp. 17 and 47.
3. Jennifer A. Watts, 'Swimming Alone: the Backyard Pool in Cold War California,' in Daniel Cornell, (ed.), *Backyard Oasis: the Swimming Pool in Southern California Photography, 1945–1982*, (Delmonico Prestel/Palm Springs Art Museum, 2012), pp. 52–9.
4. Keith Hamm, 'Coping Conquistadors', *Slap*, v.4 n.9 (September 1995), p. 48.
5. 'Pool Riding Symposium', *SkateBoarder*, v.3 n.1 (October 1976), p. 74.
6. Iain Borden, *Skateboarding and the City: a Complete History*, (London: Bloomsbury, 2019), Ch. 7 'Skatopia' and Ch. 8 'Skatepark Renaissance'.

Acknowledgements

Mussolini's Boys: Muscles, Messages and Mosaics (Tatjana Crossley)

During my initial research of this striking space, I came across the essay by Sarah Morgan entitled *Mussolini's Boys (And Girls): Gender and Sport in Fascist Italy*. In the first sentence, she includes the fascinating fact that the 1932 Italian Olympic athletes were given the nickname 'Mussolini's Boys', a title so pertinent to the mosaic imagery of the Foro Italico indoor swimming pool (and the imagery used throughout the sporting complex).

Under Mussolini's regime, the Italian government propagated the idea of a new Italian man through fitness programmes and sporting institutions. The pervasive imagery of strong, virile athletes depicted in the mosaics served as potent propaganda that could cultivate this aspiration.

While analyzing the space, its materials and meanings, I benefitted from the historical research provided by scholars such as Patrizia Dogliani, Lisandra Franco de Mendonça, Angela Teja and Michael Tymkiw. Their contributions enriched my interpretation of the Palazzo delle Terme and the nuanced messages it conveys.

Acknowledgements

I started researching swimming pools in 2021 at the end of the Covid-19 lockdown, after I completed my doctorate. I am grateful to Barbara Penner, who excitedly egged me on when I told her about my then growing passion. Barbara has been a scaffold throughout this research, which I have presented internationally in many different registers. These conversations led to me teaching a history course on swimming pools and a day-long symposium at the Architectural Association, School of Architecture (AA) where Manijeh Verghese and Harriet Jennings as leads of the AA Public Programme, and Mark Morris as head of Teaching and Learning, supported and gave me a platform for my research, which caught the attention of Lilly Phelan and Polly Powell at Batsford, which resulted in this book. I am thankful to all my friends, students and colleagues who participated in the symposium and contributed to my understanding and knowledge about swimming pools. Further to that, Tatjana Crossley, Mathilde Redouté and Anna Font have contributed to this work, spending their time in writing original essays that are not necessarily a part of their intellectual interests. Iain Borden was extremely generous in sharing his work with me to add to the volume. I am especially grateful to Logan Paine, Thibault Nugue and Alexander Teddy who shared remarkable examples with me that are now part of this book. Lastly, I am thankful to the library at the AA and its librarians Simine Marine and Beatriz Flora, who have helped me find articles and books – several examples are less well-known, especially in the English-speaking world. I have visited several pools, translated many articles from German, French, Spanish and Italian and used my decades-long architectural training as I pored over photographs to describe each of the pools such that they provide us with a novel reading of the projects when viewed from the point of view of the swimming pool. It is a project close to my heart and I am grateful for it.

About the author

Naina Gupta is an architect with degrees from Bangalore University and the Architectural Association, School of Architecture in London, where she got her PhD. She has worked internationally. She taught a course on swimming pools at the Architectural Association and currently teaches in several schools of architecture in England while also devoting time to researching the social and architectural history of swimming pools around the world.

Picture credits

Front cover: London Sky Pool, photo by Steve Tulley / Alamy
Back cover: Marina Bay Sands Hotel, imageBROKER.com GmbH & Co. KG / Alamy

p.2 Geza Kurka / Alamy
pp.4–5, 121, 122–123 Photography courtesy of gh3*
pp.6, 183, 184, 189 Piscine by Alain Capeillères, photo by Romain Laprade for Villa Noailles exhibition 'Domestic Pools', 2018
p.8 Alexander Teddy
p.11 Architectural Association Archives, London
pp.15, 16–17 Julie Bertelsen/Arkitekturbilleder.dk
pp.18, 20–21 Courtesy of The Berkeley City Club, image by Trevor Johnson, 2018
pp.23, 131 Image Professionals GmbH / Alamy
p.24 Susanne Masters / Alamy
pp.26–27 Guy Bell / Alamy
p.29 Courtesy of Gili Merin
p.30 MAXPPP / Alamy
p.33 Andia / Alamy
pp.34–35 Hemis / Alamy
p.38 Peter Forsberg / Alamy
pp.41, 45, 49b Adam Eastland Art + Architecture / Alamy
pp.42, 49t Images supplied by Instituto Luce Cinecittà
p.50 Brisbane City Archives BCC-T54-0168
p.53 Soo Burnell
pp.54, 128–129 Arcaid Images / Alamy
p.57 DanO / Alamy
pp.58–59 Johnny Greig / Alamy
p.62 © J. Paul Getty Trust. Getty Research Institute, Los Angeles (2004.R.10)
p.65 © Peter Aaron/OTTO
p.66 STUART WALKER / Alamy
p.68 © Anna Font
pp.71, 75 Paolo Bona / Alamy
p.72 Rob Watkins / Alamy
p.77 Thermae Bath Spa
pp.78–79 Thermae Bath Spa / Philip Edwards

pp.80, 82–83 Edmund Sumner-VIEW / Alamy
p.85 imageBROKER.com GmbH & Co. KG / Alamy
pp.86, 88–89 The Royal Portfolio
p.93 Courtesy of Teardrop Hotels
pp.94, 96–97 Mathilde_Mrst / Alamy
p.99 BYphoto / Alamy
pp.100, 102–103 © RBTA Archive / Gregori Civera
p.105 © Arnout Fonck
p.108 Ruth Corney
p.111 Serrat / Alamy
pp.112–113 In These Moments Studio / Alamy
p.114 Indoor Pool © 7132 Hotel – Julien Balmer
p.117 Oliver Förstner / Alamy
p.118 © Leonardo Finotti
p.126 David Reed / Alamy
p.132 Marc Treib
pp.134, 137 © Iain Borden
p.138 Maynard L. Parker, photographer. Courtesy of The Huntington Library, San Marino, California
pp.141, 142 Copyright Jim Goodrich
pp.147, 148–149 © Nelson Kon
p.150 Archivio Domus – © Editoriale Domus S.p.A.
p.155 David Lichtneker / Alamy
pp.156–157 Nick Higham / Alamy
p.158 Photo by Slim Aarons/Getty Images
p.161 Photo by Michael Childers/Corbis via Getty Images
p.162 Flickr
p.165 Nano Calvo / Alamy
pp.166–167 David Cherepuschak / Alamy
p.168 © Dean Bradley
p.171 Peter Dazeley
p.174 Mr. Megapixel / Alamy
p.177 dpa picture alliance / Alamy
pp.178–179 andrea sabbadini / Alamy
p.180 Sid Game Archive / Alamy
p.192 © Inigo Bujedo Aguirre/VIEW
p.195 Kiki Streitberger / Alamy
pp.196–197 Simon Turner / Alamy

For my father.

Published by
Princeton Architectural Press
A division of Chronicle Books LLC
70 West 36th Street
New York, NY 10018
papress.com

First published in the United Kingdom in 2025 by Batsford,
an imprint of B. T. Batsford Holdings Limited.

Copyright © B. T. Batsford Ltd 2025
Text copyright © Naina Gupta 2025

Reproduction by Rival Colour Ltd, UK
Printed and bound in China by Toppan Leefung Printing International Ltd.

28 27 26 25 4 3 2 1 First edition

ISBN 978-1-7972-3129-7

Library of Congress Control Number: 2024046338

No part of this book may be used or reproduced in any manner without written permission from the publisher, except in the context of reviews.

Every reasonable attempt has been made to identify owners of copyright.
Errors or omissions will be corrected in subsequent editions.